Jim Zuckerman's
Secrets
of
Color
in Photography

Jim Zuckerman

WRITER'S DIGEST BOOKS
Cincinnati, Ohio

Jim Zuckerman's Secrets of Color in Photography. Copyright © 1998 by Jim Zuckerman. Manufactured in China. All rights reserved. No part of this book may be reproduced in any form or by any electronic or mechanical means including information storage and retrieval systems without permission in writing from the publisher, except by a reviewer, who may quote brief passages in a review. Published by Writer's Digest Books, an imprint of F&W Publications, Inc., 1507 Dana Avenue, Cincinnati, Ohio 45207. (800) 289-0963. First edition.

Other fine Writer's Digest Books are available from your local bookstore or direct from the publisher.

02 01 00 99 98 5 4 3 2 1

Library of Congress Cataloging-in-Publication Data

Zuckerman, Jim.
　　[Secrets of color in photography]
　　Jim Zuckerman's secrets of color in photography / Jim Zuckerman.
　　　　p.　　cm.
　　Includes index.
　　ISBN 0-89879-800-0 (alk. paper)
　　1. Color photography. I. Title.
TR510.Z83　1998 97-28308
 CIP

Edited by Mary Cropper
Production Edited by Michelle Kramer
Interior and cover designed by Chad Planner

To my father, whom I knew for only ten short years.

Acknowledgments

I would like to thank my good friend, Scott Stulberg, for keeping me abreast of new programs and techniques in digital imaging, and for his invaluable assistance in making sure my Macintosh 9500 runs smoothly.

Thanks to my service bureau, Imagi-tech, [8379 Topanga Canyon Blvd., West Hills, California 91304 (818) 999-4319], for all the great scans and output.

I would also like to express appreciation to my eighth grade English teacher, Mr. Don Kuick, at O.E. Dunckle Junior High School in Farmington, Michigan, for teaching me virtually everything I know about grammar and sentence structure. I smile to myself when I remember how he used to call kids "kamikazes" when we used too many commas.

Thanks to Mary Cropper, my editor, for her help in organizing and presenting the information herein, and Michelle Kramer, the production editor, for overseeing the project and making sure all the loose ends were taken care of. And to Chad Planner, the designer, I am grateful for making my photography look good.

About the Author

Jim Zuckerman left his medical studies in 1970 to turn his love of photography into a career. He has taught creative photography at many universities and private schools, including the University of California at Los Angeles and Kent State University in Ohio. He also leads many international photo tours to destinations such as Burma, Thailand, China, Brazil, Eastern Europe, Tahiti, Alaska, Greece and the American Southwest.

Zuckerman specializes in wildlife and nature photography, travel photography, photo and electron microscopy and special effects. He also applies his talents to computer manipulation, producing cutting-edge imagery that would have been impossible only a few years ago.

Zuckerman is a contributing editor to *Peterson's Photographic Magazine*. His images, articles and photo features have been published in scores of books and magazines, including several Time-Life books, publications of the National Geographic Society, *Outdoor Photographer*, *Outdoor and Travel Photography*, *Omni* magazine, *Condé Nast Traveler*, *Science Fiction Age*, Australia's *Photo World* and Greece's *Opticon*. He is the author of four other photography books: *Visual Impact*, *The Professional Photographers Guide to Shooting and Selling Nature and Wildlife Photos*, *Outstanding Special Effects on a Limited Budget* and *Techniques of Natural Light Photography*.

His work has been used for packaging, advertising and editorial layouts in thirty countries. It has also appeared in calendars, posters, greeting cards and corporate publications. His stock photography agency, Westlight, is in Los Angeles.

You can visit Jim Zuckerman's website at www.jimzuckerman.com.

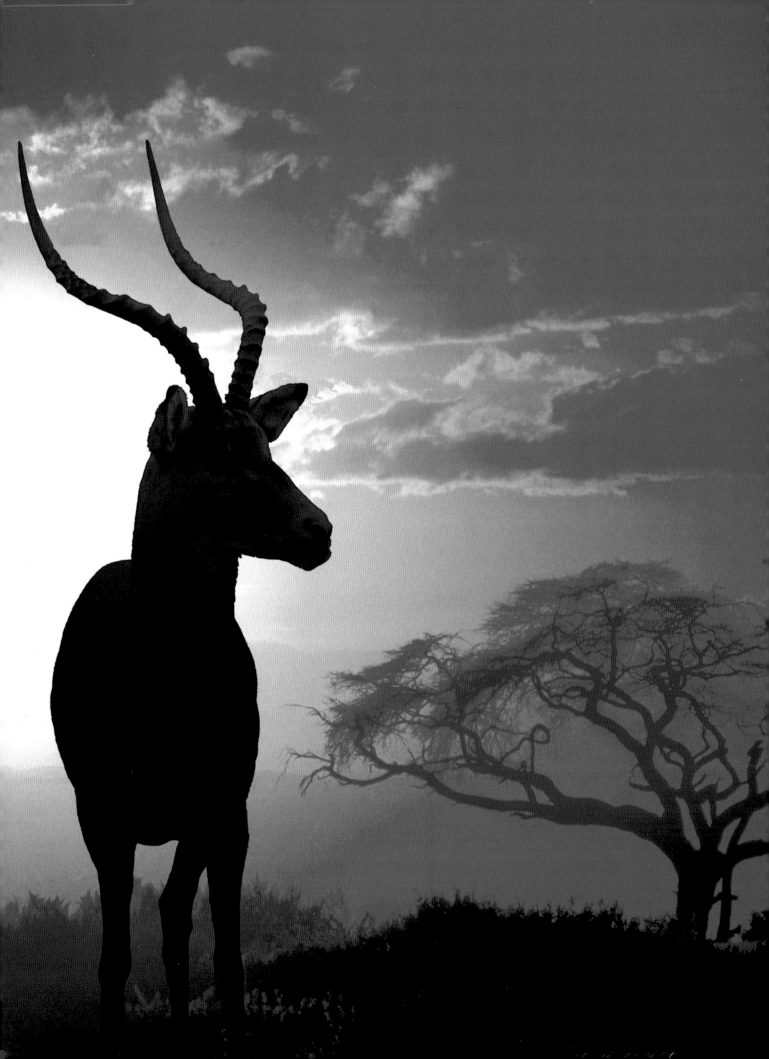

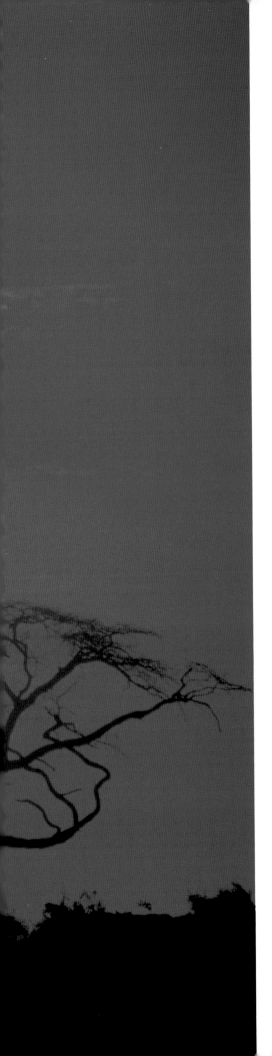

Table of Contents

Introduction

My primary goal in writing a book on photography is to help you take better pictures. This book, my fifth, explores techniques by which you can use color as a creative tool to produce stunning images of a variety of subjects.

The first step in working with color is learning to recognize its many moods. As you read the following chapters and study the detailed captions to the photos, you will become more aware of the subtleties of the ways natural and artificial light affect color, and you will see how different color combinations influence the final image. I will show you how a splash of color in a muted environment produces striking pictures, and how to make bold statements using outrageous elements of color.

You will discover how to manipulate color through the traditional use of filters and films, and how to alter the color of an image after the film has been developed. I also devote a section of the book to the latest computer techniques for altering color and contrast with remarkable ease.

This book is not a treatise on color theory. While some photographers find a scientific understanding of color interesting, that alone will not help you take better pictures. In chapter one I discuss some of the fundamental color concepts that are important to understand, because I often refer to them throughout the book. But the bulk of the material is a hands-on approach to creative ideas that you can translate directly from this book to your photos.

I want to help you create images that excite you, that make you feel proud of your achievement and that will be competitive in the marketplace, if that is your objective.

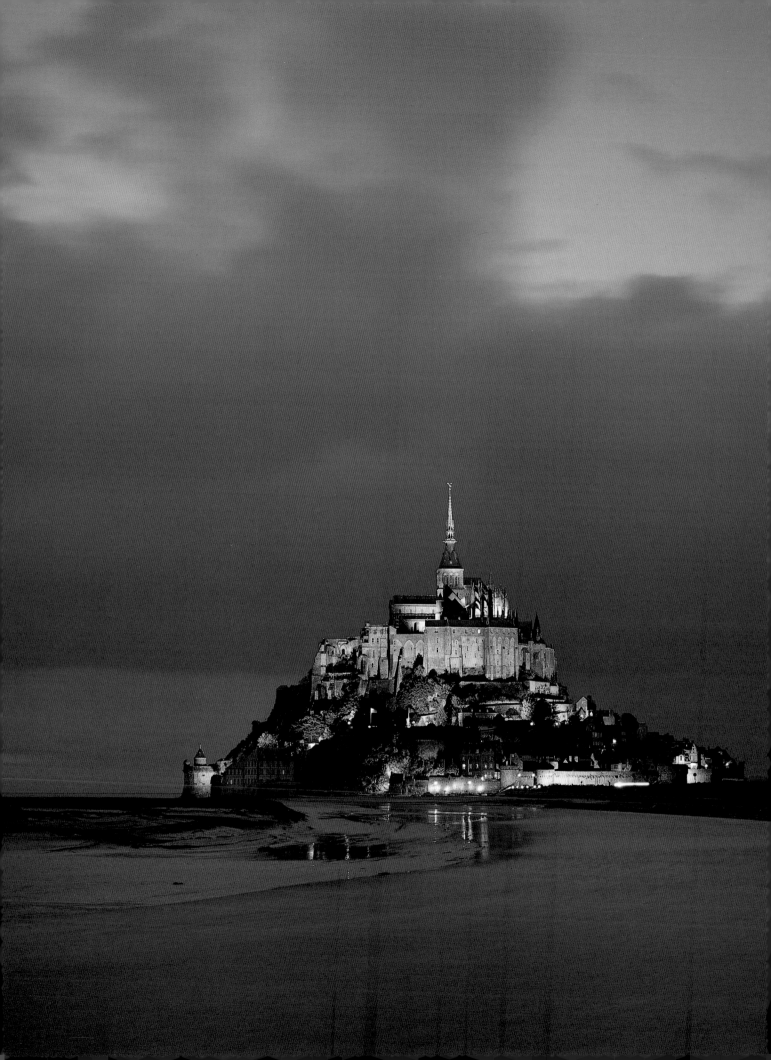

1

Concepts in Color Photography

One of the most important lessons to learn when you begin taking pictures is that the images captured on film are not exactly what our eyes see. The camera doesn't interpret the visual world the way our built-in optical system does. Consider how telephoto lenses work: They compress perspective, crop the scene before you and usually render the background out of focus. Our eyes do none of this—they take in the whole scene via our peripheral vision. Similarly, the color that you see may not be reproduced on film exactly as your eyes perceive it: It can't be.

Color film comes very close to approximating what you see, but it isn't an identical match. Some films reproduce certain colors accurately—i.e., very similar to the way our eyes see them—but reproduce others poorly. For example, Kodachrome renders skin tones accurately, but it doesn't do justice to the saturated greens in foliage. (*Saturation* refers to the richness and intensity of a color.) Fujichrome Velvia, on the other hand, produces rich, luxurious green hues, but skin tones are too red.

Contrast can also vary, and as it does, color is affected. Some films can't hold detail in subtle shadows and highlights, which means, for instance, that your eyes may have seen deep blue in a shadow, but on the film it looks black. Or a highlight might have a subtle pastel quality, but a contrasty film turns it to white.

The lesson to be learned from this is that it is a mistake to expect exact color reproduction on film. Your choice of film should be based on your personal preference for the characteristics of that particular emulsion. Is it important that the whites be white without any color bias? Is super color saturation what you want, or do you feel that exaggerated color intensity appears too artificial? Do you like increased contrast in color

film? The only way you will know which films appeal to you is to test them. If you frequently shoot flowers, shoot, on different kinds of film, an arrangement of flowers outdoors during midday under a bright sun. Compare the results to the subject itself to ascertain which color characteristics you like. I don't recommend making the test when the sun is low in the sky, even though golden sunlight is beautiful, because you want to avoid the introduction of any color bias.

There is one important factor that photographers shooting negative film must remember: Unlike slides, negatives must be printed to appreciate what you've taken. Color alterations can be introduced during the printing process. If the filter pack used to print the negatives is slightly off, an unwanted color bias can occur. If you do the printing yourself, it is a simple matter to make a correction based on your particular taste; if a commercial lab does the printing for you, you can judge a film's grain structure and color saturation, but the accuracy of the color will be affected by another person's eye or by automated equipment.

Color Temperature

Color and temperature don't seem to have any relationship with each other. When color is defined in photographic terms, however, it is ascribed a particular temperature on the Kelvin scale.

Kelvin, like Fahrenheit and Celsius, is a scale for measuring temperature. Zero degrees Kelvin—defined as absolute zero, where there is no molecular movement—corresponds to -459.67°F. The relationship between specific colors and their Kelvin temperatures was determined by heating a "blackbody radiator" (think of this as a piece of black metal that can completely absorb all the radiation striking

it) until it glowed. The particular color seen at a defined temperature became the color temperature. When the blackbody is hot enough to begin emitting light, the color is dull red. As more heat is applied, the device glows yellow, and then white and ultimately blue.

The colors radiating from the blackbody are correlated to colors we are familiar with in our daily lives. The color emitted from a tungsten lamp in your living room is identical to the yellow-white glow when the Kelvin temperature is 3200 degrees (3200 K). When the temperature rises to 5500 K, the quality of white light is identical to the color of the sun at midday.

As the Kelvin temperature rises, the colors begin to shift toward the blue end of the spectrum. Under a deep cloud cover or in shade (roughly 7500 K), for example, the longer red and yellow wavelengths are absorbed by minute water particles, and it is primarily the shorter blue wavelengths that reach the ground. The bluish light just before dark (twilight) is similar to the color of the blackbody at about 12,000 K.

How does color temperature affect what you get on film? If you look at a white shirt in daylight, it appears pure white. If you see the same shirt in your home at night under the indoor tungsten illumination, it will still look white to you. Our brain has the capacity to adjust automatically to different colors of light—we see what we expect to see, ignoring subtle variations of color. Film, however, records the predominant color of the light literally. That white shirt you see in the tungsten light would appear slightly yellowish on film, its color altered by the color temperature of the light. Therefore, film manufacturers design emulsions that produce accurate colors under different light sources.

Pay attention to the color temperature rating when you purchase film and photographic strobe equipment. Film manufactured to give you accurate colors indoors with tungsten illumination is balanced for 3200 K lighting. Daylight film is balanced for 5500 K, the color of midday light.

This means that the colors of objects photographed under midday light with daylight film will approximate the colors that you saw with your eyes. If you use an electronic flash that is rated at 5500 K, the same will be true. If the flash is rated 6000 K, however, it produces light with a slightly bluish tinge. A 4800 K flash provides light that is slightly warmer, or more yellowish, than white light.

If you don't pay attention to the color balance of your film and of the light source, you may be disappointed by the colors in your images. At twilight, when virtually all the red and yellow are gone, the high color temperature of the light produces cobalt blue colors on daylight film. On the other hand, daylight appears increasingly bluish on tungsten film as the sun moves toward the zenith. Daylight film, which is balanced for midday sunlight, renders sunrise and sunset lighting as yellow-white on film. The closer the sun is to the horizon, the lower the color temperature is, and the warmer, or more yellow, the light is. On film balanced for a tungsten light source, sunrise and sunset light is rendered very close to a correct color balance. When you photograph indoors, the same factors apply. Daylight film used with tungsten lights looks very yellow or yellow-orange. Tungsten film provides correct colors with tungsten lighting.

Complementary Colors

Two colors are complements if they form gray when combined in equal amounts. The colors that are opposite each other on a color wheel (see illustration page 9) are complements. The three main combinations that you should know (because they involve the primary colors of light) are: blue and yellow, green and magenta, and red and cyan.

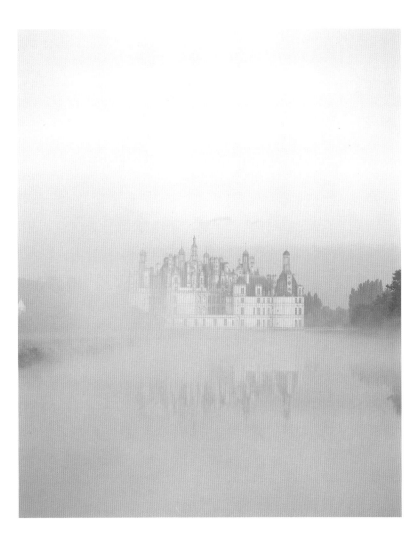

When a film has a bias toward a color, this shift will be easily seen in skin tones, winter landscapes, fog-enshrouded subjects and pastel scenes. In other words, when a subtle color is noticeable and critical, even a small bias is detectable.

This early morning study of the spectacular Chambord Chateau in France was an exercise in photographing shades of white. The sky was bluish white; the fog and the building were white. I use Fujichrome Velvia for most of my travel photography because it is remarkably sharp and I like saturated colors. However, Velvia has a bias toward the red end of the spectrum. Red objects appear supersaturated on Velvia, but subtle subjects with very little color are also altered by the red bias.

Notice the slight reddish cast in the fog. The sky and its reflection in the water appear less red because of the very subtle hint of blue. However, even those portions of the frame are affected by the film bias.

Technical Data:
Mamiya RZ 67 II, 250mm telephoto lens, 1/8, f/11-f/16, Fujichrome Velvia, tripod.

Color distortion can occur when one color in a scene affects another and causes a shift. Sometimes the alteration can be subtle; other times it is obvious. In this picture of a great horned owl, photographed in Colorado, the surrounding foliage in the forest influenced the color of the bird. It has subtly shifted toward green. I didn't recognize the possibility of this at the time, but had I anticipated the distortion, a correction could have been made. A warming filter such as an 81A (see page 30) could not be used because it is designed to neutralize a shift toward the blue portion of the spectrum. To counteract green, a subtle magenta filter, like a 5M (available as a gelatin filter from Kodak), must be used.

Technical Data:
Mamiya RZ 67, 500mm APO telephoto, 1/125, f/6, Fujichrome Provia 100, tripod.

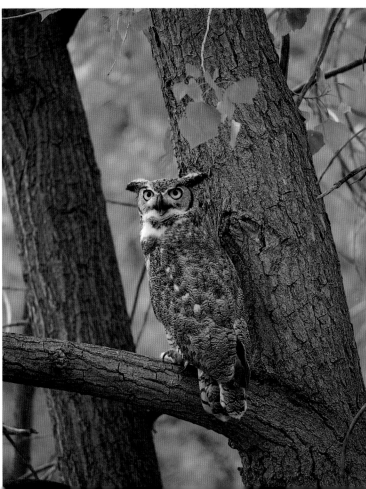

Color Temperature

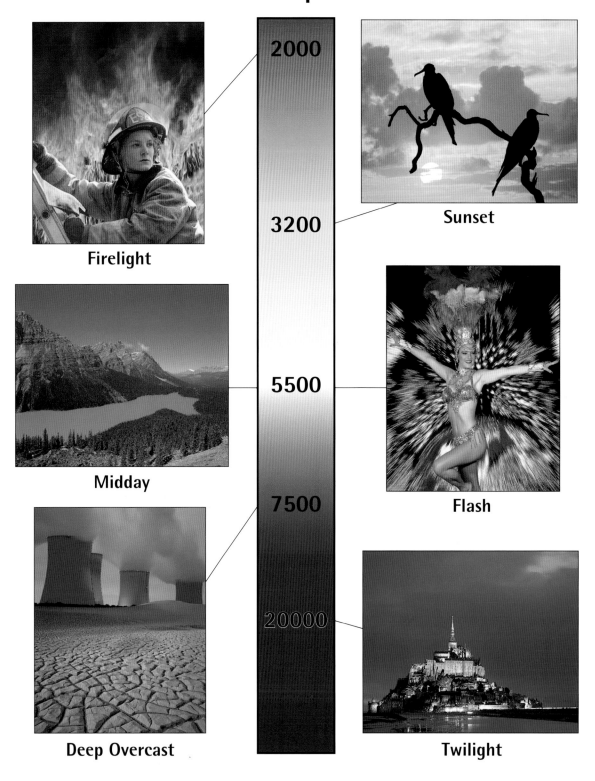

Firelight

2000

3200

Sunset

Midday

5500

Flash

7500

Deep Overcast

20000

Twilight

Color temperature is measured on the Kelvin temperature scale. Midday sunlight, the light that is traditionally called "white," correlates to a color temperature of 5500 degrees Kelvin (5500 K), as does the light from an electronic flash. Temperatures below this point reflect reddish or yellowish color, while those above it are blue and purplish. Firelight, sunrise and sunset lighting and tungsten lamps are at the warm end of the spectrum, and are thus measured in the range of 2000 K to 3000 K. Overcast conditions, deep shadows and twilight all produce bluish tones and are thus rated at temperatures above midday sunlight, roughly from 6000 K to 12,000 K.

When you are aware of how a film will react to a particular light source, you can predict how the colors will look in the final image. Consequently, your control over the medium increases, and you can exercise greater creativity in your work.

The interior of the famous opera house in Vienna was illuminated with tungsten lights. I had gone to great trouble and expense to get permission to photograph here without hundreds of people milling about before a performance, and I wanted to cover all my bases. I used two films to capture the stunning architecture. First, a tungsten-balanced film, Fujichrome 64T, captured approximately what I saw with my eyes. Next, I used my favorite daylight-balanced film, Fujichrome Velvia, for a very different effect.

The 3200 degree Kelvin (3200 K) lights are interpreted by outdoor films with a saturated golden (yellow-orange) cast. Under most circumstances, this bold shift in the color balance is considered an undesirable outcome, and photographers often use correction filters to compensate for it. But in this case, I actually liked the golden tonality on Velvia better than the original colors. It makes the opera house glow with warmth. Both images are successful, however, and both have sold through my stock agency.

One of the advantages of the Mamiya RZ 67 is that it has interchangeable film backs. If I want to shoot two different kinds of film at one location, it is not necessary to finish one roll before loading another: I simply use two film backs, each loaded with a different type of film. In mid-roll, I can switch backs without losing any frames.

Technical Data:
Both shots—Mamiya RZ 67, 37mm fisheye, tripod. Top—1/2 second, f/5.6, Fujichrome 64T; Bottom—1 second, f/4.5, Fujichrome Velvia.

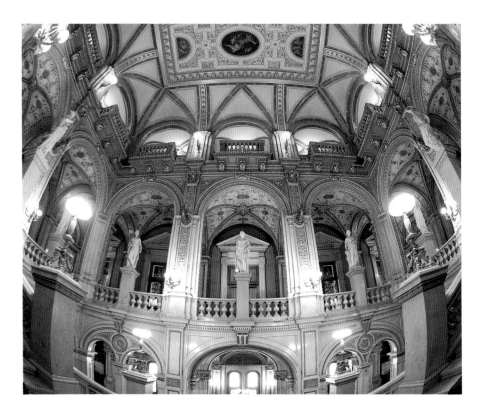

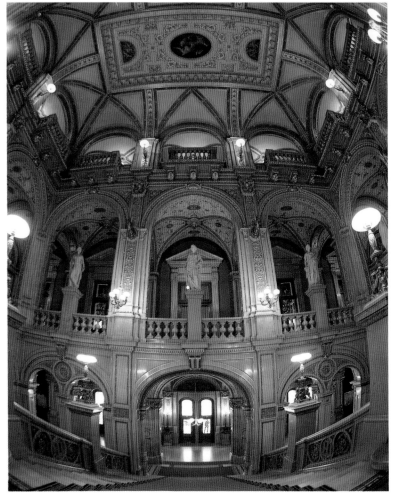

The color temperature under a deep overcast sky rises well above that under a midday sun, and outdoor scenes have a bluish tinge that is obvious even when your subject is rich in red and yellow. The thicker the layer of clouds, the more apparent the blue shift will be.

This autumn foliage composition (left) in northern Vermont was photographed late in the day under a thick cloud cover. I could even see the effect of the cool light on the red and yellow leaves as I stood there. Daylight film, balanced for 5500 K, responds to the higher color temperature by shifting toward blue. You can see that the leaves seem dull, and the sky itself is bluish gray.

The photo on the next page was also photographed on an overcast day in Vermont, but the cloud layer was significantly less dense. More daylight penetrated to the ground and, as a result, the color temperature was closer to 5500 K. Notice how the colors of the foliage are more brilliant. They are still influenced, but less so, by the cool tones caused by inclement weather.

Technical Data:
Left—Mamiya RZ 67 II, 350mm APO telephoto lens, 1/15, f/8, Fujichrome Velvia, tripod. Right—Mamiya RZ 67 II, 350mm APO telephoto lens, 1/30, f/8, Fujichrome Velvia, tripod.

Complementary color relationships define color contrast in photography. (When we talk about *film contrast*, on the other hand, we're talking about only contrast—brightness or darkness—not the actual colors.) Consider a photograph consisting primarily of green and blue, such as palm trees on a beach in the South Pacific. The blue sky, green palms and turquoise (cyan) water are a beautiful combination, but the image is relatively low in color contrast. Now imagine a model in a red bathing suit standing in the water. The striking contrast between the red suit and the cyan water occurs because these two colors are complements.

The manipulation of contrast in color images—composing pictures with certain combinations of color—plays a pivotal role in creating powerful statements. In some instances, your color combinations are planned beforehand, as when you choose the elements that will comprise an image in a model shoot or a studio setup. When shooting wildlife and nature, it's a matter of finding the right pieces in the wild. A low-angled shot of a yellow flower against the blue sky is an example of high contrast. A green butterfly against jungle foliage is an example of an image that is low in contrast. Both can be beautiful. However, an awareness of the impact of color combinations will give you greater control over your work.

Let me give you some more examples of the effective use of both high- and low-contrast photographs. One of my favorite color combinations, white on white, is low contrast. (It is considered high-key lighting, but the contrast is low.) Examples include an Arctic fox in a snowstorm or a mass of cumulus clouds filling the frame. Distant mountain ridges at dusk are low in contrast, because their subtle shades of color are in the same family. A macro shot of a rose also represents low contrast because, even though the petals are usually bright, when the composition is composed of a single color, or similar hues, the contrast is considered low.

Red or orange tulips photographed from a low angle with the blue sky in the background is a high-contrast image, because red and orange are complements of blue and cyan, the two colors that define the sky on a clear day. Similarly, the intense magenta flowers of ice plant juxtaposed with green leaves is a wonderful high-contrast image. In Southern California, this plant is used to minimize the spread of wildfires, and everywhere I see it my eyes are practically glued to the dazzling, contrasty color.

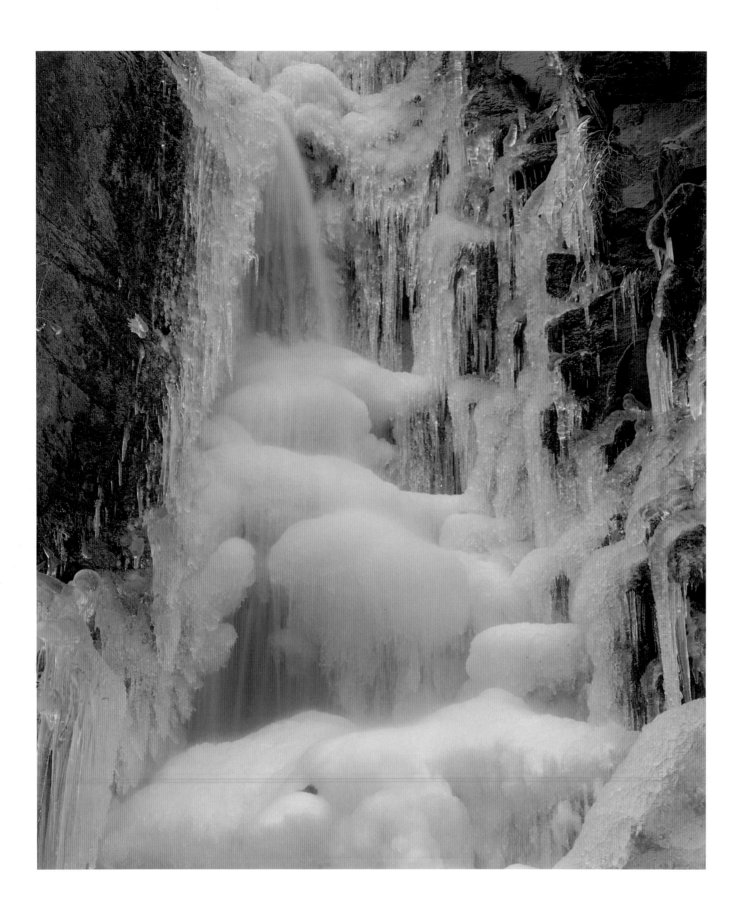

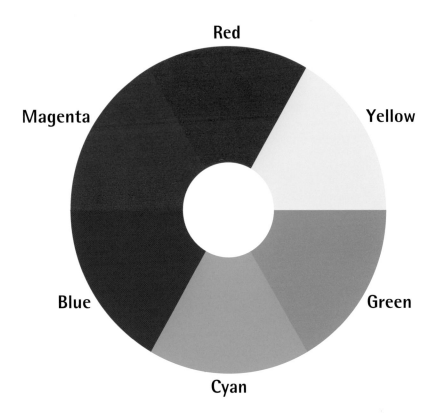

Two colors are complements if they form gray when combined in equal amounts. The colors that are opposite each other on the color wheel are complements. The primary colors of light are red, blue and green. Their complements are blue-yellow, green-magenta and red-cyan.

◀In deep shade, the Kelvin temperature is very high; hence, colors shift to the blue end of the spectrum. This is true even when the sun is shining at midday. Subjects situated in dark crevices and under a thick forest canopy will photograph with blue overtones.

This frozen waterfall that formed on a rock face in a sheltered canyon in North Cascades National Park in Washington looked neutral in color to the eye. Using daylight-balanced film, the composition shifted dramatically to blue. The color temperature was approximately 8000 K, which is 2500 degrees above the midday sunlight measurement of 5500 K.

I am not implying that this color shift is always undesirable. In fact, I find it quite beautiful. It is entirely a matter of personal taste. If a deeper saturation of blue is desired, tungsten film can be used. Should you want to capture the actual color of the ice you saw, you could counteract the blue color with a complementary correction filter, which in this case would be yellow.

Technical Data:
Mamiya RZ 67, 250mm telephoto lens, 2-second exposure, f/32, Fujichrome 50D, tripod.

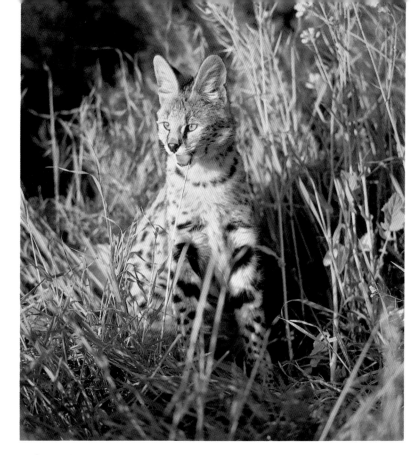

The color temperature of a tungsten light-bulb in your living room is approximately 3200 K. It is yellow-white in color, very similar to the golden tones of sunrise and sunset. If you use tungsten-balanced film (like Fujichrome 64T or Ektachrome 50) indoors with a living room light fixture, you will reproduce colors correctly. The same is true for shooting outdoors when the sun is close to the horizon: Tungsten-balanced film will produce colors similar to those seen under a midday sun.

However, when daylight-balanced film is used to shoot sunrise or sunset lighting, the yellowish color is exaggerated in rich tones. The resulting photographs look as if you'd used a yellow filter. This shot of a serval cat from East Africa was taken about twenty minutes before the sun touched the horizon. Note how saturated the color is. The same is true for the acacia tree below, photographed at sunrise. This was taken moments after the sun cleared the horizon. Note the yellow and red-orange hues at the base of the tree. When the sun is lower in the sky, the Kelvin temperature drops further and the color becomes more reddish.

Technical Data:
Both shots—Mamiya RZ 67, 500mm APO telephoto lens, 1/250, f/5.6, Fujichrome 100D, camera rested on a beanbag in the Land Rover.

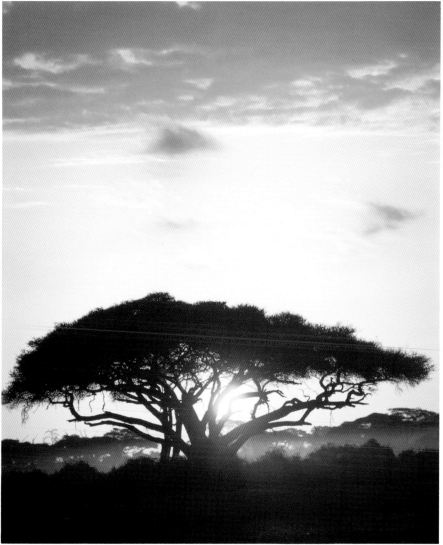

▶ One of the highest naturally occurring color temperatures, measured in degrees Kelvin, is the light in the sky at dawn and the last vestiges of light at dusk. This shot of Le Mont St. Michel in Normandy, France, was taken during that fifteen-minute window when the lights of buildings are turned on but the sky isn't yet black. Notice the contrasting colors. The sodium vapor lights on the ancient monastery and cathedral are yellow, and the sky is a blue-purple.

I usually use daylight-balanced film at twilight because I like the quality of blue-purple it gives. When city lights are on, the yellow or greenish cast of the artificial illumination provides a dramatic contrast to the sky. It doesn't matter if there is a thick cloud cover or if the sky is clear. In either case, you will capture that saturated blue-purple color characteristic of twilight.

Technical Data:
Mamiya RZ 67 II, 250mm telephoto lens, 10-second exposure, f/5.6, Fujichrome Velvia, tripod.

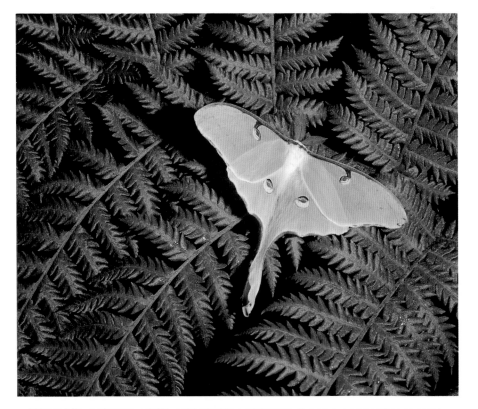

One of the ways you can control contrast in color photography is by manipulating color combinations. Juxtaposed complementary colors—for example, red with cyan or green with magenta—create tremendous contrast. When only different shades of a single color appear together in a photograph, on the other hand, the image has low color contrast.

I placed a mint green luna moth that I had raised from a caterpillar on a dark green fern to create a low-contrast color picture. It doesn't have the same visual shock value as the photo on page 12, where the juxtaposition of complementary colors produces a dramatic effect. Rather, the soft shades of green are quiet and soothing to the eye. The other element that helps make this shot successful is the placement of the lighter moth against the darker fern. This offers a beautiful tonal contrast, light against dark, that adds impact to the picture.

It is usually difficult to arrange color combinations when shooting in the wild. Nature photographers spend an enormous amount of time wandering around deserts, mountains and forests searching for beautiful designs in nature with striking, or subtle, colors. I have never been averse to creating a beautiful design in nature, whenever possible, by physically combining various components into a composition. Some photographers feel this is cheating, because the image isn't authentic. While I agree that one shouldn't sell a biologically incorrect photo for a scientific article, I feel that in some cases we have the right to exercise our artistic license to improve on nature to create a more beautiful image.

Technical Data:
Mamiya RB 67, 127mm normal lens, 1/125, f/16, Ektachrome 64, Speedotron 2403 power pack, Photoflex soft box, tripod.

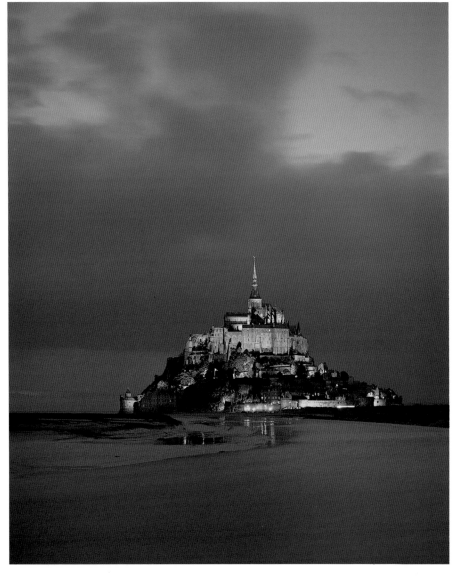

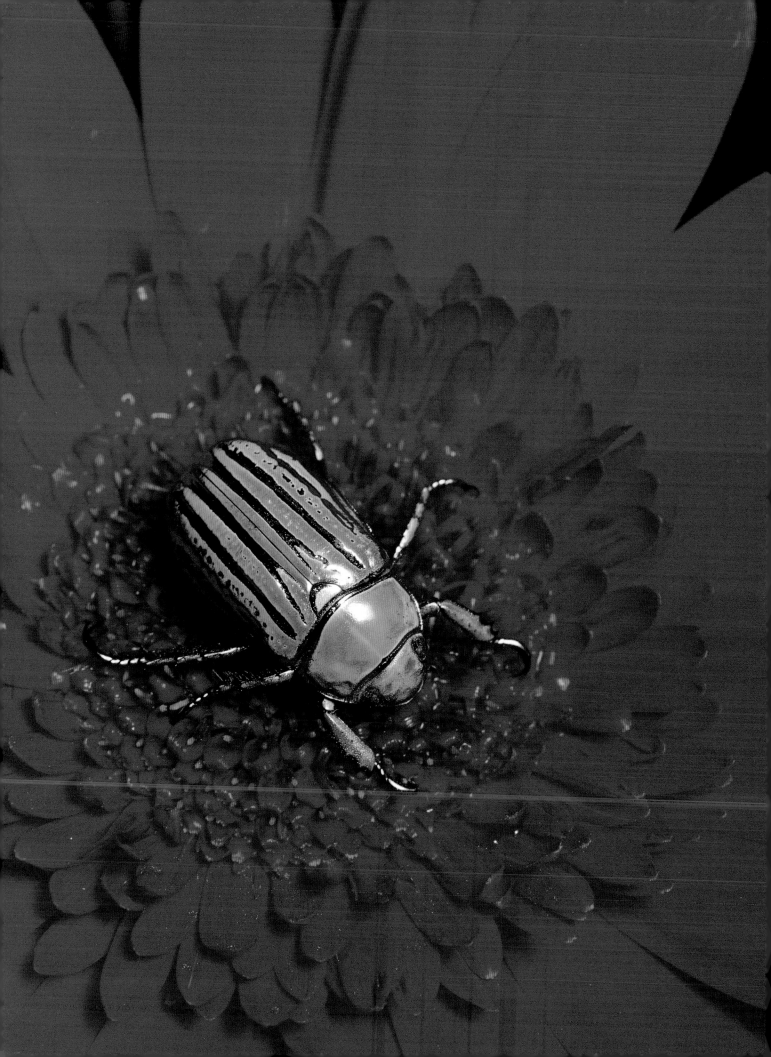

◀ Arranging elements in nature can produce wonderful pictures, although the images aren't biologically correct. This silver-striped scarab beetle, native to southern Arizona, is seen on alligator juniper. Juniper is a dull green plant with small leaves, and a photograph of the scarab beetle on this background would be a salable image for a textbook. However, it wouldn't offer the impact required for advertising or magazine covers.

Using the shock value of juxtaposed complementary colors, I placed a live scarab beetle on a magenta African daisy I had purchased at a flower shop and then took the shot outdoors with a strobe unit. I used the artificial light, even though the sun was bright, because I could place the flash head close to the insect, which let me use a small aperture to achieve maximum depth of field. If I depended solely on the sunlight, an aperture of f/22 would mean a shutter speed of 1/8 (even with the extension tube). I was concerned that the beetle might move during the exposure, rendering the photograph less than tack sharp. The strobe enabled me to freeze any movement, because the length of the exposure was defined by the flash duration. I angled the camera so the film plane was parallel with the face of the flower. This increased my assurance that I had complete depth of field.

Technical Data:
Mamiya RZ II, 110mm normal lens, no. 1 extension tube, 1/250, f/22, Speedotron 2403 power pack, Fujichrome Velvia, exposure determined by a Minolta Flash Meter IV, tripod. In the Mamiya 6 × 7 (15cm × 18cm) camera system, there is a $^2/_3$ f/stop loss in light when the no. 1 extension tube is used. When using the no. 2 extension, a 1$^1/_3$ f/ stop light loss is experienced. This must be compensated for by opening the lens the appropriate amount, based on the light reading.

The complementary colors juxtaposed in a photograph don't have to be intense or pure to create a successful image. Many colors in nature are subtle, and this decreased saturation is beautiful in and of itself. Sometimes subtle color combinations are more difficult to identify because they don't hit you in the face the way bold ones do. Once you start looking for them, though, you'll be amazed at how easy they are to spot.

This classic view of the Yellowstone River in Yellowstone National Park was taken under an overcast sky. The soft colors in the landscape are complementary—blue and yellow. Both colors are greatly reduced in saturation, so they really don't look like the familiar rich blue of new jeans or the deep yellow of a daffodil. Yet, artistically, the two colors work very well together, primarily because they are complements.

Technical Data:
Mamiya RZ II, 350mm APO telephoto lens, 1/60, f/8, Fujichrome Velvia, tripod.

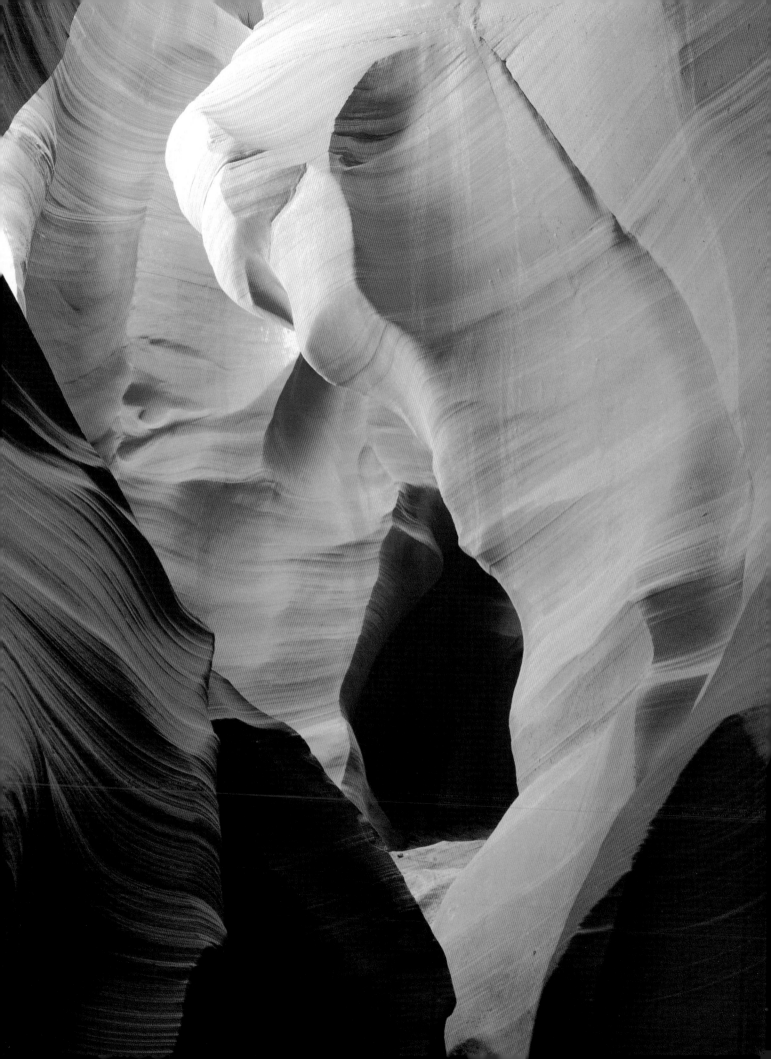

Color Films

There are many color films on the market today, and each has specific characteristics. Some of them are fine grained and supersaturated in color, while others offer muted colors and are very grainy. Some films are perfect for reproducing skin tones, while others are designed to be used for high-speed action.

There are also two main types of film—daylight- and tungsten-balanced—keyed to specific color temperatures of light. Although we'll look at how this color balance affects your photography in more detail in other chapters, for now keep in mind that you must choose the appropriate type of film for the lighting conditions. And remember that the color of the ambient light is interpreted differently by these films. Daylight-balanced film, for example, renders sunrise and sunset light yellowish; tungsten-balanced film would produce a much less yellow interpretation. It would appear almost like the colors of light seen at noon on daylight film. Conversely, tungsten film used on an overcast day will give you a pronounced bluish cast; daylight film will produce a scene with only a subtle bluish tone.

In this chapter, I do not describe every film on the market. Instead, I share with you a list of my favorite films, summarize their characteristics and explain why I prefer them. I also tell you why I do not use other films.

Comparing Films in Print

Before we begin discussing film characteristics, it's important to cover certain problems inherent in any comparison of films in printed media. First, the reproduction of each photograph in this book, or in any print medium, is almost never identical to the original transparency. There are dozens of factors that alter the color balance, contrast and resolution during the printing process.

How, then, can you compare two films from images printed side by side in a book or magazine? If you see two photos in this chapter taken of the same subject in the same lighting, one with a Kodak film and one with a Fuji film, can you determine which film you prefer? If the contrast in one or both of the reproductions has been altered from the original, or if the color has been slightly altered by the four-color printing process, how can you predict what your own results will be?

The point, of course, is that you can't really compare the characteristics of films by seeing them side by side on a printed page. You can distinguish the actual differences between two slide films only by shooting a roll of each in similar conditions and then comparing the actual transparencies using a loupe. That's why I don't ask you to try to compare films from the images you see here. Instead, I describe the characteristics of each film and then show you examples that clarify the text. (Keep in mind that the reproductions in this book are close to the original transparencies, but not exact copies.)

Another point to remember is that any discussion of films involves some subjectivity. My personal taste in color saturation, grain structure and contrast may not be yours. For example, sometimes I like colors that are so saturated they practically scream. Some photographers find this kind of rendition disturbing, and they use

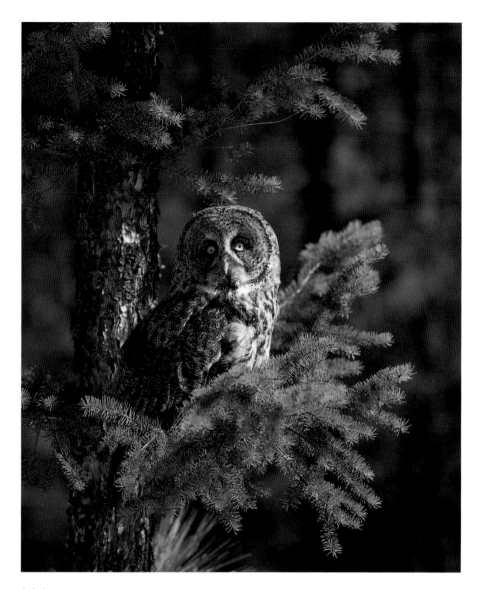

When choosing a film, analyze its ability to handle contrast and hold detail in both highlight and shadow areas of a scene. You should find detail in both areas, but a contrasty film—one with too much contrast—typically has highlights that are a little too light (they look washed out) and shadows that are flat, black patches.

When evaluating a film's contrast, keep in mind the light conditions under which you were shooting. Natural light is contrasty when the sun is high in the sky at midday. As you move toward the equator, the angle of the sun is more perpendicular to the Earth, and contrast is at its maximum. Sunlight near the poles, even at noon, is much softer, so you can use contrasty films such as Fujichrome Velvia and still hold detail.

The light was soft when I photographed this great gray owl in British Columbia, Canada, in March. But the side lighting illuminating the raptor made this a contrast situation. The Fujichrome Provia 100 held detail well in both the highlight and shadow areas. Note how much detail there is in the darkest part of the bird's feathers toward the bottom of the image and in the brightly lit white feathers on the side of its face.

I exposed for the highlights when I took this shot. When you must decide which portion of the frame to expose for—the highlights or the shadows—you will almost always be safe if you expose for the highlights. Dark shadows are acceptable to viewers, but overexposed highlights are not.

Technical Data:
Mamiya RZ 67 II, 350mm APO telephoto lens, 1/250, f/5.6, Fujichrome Provia 100, tripod.

I use Fujichrome Velvia for two reasons. First, it is incredibly sharp: The grain structure is so tight that it is actually difficult to discern even under an 8X loupe. Second, the colors are rich and saturated. Some photographers feel Velvia exaggerates the color intensity too much, but I love the brilliant saturation. The intense reds and yellows you see here, the effect of the sunset light on the rock formations, are typical of the rich colors you get with this film.

Notice in this photograph of Spider Rock in Canyon de Chelly, Arizona, that the contrasty Velvia did a very good job of rendering both shadows and highlights with detail. Only the distant cliff face at the right is somewhat light. The top of the monolith, the rocks in the foreground and the sky are all rich in detail. When the sun is close to the horizon, the contrast between light and shadow is low. Under these circumstances, Velvia, or any other contrasty film, produces beautiful tonalities. When the sun is higher in the sky, contrast between light and shadow increases, and the use of Velvia becomes more problematic.

Technical Data:
Mamiya 7 (a range finder camera), 43mm wide-angle lens, 1/4 second, f/22, Fujichrome Velvia, tripod.

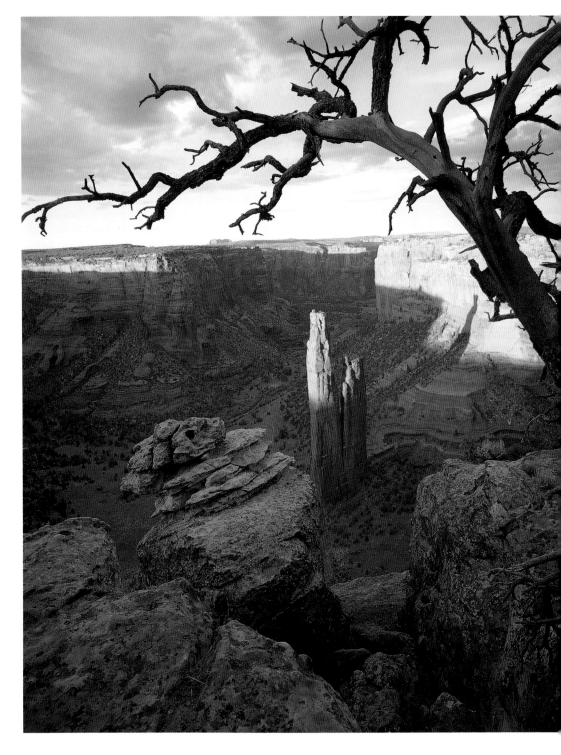

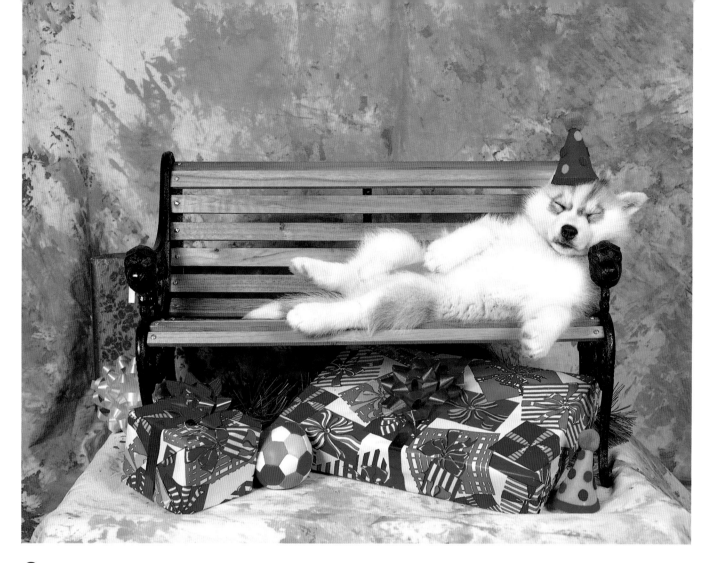

Color is very important for stock photography, because brilliant color sells. Therefore, Fujichrome Velvia is often my first choice for film. The film's brilliant colors come into play when products or models are photographed by electronic flash in the studio. On the other hand, I don't use Velvia if the precise reproduction of color is critical for an assignment.

The "party dog" pictured here pooped out during the photo shoot. The husky puppy slept for about twenty minutes while my assistant placed the hat on him, and I took pictures from several angles. I used Velvia because I wanted the colors of the Christmas presents to really pop. Notice how the white hair of the dog didn't shift toward a reddish hue, although skin tones would have.

Technical Data:
Mamiya RZ 67, 110mm normal lens, 1/125, f/11, Speedotron 2403 Power Pack, two flash heads softened by white umbrellas, Fujichrome Velvia, tripod.

films that tone down colors to be less saturated than the original subject. There is no right and wrong here, because art is truly in the eyes of the beholder.

Another aspect of the subjectivity of this discussion is this: When I use a term such as *muted* or *subtle* when referring to color, your understanding of these words may, in fact, be different from the mental picture I have when I use them. We're probably close, but you should at least appreciate that there may be a difference.

Remember, also, that reviews in photo magazines may describe characteristics of a film but stop short of seriously criticizing one, even if the writer actually dislikes it. This is due, in part, to the editor's attempt to keep subjectivity out of a product review (that is, after all, one person's opinion). There is also some self-interest in this caution. Film manufacturers spend a great deal of money advertising their products

in photo magazines (as do manufacturers of cameras, lenses and printing papers), so there is a strong incentive not to offend a major source of revenue with a negative review of a product. Therefore, you should always read these articles with an awareness that they may not be completely impartial. Since no film manufacturers advertise in this book, I can express my honest, if subjective, opinion, unaffected by such financial considerations.

Transparency vs. Negative Films

I shoot slide film almost 100 percent of the time because virtually all books, magazines, calendars, posters, brochures and greeting cards are reproduced from trans-

parency film. The printing industry, with the exception of newspapers, has traditionally used color separations (the film that makes the printing plates) made from slides to create four-color artwork. It makes no sense, therefore, for me to shoot negative film when my business requires that I sell slides.

I also shoot slides because I can immediately see exactly how the scene I visualized appears on the film. A print is not only a second-generation image, but it may also have been altered by a commercial lab technician. A technician does not know what you previsualized; consequently, the contrast, color balance and exposure chosen during printing may not be what you had in mind. I don't know about you, but I don't like my work to be altered unless I give specific instructions.

Unlike prints, slides are developed exactly the same way every time: There is no interpretation by a technician. This means that if your images are under- or overexposed, you can see the error in the processed film and correct your technique for the next shoot. When a negative is poorly exposed, it is harder to analyze. Sometimes you will get a print back from the lab and, unless you are skilled at analyzing negatives, you may not understand what went wrong.

Having said all this, if you prefer to take prints, for whatever reason, then you should learn about and use negative emulsions. I shoot very little color negative film, but when I do, I choose Fujicolor Reala 100. It is known for its extremely accurate rendition of color, even under fluorescent illumination. The film has an added cyansensitive layer that provides a response to light similar to the human eye. Its grain structure and sharpness are among the best in its speed class. I've made 16 × 20 (41 cm × 53 cm) prints from Reala negatives, and they have been very impressive.

Color Transparency Films

Although there are many good negative films on the market, they are seldom used for print reproduction. Their primary use in commercial photography is for studio portraiture and wedding photography, subjects beyond the scope of this book, so I have focused on reviewing color slide films here. If you prefer to shoot print film, Fuji and Kodak films both have their fans, so try several rolls of different emulsions from each manufacturer to determine which one best suits your aesthetic approach.

Remember that one's choice of film is a matter of aesthetics. Overall, I prefer Fujichrome to Ektachrome films for their grain structure and color saturation. But I know many photographers who disagree with my opinion in some, if not all, circumstances. What you'll read here are my opinions, based on my tastes and my experiences. I encourage you to try the films that I recommend because I think so highly of them. However, if you are happy with a film I don't recommend, or one that I don't even describe here, continue to use it—photography is an art, not a science, and there is room for everyone's tastes.

Fujichrome Velvia. My favorite film for shooting landscapes, many architectural subjects, flowers and insects is Fujichrome Velvia. The most striking characteristic of Velvia is its ultrasaturated rendition of color. Some photographers feel this film exaggerates color too much, but I like its rich intensity and depth of color. Reds and oranges are especially saturated, which can cause problems with por-

traits. Skin tones show an unattractive shift toward the red, so I generally use another film for photographing people.

Velvia is extremely fine grained and very sharp. When I make duplicate slides in my darkroom, it can be difficult to critically focus on the grain of the original Velvia slide with a grain focuser because the film has extremely high resolution and tight grain structure. With a more grainy film, focusing is easy. Velvia is, however, very contrasty. Avoid using it in midday sunlight or other lighting situations where the contrast is extreme, because shadow detail usually is lost.

Velvia is rated by Fuji as an ISO 50 daylight film, but the true ISO is lower. I use the film at ISO 40, but other professionals I know rate it at ISO 32. If your camera automatically reads the bar code on the film cassette to calibrate the meter with the manufacturer's recommended ISO, you must override this reading and manually correct the setting. Pushing Velvia is a good way to gain additional speed while retaining the high resolution. I've pushed it both one and two stops and have been impressed with the retention of rich color and fine grain.

Fujichrome Provia 100. I would shoot wildlife with Velvia if I could, because I love the saturated colors I get from this film. But ISO 40 is too slow to use in a medium format camera in the wild. Therefore, my choice for wildlife photography is Provia. This slide film is sharp and fine grained, although not quite as sharp or fine grained as Velvia. The colors are saturated, but not too saturated. Unlike Velvia, where the depth of the color saturation is obviously more intense than the original subject, Provia more closely matches what you see with your eyes to the colors reproduced on film. (The film is similar to Fujichrome 50D, which is no longer available.) Provia is less contrasty than Velvia. In

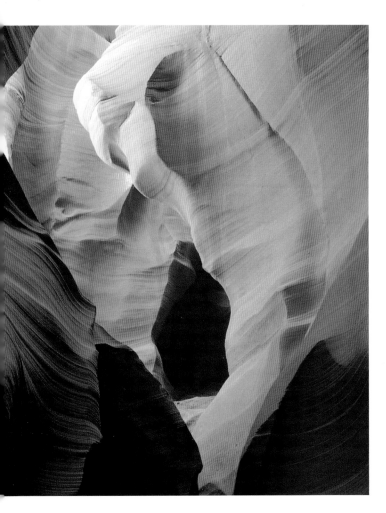

I use Fujichrome Velvia for selected situations in nature where the contrast is high, such as slot canyons, even though the film is contrasty. The dramatic contrast among the abstract forms of sandstone and their artistic shapes make the shot. Had I used a lower contrast film, such as Ektachrome EPP, this contrast of color and light would have been diminished. As a result, the drama and impact of the photograph would be less intense.

I took this shot in Lower Antelope Canyon near Page, Arizona, when the sun broke through the clouds for a few minutes. Sunlight entered the narrow slot from the top, illuminating the upper reaches of the sandstone contours in rich shades of orange. In the areas near the ground, concave niches in the rock were hidden from the light and remained very dark. Note the range of colors from the almost-white yellow at top center to the bluish purple hues of the shadowed rocks at the lower right.

Technical Data:
Mamiya RZ 67, 110mm normal lens, 4-minute exposure, f/22, Fujichrome Velvia, tripod. The exposure was determined with a Minolta Spot Meter F by reading a midtone portion of the composition.

An unusual approach to shooting slot canyons is to use tungsten film. Daylight produces predominant blue tones on tungsten film. Since these canyons are usually photographed with daylight-balanced film to accentuate the intensity of the orange colors, I chose Fujichrome 64T to make this image. Rendered in shades of blue and blue-purple, the contoured canyon walls look completely different from the photo above.

Fujichrome 64T and other tungsten films are normally used with tungsten illumination, such as photofloods and household lamps. A correct color balance is achieved when the light source is 3200 K. If the bulbs being used are old, or if they were originally designed to be less than 3200 K, even tungsten film will shift to the reddish end of the spectrum.

Technical Data:
Mamiya RZ 67, 110mm normal lens, 4-minute exposure, f/16, Fujichrome 64T, tripod. No filter was used.

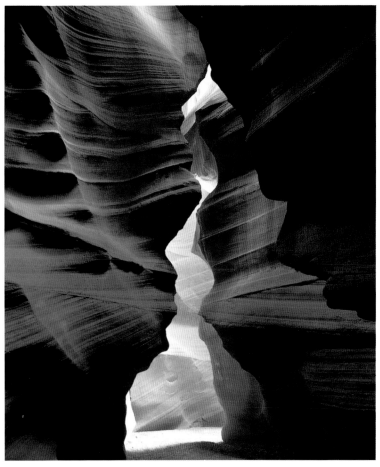

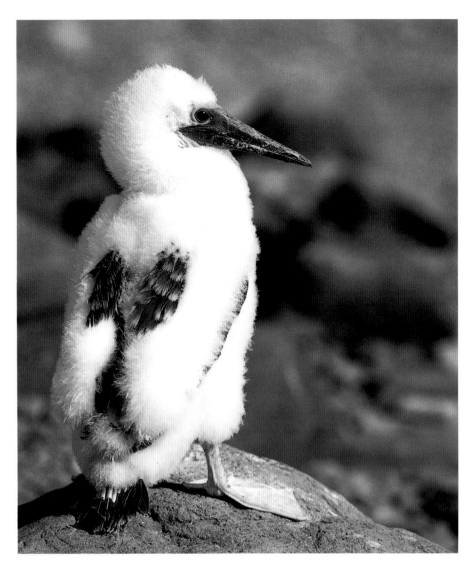

One of the important measuring sticks for analyzing a film's color balance is its ability to render "pure" white. If there is a color bias toward any portion of the spectrum, it will readily be seen in a white area.

I photographed this downy-masked booby in the Galápagos Islands, and the pure white of the feathers was captured on Fujichrome Provia 100. I use this film because I find the colors to be neutral and accurate. The ambient lighting was hazy sunlight, and the surrounding terrain was black and gray lava. There was no nearby color that could influence the outcome of this shot, making this image the perfect test to determine Provia's ability to capture whites. It is true that the shadow on the back of the head and along the edge of the booby is bluish, but that is typical of all films. Shadows have a higher color temperature (see pages 2-4), which film interprets as bluish.

Technical Data:
Mamiya RZ 67 II, 250mm telephoto lens, 1/250, f/8, Fujichrome Provia 100, tripod.

addition to wildlife photography, I have used it for outdoor portraits and general travel photography.

I have found Provia to be a true ISO 100. Because of the speed, it's a good film for most situations encountered during domestic and international travel. Like Velvia, Provia can be pushed with excellent results. I've pushed it to ISO 200 and 400 with only a modest increase in grain.

Fujichrome Sensia 100. This is Fuji's excellent consumer medium-speed film, which replaced Fujichrome 100. It has finer grain and greater sharpness than its predecessor, and reproduces subjects with superb, realistic color. This excellent all-around film is similar to Fujichrome Provia 100, except it isn't kept under constant refrigeration, as are professionally designated films, and is less expensive. Projected slides look great. Sensia can be pushed one stop with little adverse effect on image quality. In a side-by-side comparison with Provia, it would be difficult to distinguish between the two films.

Fujichrome Provia 400. For a high-speed film, Provia 400 has exceptionally tight grain structure, natural looking colors and decent contrast characteristics. It does have a red bias, but this is a small price to pay (if you don't like a shift to the red) for the speed plus fine grain.

Provia 400 can be pushed both one and two stops. A two-stop push means an ISO rating of 1600, which allows you to shoot in very low light conditions. When I travel, I always carry a few rolls of this film for those inevitable situations where extra film speed is needed.

Kodak Ektachrome E-100S. E-100S is extremely sharp and fine grained, surprising for a medium-speed film. The color saturation (the *S* stands for *saturated*) is rich and pleasing and is very similar to Provia. Green has proven to be difficult to reproduce accurately on many of the Ektachrome films, but there's no problem at all with the E-100S used with either daylight illumination or electronic flash. The other colors in the spectrum are rendered with accuracy as well. Kodak also makes an Ektachrome E-100SW (the *SW* stands for *saturated warm*). This film has a warmer, or more yellowish, bias for those photographers who prefer this color balance. Of the two films, I prefer the E-100S.

The contrast in E-100S is excellent. I photographed a model on a boat in sunset lighting against dark blue water, and the shadow detail was very close to what I saw with my eyes. I still prefer Fujichrome Provia, but if I didn't have that film, I would be happy with E-100S.

When I push-processed this film one stop, the fine grain structure was maintained, as were the rich colors. It was

actually hard to distinguish between E-100S that was and was not pushed.

Kodak Ektachrome 64 (EPR). I shot a lot of Ektachrome 64 for many years, before I started using Velvia, Provia 100 and E-100. This film was, in my opinion, one of the best films on the market in the 1980s. However, it is too grainy and doesn't have as high resolution when compared to the fine-grained, sharp films available today. The colors are reasonably accurate, although EPR doesn't bring out the richness of green foliage like Velvia and Provia 100 do.

Kodachrome 25 and 64. The Kodachrome films have been used by millions of photographers for years, but I believe they can no longer compete with the color renditions of more modern films. I feel that Kodachrome colors are flat, dull and lifeless. Reds and oranges are never captured in their full intensity. Rich, saturated green comes out as a drab gray-green on the film. Similarly, the blue in a Kodachrome sky is immediately obvious because it is dull and tends to shift toward the red portion of the spectrum. Kodachrome does do justice to skin tones, but if your subject is wearing bright colors or if the background is colorful, you probably will be disappointed with the results.

The two Kodachrome films are extremely sharp. All other films used to be compared to Kodachrome 25 in terms of resolution. Is Fujichrome Velvia comparable to Kodachrome with respect to sharpness? In my opinion, it is.

Kodachrome is considered an archival film, which means that the color dyes that comprise the image will not fade for decades. If you compare an Ektachrome slide taken in the 1950s, 1960s or 1970s with a Kodachrome transparency taken at the same time, it is remarkable how faded the Ektachrome emulsion has become, while the Kodachrome image still retains the original colors.

Kodak Ektachrome EPP 100. This

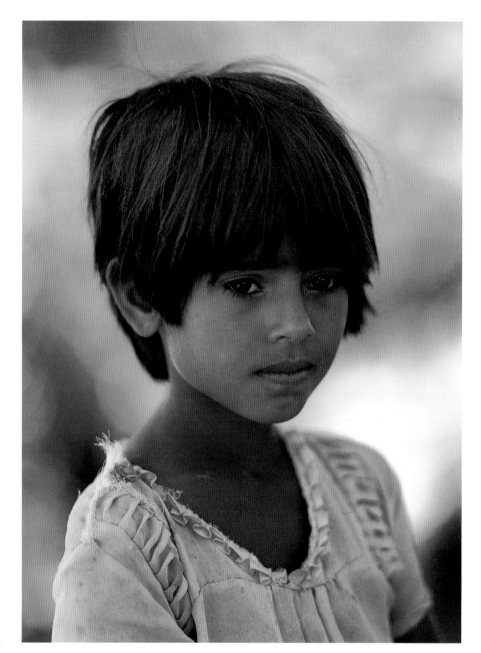

I use high-speed film very selectively. My preference is ultrasharp, fine-grained films, which unfortunately are always very slow and difficult to use in low-light situations. Only when I am forced to use high-speed films will I do so.

In tropical countries, such as Myanmar (formerly Burma), contrast at midday is extreme, with very dark shadows and brilliant highlights. If you want to shoot a portrait, there are four choices. (1) The subject can be placed in sunlight, but harsh shadows will be terribly unattractive. (2) A diffusion panel can be used to soften the sunlight and spread the light evenly across a face. This is a good solution if you happen to have one in the camera bag. (3) You can place the person in the shade of a tree or building and use an on-camera flash, but the light is flat. Even with fill flash, there is an artificial look to the lighting. This is, however, not a bad choice. (4) High-speed film can be used to permit a shutter speed fast enough for a sharp picture, and with a little depth of field if you're lucky.

For this portrait of a beautiful young Nepalese girl living in Myanmar, I used Fujichrome Provia 400. I exposed for her skin with a Minolta Spot Meter F.

Technical Data:
Mamiya RZ 67, 250mm telephoto lens, 1/125, f/8, Fujichrome Provia 400, tripod.

Kodak's E-100S is a beautiful film that is very similar to Fuji's Provia 100. E-100S is rich in color, fine grained and sharp, and has superb contrast. This photo of a dancer at Ta Phram temple in Cambodia was photographed under a dense cloud cover with light rain falling. The light was dull and low in contrast. In spite of this, the green lichen on the eight-hundred-year-old rock walls reproduced accurately without appearing dull. The clothes and makeup of the dancer appear rich in color and create a striking counterpoint to the neutral gray stonework.

Technical Data:
Mamiya RZ 67 II, 110mm normal lens, 1/30, f/2.8, tripod, Kodak E-100S.

The subtleties of a deep winter overcast can be a challenge for many films to render with accuracy; however, the muted tones of white on white are delineated perfectly in this stark Michigan landscape. I used Kodak Ektachrome E-100S for this shot because I didn't want the possible reddish bias that is characteristic of Velvia or the shift to the warmer end of the spectrum that Kodak Ektachrome E-100SW can cause.

The exposure reading for this picture could have been done in only two ways. Because there is no midtone for a TTL meter to read, I had to use either an incident meter to read the ambient light falling on the scene, or a reflective meter that read a medium gray subject, like a camera bag or gray card. For this particular exposure, I use the Minolta Flash Meter IV, which can read both flash and ambient light.

Technical Data:
Mamiya RZ 67, 350mm telephoto lens, 1/15, f/8, Kodak Ektachrome E-100S, tripod.

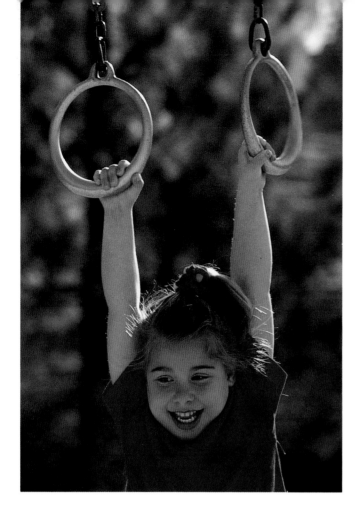

This photograph was taken in 1990, when I occasionally shot Kodachrome slide film. Kodachrome is sharp and exceptionally fine grained, which is why so many photographers liked it—and some still do, of course. In addition, the film is archival, which means that the dyes in the image are very stable and won't fade for many decades.

Kodachrome 64 does reproduce skin tones well, as you can see in this sweet picture of my niece Jamie, who is losing her grip on the swing. But both Kodachrome 25 and 64 have problems capturing color. Unlike Fuji's Velvia and Provia and Kodak's own E-100S, colors in the older Kodachrome films are not very saturated. Notice the colors of the foliage in the background. The rich green background was reduced to a muddy gray-green, and Jamie's red shirt is considerably duller than it was in reality.

Some photographers prefer more muted tones in their images. If you do, then you'll like the Kodachrome films. However, if you like rich, saturated color, look for another emulsion to shoot.

Technical Data:
Canon EOS I, 50–200mm zoom, Kodachrome 64, handheld. Exposure data unrecorded.

film reproduces colors accurately without an increase in saturation and without color bias. It is especially known for its ability to render skin tones correctly.

EPP is more grainy and less sharp than Fujichrome Velvia, Provia 100 and Ektachrome E-100. Pushing the film exacerbates the graininess, although the color and contrast remain true. I use this film only when I shoot fashion, where color accuracy is critical. For most of my work I prefer films that are finer grained than this one.

Most computer service bureaus use Ektachrome EPP to output digital photos onto film. The calibration scales that come with film recorders (the equipment that transfers digital information to film) are designed to be used only with Ektachrome EPP, probably because of the fidelity of the colors to the originals. The ISO 100 rating also means that the transfer time from the digital file to film is half that of the finer grained and sharper ISO 50 films.

Agfachrome 200. Films rated ISO 200 and above typically render subjects with lower contrast and increased grain than the slower ISO 100 films. Agfachrome 200 exaggerates both characteristics. Colors are muted, and the grain is definitely noticeable. I use this film once in awhile to creatively interpret particular subjects. Fashion models, wedding portraits, landscapes, macro shots of flowers and many other subjects are rendered in an artistic manner with a grainy texture and soft, desaturated colors.

If you want really exaggerated grain, you can push Agfachrome 200 one and two stops (one-stop push is ISO 400, and two stops is ISO 800). A two-stop push produces coarse grain and very low contrast. The color saturation is substantially reduced. Despite these disadvantages, you can create interesting effects with this film—and it's fun to use an ISO 800 film.

Fujichrome 64T. When I shoot under tungsten illumination, my film of choice

is Fujichrome 64T. Designed for long exposures, it is rich in color and very sharp, and has a fine grain structure. I also use this film for shooting after the sun goes down. Twilight and night scenes are rendered in a wide range of blue tones with tungsten-balanced film.

I switched from Kodak's Ektachrome 50T, that company's version of a fine-grained tungsten film, after I did a comparison test between the two emulsions. I photographed the skyline of Rio de Janeiro, Brazil, at twilight. The Fujichrome 64T produced a rich palette of cobalt blue and mauve tones in the sky and the cityscape. The Ektachrome 50T transparency captured the scene as a monochromatic blue. I preferred the rich variation in hues in the Fuji film, and I've been using it ever since. If you are shooting people indoors and you are concerned with skin tones, either film will work well.

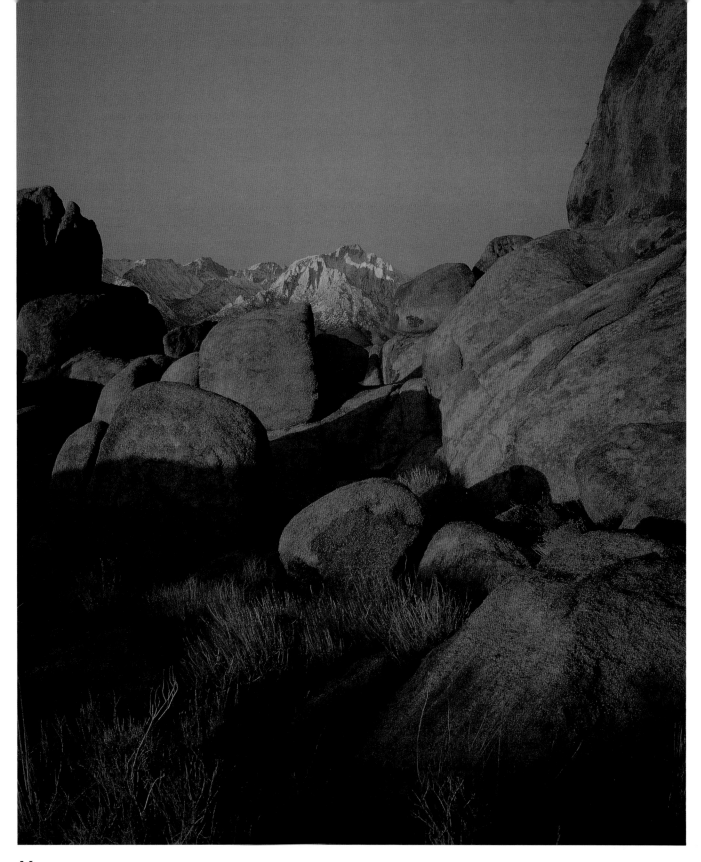

Kodak Ektachrome 64, or EPR, was my film of choice in the 1980s. Its color balance was fairly accurate, the grain structure was considered excellent at the time and the contrast was quite good. When compared to modern films like Fujichrome Velvia and Provia 100, and Ektachrome E-100, EPR no longer looks as good. It is too grainy and doesn't have the high resolution we now expect from film.

This sunrise shot of Mt. Whitney and the Alabama Hills near Lone Pine, California, was taken years ago on EPR. It may be difficult to see the grain in the reproduction in this book, but if you were to look at the original with a loupe, you couldn't miss it: It is quite obvious. (Grain is hard to see in a printed piece because the color is laid on the page with dots of ink.) A side-by-side comparison of EPR and E-100S on a light table would give you a great appreciation of how far technology has advanced in the last decade.

Technical Data:
Mamiya RZ 67, 50mm wide-angle lens, ¼ second, f/32, Kodak Ektachrome 64, tripod.

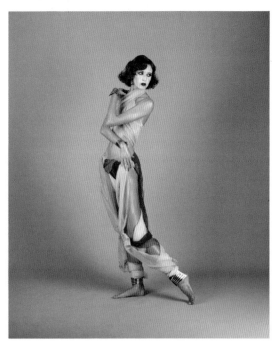

Some photographic disciplines require that color be reproduced on film as close as possible to the way the eye perceives it. Fashion photography falls into this category. The color of clothing and makeup is obviously critical to the manufacturers of these products. A good film to use in these circumstances is Kodak Ektachrome EPP, which is an ISO 100 film. EPP is more grainy than E-100S, but it's a reliable and consistent color film that reproduces color with great accuracy. As with all daylight films, EPP is balanced for 5500 K, so if you are doing studio work make sure that the strobes you are using are corrected for the same color temperature. This information is listed in the manufacturer's specifications.

This photo of model Kelly Ramin was made with fantasy makeup and styling by Loalynda Bird.

Technical Data:
Mamiya RZ 67, 250mm telephoto lens, 1/125, f/11, Speedotron 2403 flash unit, two flash heads softened by Photoflex soft boxes, Kodak Ektachrome EPP, tripod.

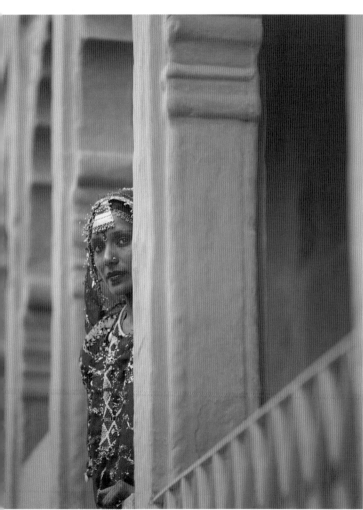

The subjects you photograph can be influenced by their environment, no matter which film you use. This young girl in Jodhpur, India, was photographed as she peered at me from between columns painted a rich cobalt blue. The color of the building was so saturated that it affected the young girl's skin tone. Note how blue her face looks. In actuality, it was a beautiful suntanned color, but her proximity to the paint caused a discernible shift. Her vibrant, magenta sari was also affected.

If I used a filter to correct the color shift and bring the skin back into the normal range, the hues in the rest of the frame would be altered as well. For example, if a warming filter were placed over the lens to add more yellow to the skin, the building would also appear more yellowish. If fill flash was used in an attempt to replace the cool color shift with daylight-balanced illumination, the columns closest to the flash would receive more light than the background, and the imbalance in exposure would ruin the shot.

There basically isn't a solution here when shooting on location. So, I decided to see if Kodak Ektachrome EPP film could still render the skin tones close to normal. The film has no bias toward any particular part of the spectrum, so I hoped it wouldn't be too affected by the color surrounding my subject. It was a good idea, but it didn't work this time.

The only way to correct the color shift without affecting the entire image requires the type of equipment most of us don't carry when we're traveling. If you did have access to any type of equipment you wanted, a narrow beam of light—either tungsten or strobe—could be focused on the model without affecting her environment. The light could be filtered to correct her skin tone. This is done with either a honeycombed grid spotlight or a snoot with a built-in narrow-angle lens to focus the light.

Technical Data:
Mamiya RZ 67 II, 250mm telephoto lens, 1/15, f/8, Kodak Ektachrome EPP, tripod.

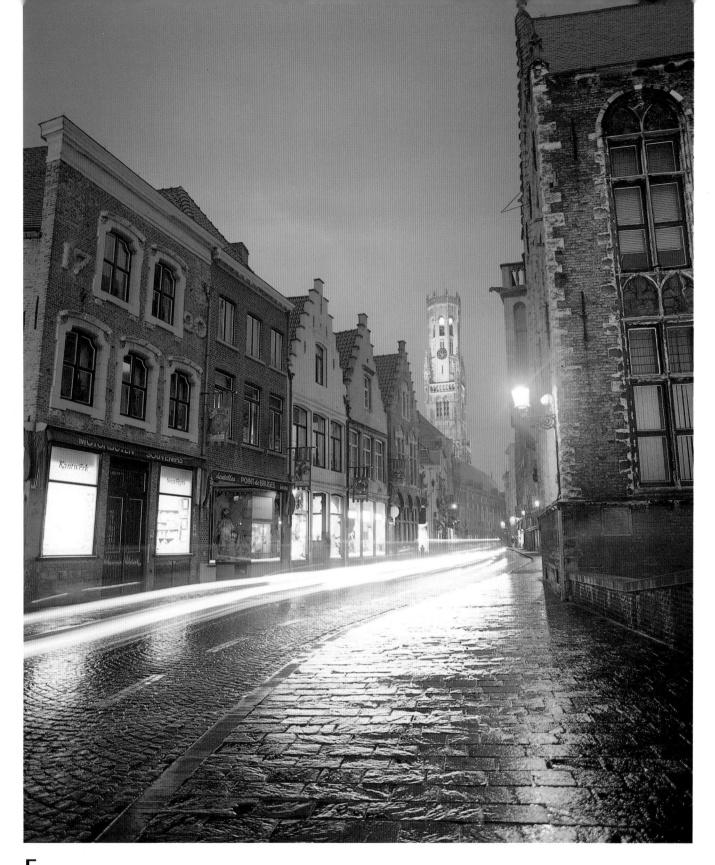

Fujichrome 64T is designed to produce accurate colors when used with tungsten light sources. However, it can be used creatively at night, as seen in this rainy street scene taken in Brugge, Belgium. The blue cast is typical of tungsten-balanced films when used outdoors or when shooting at night. Fujichrome 64T, in particular, produces a range of interesting colors that interprets evening cityscapes in a quite different way from what you see or from daylight-balanced emulsions. With my eyes, I saw the cobblestones reflecting the cold, white light of the street lamps rather than the blue cast seen in the photo. Note that there is an absence of true white in the shot.

Technical Data:
Mamiya RZ 67 II, 50mm wide-angle lens, 10-second exposure, f/8, tripod.

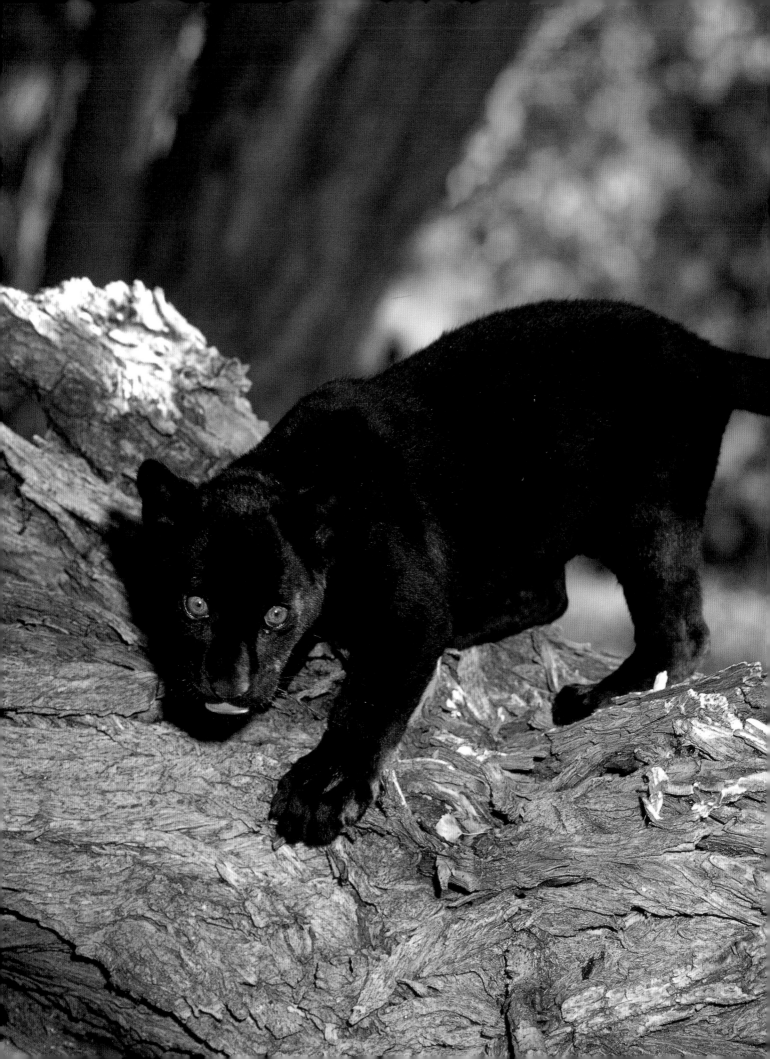

3

Filters for Color Photography

A filter is not a tool you can employ to transform a mediocre composition into a good one: If the shot framed in your viewfinder can't stand on its own, a filter won't help. You can, however, use a filter to enhance a good shot or to correct color. There are four categories of filters used in color photography: color correction, color printing, black-and-white and special effects. Each of these filters produces different effects. All but color-printing filters are used to alter the nature and color of light that falls on the film as you take a shot. (Color-printing filters, used only for darkroom work, will be discussed at length in chapter six, which focuses on color manipulation after the shot is taken.)

The glass filters that screw into the front of your lens, and the optical-quality plastic filters that slide into a holder (which then screws into the front of the lens), both accomplish the same result. The only difference is that the glass filters are more expensive and don't scratch as easily as the plastic ones.

Color-Correction Filters

You use color-correction filters to reproduce a color in its correct hue on film. For creative purposes, sometimes you may not want to make this correction. Unnatural and experimental colors can often make a strong artistic statement, and while they won't make a boring shot great, they can certainly make an image with good graphic design and composition more exciting. Under most circumstances, however, you will be glad the appropriate filter was in your camera bag.

Color slide film is manufactured to provide a correct color balance when it is used with a particular color temperature of light. For example, Fujichrome Velvia and Ektachrome E-100 are daylight films. Their emulsion is designed to produce accurate colors at 5500 degrees Kelvin, the temperature of the midday sun and electronic flash. If you shoot these films with tungsten lighting, the color balance will be too orange-yellow when compared with what you actually saw. When daylight film is used with photofloods (which use a tungsten filament), a bluish filter, an 80B, is needed to counteract the orange-yellow shift.

Similarly, Fujichrome 64T is a tungsten film. It is designed to provide correct colors when photofloods are used and the Kelvin temperature is 3200 degrees. If you use 64T outdoors, the slides will be too bluish. So you would use an 85 series, orange-colored filter over the lens to counterbalance the unwanted shift toward blue.

There may be times when you want to make more subtle alterations in color, shifting the warm colors typical of a sunrise or sunset to make your subject less yellowish, for example. This might be used when shooting a model, to prevent her skin from looking amber. Most outdoor photographers like the golden tones of low-angled sunlight, but if you want to make minute changes, you can use the 82 series filters. These are slightly bluish, and the amount of correction increases as the letter designation increases: 82A offers the most subtle change; 82C is more of a significant move toward a neutral color balance.

The 81 series filters are also subtle in their correction, and they do the opposite of the 82 series; 81 filters are yellowish or amber, and they lower color temperature. You can neutralize the bluish cast in muted light or deep shade with these correction filters.

Another example of a correction filter is the FLD. It looks magenta and is used to correct the blue-green cast typical of the way color film reacts to fluorescent lights. The FLD filter can also be used with mercury vapor lights, such as street lamps. Very similar to the FLD, but with a slightly warmer bias, is the 30 magenta filter.

When I take travel photographs around the world, I always use the available light in cathedrals, palaces and city night scenes, because I prefer the uncorrected mixture of colors in the lights. However, sometimes accurate color may be more important than mood—when you're shooting architecture on location or doing a corporate portrait in a factory environment, for example. Then photographers often use a color temperature meter. This expensive meter can determine how much filtration is needed to balance the lighting with the film being used. Based on the reading from the color temperature meter, correction filters that can subtly shift the color balance in any desired direction are used to achieve accurate colors on film.

Black-and-White Filters

It may seem like a contradiction, but filters for black-and-white photography can actually be used for color photography, too. The filters are, in fact, colored. They are designed to be used with black-and-white film to alter the density relationships among different elements in the composition; for example, an orange or a red filter is used to darken a blue sky. When used with color film, these filters cause a dramatic monochromatic shift in the colors caught on your film.

Black-and-white filters, unlike color-correction filters, are all highly saturated. They come in red, orange, yellow, green and deep blue. When used with any color film, your subject becomes the color of the filter. The only filter that I have never liked is the red one, because most subjects photographed with it lose a great deal of contrast and appear muddy.

The subjects that work best with this type of filter are simple, graphic images that are basically monochromatic to begin with. For example, a barren tree in winter against a white sky can be photographed with a blue or an orange filter with quite attractive results. The same black-and-white filters used for a shot of conifers against a distant ridge, with no sky showing, will look muddy and dull. This occurs because the color in the filter is so saturated that it eliminates many of the tones in the original scene that allow our eyes to distinguish detail in a subject.

Photographs taken in deep shade or with a flash often have a bluish cast to them. Sometimes this shift is subtle, and only a small amount of correction is needed to bring the color balance back into a more pleasing range.

This five-week-old black jaguar was photographed in captivity. I used a flash because I was afraid of losing detail in the fur, and the cat's movements were too abrupt to use fast shutter speeds in the reduced light with medium-speed film. I elected to shoot him in the shade because the sunlight was too contrasty, but the blue cast was a concern because I wanted the feisty jaguar to reproduce as a pure black without any color bias. In addition, I thought the Metz 45 flash, which is balanced for 5500 degrees daylight, might be too cool in these conditions.

I chose to use an 81A, a color-correction filter. Its slightly warm (amber) tone prevented the image from shifting toward a cool, or bluish, cast. Had I wanted a more substantial shift toward the warm end of the spectrum, I would have used an 85 series filter.

Technical Data:
Mamiya RZ 67, 250mm telephoto lens, 1/125, f/8, Fujichrome Provia 100, 81A color-correction filter, Metz 45 CT flash, handheld.

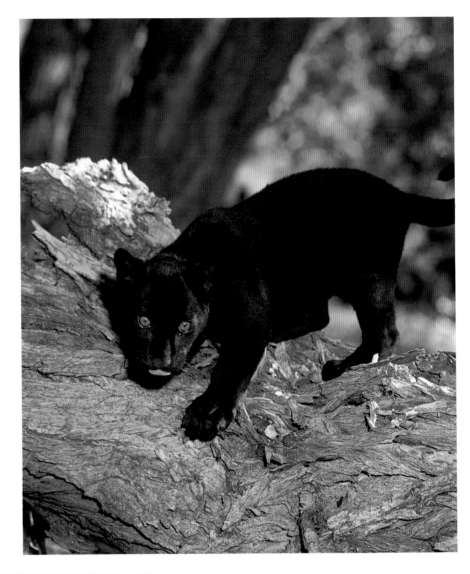

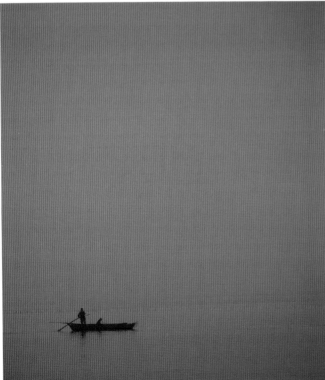

Black-and-white filters, designed to be used with black-and-white film emulsions, can be used with color films, too. These filters work best with images that are graphic in nature and very contrasty. This boat on a lake near Wuxi, China, photographed early in the morning in dense fog, is a good example of this type of image. The shot was extremely high contrast, with virtually no midtones at all. I felt the infusion of color was necessary to give the image more interest. I chose a rich, saturated color for drama, and the black-and-white filter offered a bolder statement than other types of color filters. I selected orange simply because I thought it worked best.

The sun was completely obscured by the thick fog, which meant that there was no risk of getting unwanted reflections in the glass of the filter. However, when using any filter and shooting toward a bright sun, pay attention to this possibility. You may have to angle the lens to avoid these distracting lens flares.

Technical Data:
Mamiya RZ 67, 360mm telephoto lens, 1/125, f/5.6, orange filter, Ektachrome 64, tripod.

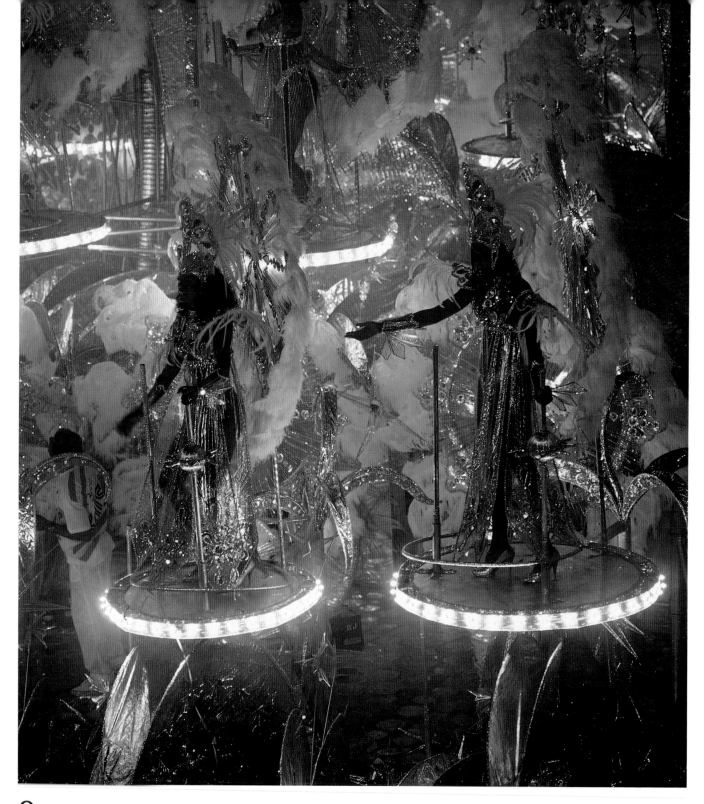

One of the most spectacular travel events occurs annually in Rio de Janeiro. During Carnival, the color, costuming, sensuality, music and dancing are beyond belief. It is dazzling to see, but very challenging to capture on film.

The procession takes place at night, and the main sources of illumination are banks of mercury vapor lights that line the parade route. To overcome the blue-green cast characteristic of this type of lighting, I used a flash for most of my pictures. I could then use a fast shutter speed to eliminate the unwanted color shift caused by the lights, because the intensity of the mercury vapor lamps was less than the light output of my flash.

This particular float, which was truly breathtaking, was illumi-nated from within by fluorescent lights, which are also seen by daylight film as blue-green. A flash wouldn't work here, because it couldn't overpower the fluorescent tubes themselves, since they are the source of the blue-green light. So I used an FLD filter that converts mercury vapor and fluorescent lights to the correct color balance. The diminished light forced me to use a slower shutter speed. To prevent a blurred image, I pushed the film one f/stop so I could use a shutter speed of 1/60 instead of 1/30.

Technical Data:
Mamiya RZ 67, 250mm telephoto, 1/60, f/4.5, Fujichrome Provia 100 (pushed to 200), FLD filter, handheld.

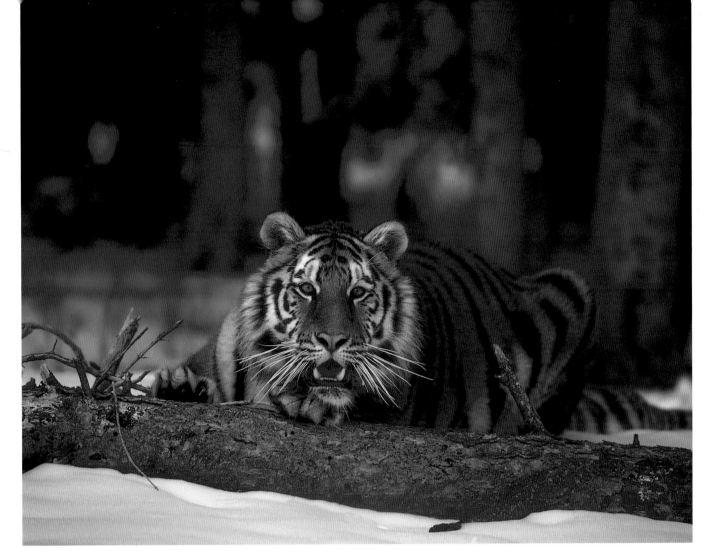

Special Effects Filters

There are dozens of unique and creative filters that can affect the colors in a photograph. Some of these filters change the color completely; others blur, diffuse or enhance existing colors. Below is a listing of the filters that can embellish your photography.

Polarizing Filter. This filter enriches some colors by eliminating glare. A blue sky, for example, can be deepened in saturation, or the color of a body of water can be enriched, simply by reducing or eliminating the sheen of light. A polarizing filter achieves its maximum effect when it is pointed 90° from the sun's light. In other words, a sky will be most affected when the sun is overhead and the camera is pointed toward the horizon. If the sun

is low in the sky, the maximum polarization will occur toward the zenith. Shooting into the sun will have no polarization effect at all.

Many photographers like the effect of a polarized landscape, but I have stopped using this filter for most of my outdoor shooting. The saturated colors provided by Fujichrome Velvia, Provia 100 and Kodak E-100S have eliminated the need for additional saturation. Using a polarizing filter with these films is, in my opinion, overkill, because it makes a landscape appear unnatural. The filters are still useful, however, for eliminating reflections from water and glass windows.

Pola Blue/Yellow Filter (Cokin 173). This filter has an effect similar to a polarizing filter where glare is eliminated. However, by rotating a built-in ring, you can also introduce a blue or yellow color. Since both of these introduced colors are quite

You can simulate photography at night with the use of a blue filter. Even though the dim ambient light of evening does not look blue to our eyes, long exposures on film reveal the high Kelvin temperatures (which translate to a deep blue color on film) present in the absence of daylight.

This Siberian tiger was photographed in captivity during daylight hours. I used a 47B filter, which is deep blue in color, to imply a nighttime exposure. Note that the large cat was completely in the shade, with no direct sunlight seen anywhere in the frame. Even with a blue filter, it is unrealistic to shoot a subject in contrasty sunlight and expect the photo to look like a night picture. I underexposed this shot by one f/stop to complete the illusion.

Technical Data:
Mamiya RZ 67, 350mm APO telephoto lens, 1/60, f/5.6, Fujichrome Provia 100 pushed one f/stop to ISO 200, tripod.

intense, this filter is best reserved for graphic images, such as a sailboat against the sun.

Graduated Filters. You can use these half neutral density/half clear filters, many of which are tinted, to selectively control the color or density of a scene. When shooting landscapes, you often will be faced with a bright sky above much darker terrain. If you expose for the ground, the sky is washed out. If you take your light reading from the sky, the ground looks too dark. This occurs because color film has an exposure latitude of five f/stops, which means that areas in the picture that are outside this range (too much light is striking the film) are overexposed with complete loss in detail, while very dark areas (not enough light striking the film) are underexposed and go black, also with a complete loss of detail. A graduated filter can be used to correct this problem by reducing the amount of light in the sky portion of the frame, thereby bringing the exposure value of the sky closer to that of the foreground.

Enhancing Filter. This filter shifts all the colors toward red-magenta. For some subjects this effect may be too intense, but for others it can be quite remarkable. When shooting in the American Southwest, where the sandstone formations are rich in orange and reddish hues, an enhancing filter produces truly dramatic shots because the warm colors are intensified. These filters also work well for close-ups of flowers, brightly colored clothing and sunsets.

Diffusion Filters. The many types of diffusion filters soften colors in a pleasing way. They are used frequently with portraits, because imperfections in skin texture can be largely eliminated when diffusion is used. Diffusion also gives portraits of women a quality that many viewers interpret as feminine. These filters can be used for many other subjects, of course, including flowers and gardens, historical sites, puppies, kittens and even sports. Try both moderate- and heavy-diffusion filters to determine which effect appeals to you. I usually use the Soft F/X no. 3 diffusion filter.

An inexpensive way to diffuse an image is to stretch a piece of nylon material, such as pantyhose, over the lens. The tauter you pull it, the less the picture is diffused. You can also try exhaling onto a skylight filter and letting the condensation of your breath create the diffusion. Skylight filters are clear glass filters that are used to absorb ultraviolet radiation to reduce unwanted exposure in natural light. Many photographers use them simply to protect the front lens element on expensive lenses.

Fog and Low-Contrast Filters. Fog or a deep cloud cover blanketing the land produces low-contrast conditions and muted colors. Fog and low-contrast filters simulate these natural conditions, softening colors and creating an ethereal effect. The difference between diffusion filters and fog filters is the latter add an ethereal whiteness that imitates fog to the scene, and they don't degrade the image (in an artistic way) as do diffusion filters. If you look through a loupe at a transparency taken with a fog filter it will still be sharp. A diffused image, while it may be in focus, won't appear to be sharp, but rather softened.

Exposure Factors

All filters that alter or enhance color have a "filter factor," which defines the amount of light loss caused by the filter. Even subtle filters have a certain amount of density, and the light passing through to the film is reduced by a measurable amount. The number of f/stops lost is indicated by the manufacturer, but it is easy to determine should you lose the paperwork that comes with the filter. Using the TTL meter in the camera, or a handheld reflective meter, take a reading of a neutral object in front

▶ **M**any nature and travel photographers frequently use a polarizing filter to enrich colors, especially the sky, and to eliminate unwanted glare and reflections. With the inception of Fujichrome Velvia and Provia, and Kodak's E-100S and E-100SW, films that offer brilliant and saturated color, I have found that my use of a polarizing filter has been greatly diminished. No longer do I have to use it to pump up the colors in a landscape or a cityscape, because the rich colors are readily reproduced in the film itself.

I do use the filter when I need to reduce glare or solve other lighting problems. Here, the angle of the sun as it struck the wall created a glare; a polarizing filter would help reduce that and bring out the beautiful blue color of the painted bricks. In addition, a darkened sky would underscore the wonderful colors in the young woman's sari. The price you must pay for using a polarizing filter, however, is a loss of 2 1/3 f/stops. This means that the shutter speed must be slower to compensate for the light loss, or there will be a diminished depth of field, or both.

Technical Data:
Mamiya RZ 67, 250mm telephoto lens, 1/125, f/5.6, Fujichrome Provia 100, polarizing filter, tripod.

of you, and then read the same object through the filter. The difference between the two readings is the filter factor.

Filter factors usually range from 1/2 f/stop to 3 f/stops. Most polarizing filters cause the loss of 2 1/3 f/stops. This means that if the light reading for a landscape is 1/125 at f/8, the corrected reading due to the use of the polarizer would be 1/125 at f/2.8 and 2/3 f/stop. If you are using the TTL meter in your camera, this compensation will occur automatically.

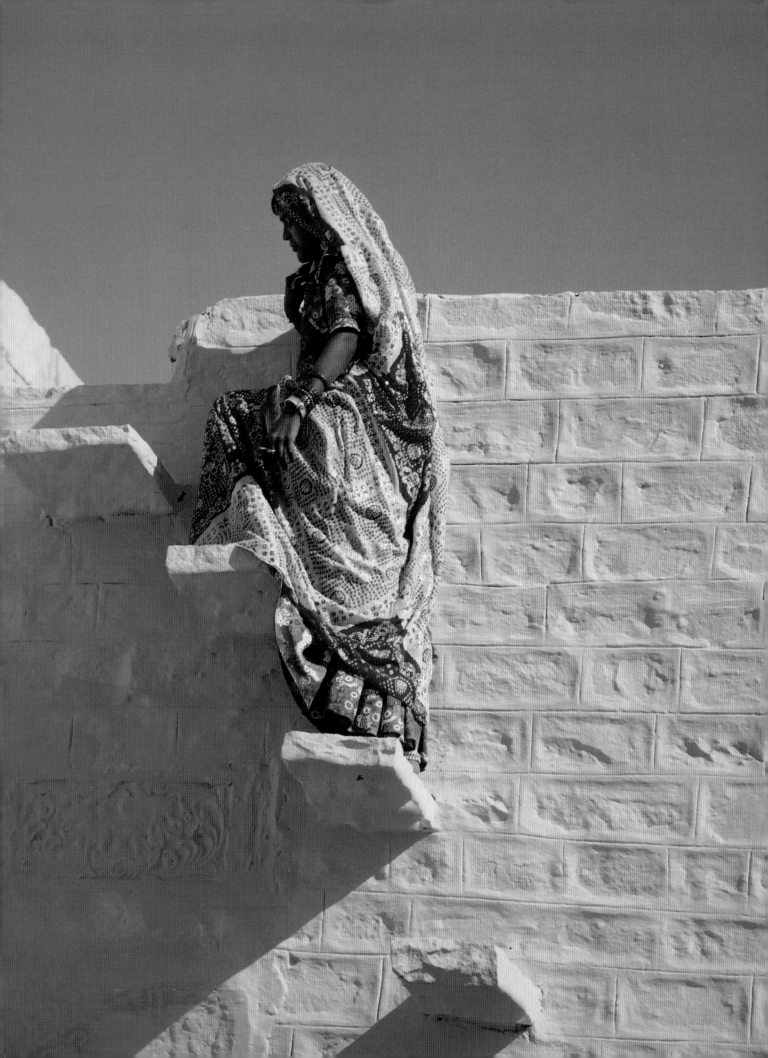

▲ **P**olarizing filters eliminate glare on water, glass, shiny leaves and any other surface where light reflects back into the camera lens. When you cut the glare, the color of the subject is enriched. Sometimes this is desirable; at other times you may want to retain the brilliant highlights to create a high-key effect.

This photograph was taken in autumn from Owl's Head in the northern part of Vermont. I composed the shot of the Groton State Forest to include the reservoir and elected not to use a polarizer. If the sheen on the water was reduced or eliminated, the contrast with the trees would have been reduced. I preferred to capture the scene as I saw it, without manipulating the tonal relationships.

Technical Data:
Mamiya RZ 67, 500mm telephoto lens, 1/125, f/8, Fujichrome Provia 100, tripod.

When the sun first appears above the horizon at sunrise and just before it disappears at sunset, the light we see travels through the atmosphere at such an angle that much of its brilliance is diminished. In the morning, the sun climbs higher after only a few minutes, and the sky becomes several f/stops brighter than the landscape. If you expose correctly for the land, the sky becomes overexposed and loses its color saturation; if you expose for the sky, the land forms go black, losing their detail.

Graduated filters are designed to correct this problem. This sunrise shot of the Taj Mahal was filtered with a graduated neutral density filter, where one half of the square, plastic filter is clear and the other half has a one f/stop density reduction (which does not alter the color balance). The transition between the two portions is gradual, so there won't be a telltale demarcation between the two segments in the final image. Let your in-camera TTL meter read the light normally for a correct exposure. Note, however, that a small aperture should not be used, or the demarcation between the clear portion of the filter and the neutral density portion may show due to increased depth of field.

For extreme situations, you can also use a two f/stop reduction in a graduated filter when the discrepancy between the highlights and shadows is great enough to warrant it.

Technical Data:
Mamiya RZ 67 II, 110mm normal lens, 1/125, f/4, Cokin graduated filter, Fujichrome Velvia, tripod.

◀The price you pay for using a polarizing filter is the 2^1/$_3$ f/stop light loss. In some cases, however, this reduction in light can be a creative advantage.

This blurred image of a crowd dispersing at the conclusion of an annual parade was taken in Brugge, Belgium. I wanted to use a 1-second exposure, but the ambient daylight was too bright. Even at f/32, my smallest lens aperture, the slowest shutter speed I could use was 1/$_4$ second. This wasn't a long enough exposure to blur the crowd as much as I wanted. I put a polarizing filter over the lens, so the loss of light would force the shutter speed to be longer to compensate. The color of the filter is neutral, or gray, which means that it does not alter the color in the original scene.

This same technique works just as well for moving water. When you want to blur a stream or waterfall, and the light is too bright for a slow shutter speed, the two f/stop reduction in light may be just the solution for achieving this artistic effect.

Technical Data:
Mamiya RZ 67 II, 110mm normal lens, 1-second exposure, f/22-f/32, Fujichrome Velvia, tripod.

Diffusion filters soften colors. It's usually best to use these filters in muted light, where subdued ambient light and diffusion glass can work together to produce an exquisite image. There are many grades of diffusion; the Tiffen Soft/FX filter series offers grades of diffusion from one to five. I prefer the middle range, as too much diffusion can result in a loss of definition, while too little diffusion may cause a viewer to believe the photo is slightly out of focus. For this shot I used a Tiffen Soft/FX filter no. 3.

These girls were photographed in Jodhpur, India, in the blue section of the city, where most of the buildings are painted cobalt blue. Bright colors shot in low-contrast light is a favorite combination of mine. So I chose to make the picture in the narrow streets to take advantage of the shadows, even though the sun was high in the sky. Because the girls were close friends, they interacted well together and were spontaneous with their expressions.

Technical Data:
Mamiya RZ 67, 250mm telephoto lens, 1/60, f/5.6, Tiffen Soft/FX no. 3 diffusion filter, Fujichrome Provia 100, tripod.

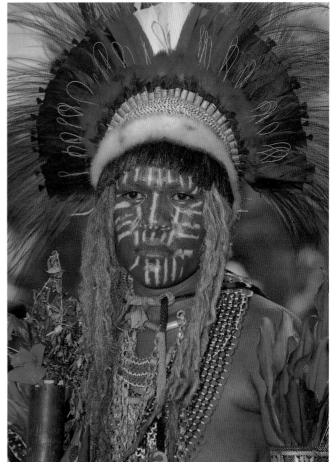

▲ These two portraits of a young woman were taken at the annual Sing Sing in Goroka, Papua New Guinea, where dozens of tribal groups gather to sing and dance. I have traveled to more than fifty countries, and this spectacular event is by far the most incredible photographic experience I've had abroad. The color is dazzling, and everywhere you look there is an amazing image to capture.

The shot on the left was taken without a filter; the one on the right was taken with a color-enhancing filter. The red-magenta shift caused by the filter offers an interesting variation of the original color scheme. Note how the skin tone has shifted, as well as the paint applied to the face. Whether or not you like this type of effect is strictly personal taste. The marketability of the two images is the same. I took both shots with a flash and compensated for the filter by opening the lens one f/stop.

Technical Data:
Both shots—Mamiya RZ 67, 250mm telephoto, 1/125, Metz 45 CT flash, Fujichrome Provia 100, handheld. Photo on left—f/8 and no filter. Photo on right—color-enhancing filter at f/5.6.

◄ The color-enhancing filter adds drama and intensity to sunsets. The reds, mauves and magentas are enriched, and the end result is a visually stunning image. This camel train in the Thar desert in northwestern India was photographed on the crest of a sand dune at sunset. Using the proper exposure for the sky caused the much darker camels to be rendered as silhouettes. Had I exposed for the sand or the animals, the beautiful colors in the clouds would have been overexposed and consequently desaturated.

Whenever you photograph on dunes, there is always a serious danger of blowing sand. Nothing, except salt water, is more hazardous to cameras than windblown sand. I wrapped a plastic bag around the camera body and lens to protect it. Even with this precaution, some sand did find its way into the equipment.

Technical Data:
Mamiya RZ 67, 50mm wide-angle lens, 1/60, f/4.5, Fujichrome Provia 100, color-enhancing filter, tripod.

4

Color Awareness

Light is the language of photography. It enables you to translate your creative vision into an image on film that others can share. Because light, even "white" light, always has color in it, the color of the light affects every photograph you take. The sun, considered to be the source of white light, actually emits a range of hues that change throughout the day and under different atmospheric conditions. Artificial light is also imbued with a range of colors. Tungsten lights, fluorescent fixtures, mercury vapor lamps and electronic strobes all look "white" to our eyes at first glance, but upon closer examination you discover they are not.

You must learn to see first in your mind's eye the colors that will appear in a photo. Instead of thinking, "I'll just take this picture and see how it comes out," your goal should be to study the scene before you, predict the results on film and obtain the outcome you want. The first step toward controlling light and color is learning the colors of light and seeing how they affect your subjects.

These two shots of Kicker Rock in the Galápagos Islands demonstrate the dramatic difference in color and mood between a scene shot when there was low cloud cover and one shot when there was a clear sunrise. I took both photographs at sunrise, one year apart. The shot at left has a cold, bluish cast, while the shot on the next page, taken about a minute after the sun first appeared above the horizon, is imbued with golden tones.

My point in illustrating this difference is not to imply that one is better than the other: Both images are beautiful. But each shot creates a completely different mood for the viewer. The golden sunrise shot suggests the drama and the warmth of the tropics. The cold, muted image is serene, tranquil and elegant. Each shot documents a particular feeling, or mood, about the same place at the same time of day. You can communicate your feelings about a place through the mood(s) you capture on film. In this instance, I was lucky enough to see two completely different moods of the same place. The monolith is indeed serene and elegant, but it is also very dramatic and dynamic.

Technical Data:
Both photos—Mamiya RZ 67 II, 110mm normal lens, Fujichrome Provia, handheld on a boat. Left—1/125, f/2.8. Right—1/125, f/4.5.

The Colors of Natural Light

Awareness of the colors of light and their impact on your subjects is a key element in controlling your photography. Why is it important to recognize the color of light? Because color influences our perception of photographic images. For example, the range of blue and yellow tonalities in ambient light directly affects people's feelings. Bluish tones imply coldness; yellow tones imply warmth. Portraits and landscapes taken under overcast conditions or in deep shade produce faces and environments that are imbued with a bluish cast. Our subconscious response to viewing this type of shot is a feeling of coldness, remoteness or sadness. The same compositions photographed with a low sun, where the subjects are enveloped in golden light, feel more inviting, warm and attractive.

When the sun is overhead at noon in a clear sky, its undiffused light is considered true white light. (This is true anywhere in the United States and in other temperate regions in the world; as you get farther from the equator, midday light is more yellow-white.) All other types of illumination are compared to it. The sunlight emitted from under a midday cloud cover, for example, is not considered true white. Compared to the undiffused noon sun, it is blue-white because it has a slight bluish tinge. As the clouds thicken, the color of the light becomes more and more blue. You may not think of a particular scene as bluish, but rather that it appears to be "cold." The feeling of coldness comes from our subconscious interpretation of light tinged with blue.

Moonlight is another example of light that is tinged with blue. It doesn't appear to be bluish to our eyes, but photos taken of landscapes at night (with long exposures) under a full moon reveal a cold color balance. The moon appears yellowish, or even reddish, only when it is just above the horizon. In this instance, you are seeing the same effect as a rising or setting sun. The atmosphere absorbs the longer wavelengths of light—the reds and yellows—and it allows the shorter wavelengths of blue light to pass through.

Before the sun reaches its zenith, the color of its light is yellowish compared to true white light. At sunrise the golden tones of light are pronounced to our eyes and very dramatic on film. Three and a half hours later, however, the yellow tinge is subtle. The closer the sun is to the horizon, the more yellow the light is. The quality of "warmth" is associated with yellow light.

As the natural light changes throughout the day, the colors of your subjects change as well. Bright sunlight shows rich, bright, accurate colors. Flowers, clothing, landscapes, architecture and all other subjects are seen with a correct color balance. In

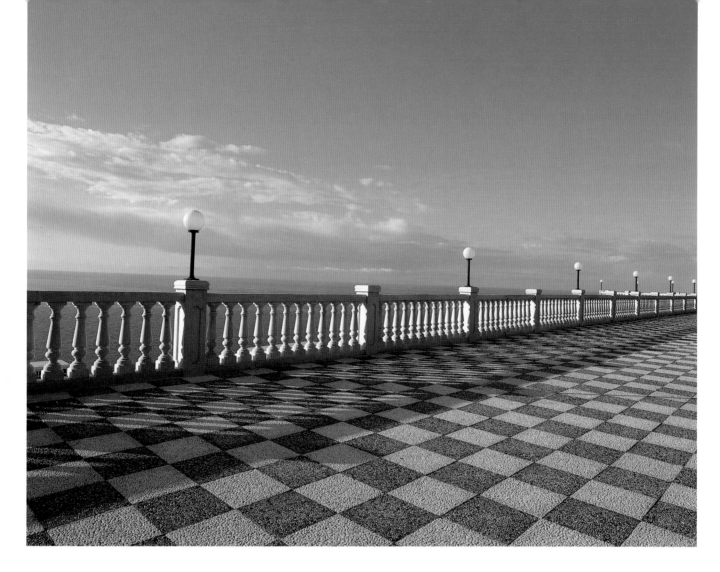

conditions such as haze, mist or fog, colors are more muted, softened by the diffused light. Subjects appear almost pastel. An overcast sky is ideal for portraits, because the color and quality of light is just cool, or bluish, enough to make the skin appear to be made of porcelain.

Artificial Light

Artificial lights attempt to approximate white light at midday. However, there are as many different shades of color in artificial lights as there are shades of color in natural light throughout the day. Learn to discern the subtle differences between artificial light sources and you can predict their effects on film.

The light emitted from a lamp in your living room looks true white, but the bulb has a tungsten filament that actually produces a yellow-white light similar to early morning or late afternoon sunlight. Test this for yourself. During the day, place a lamp next to an outside window and turn it on. You can see the marked difference between the color of daylight and the much more yellow-white of the tungsten light simply by looking first at one source of light and then the other.

Fluorescent illumination produces a wide range of color. In a large supermarket or warehouse, where dozens of fluorescent tubes light the interior, you can often see the differences in color among the tubes. Some will be yellow-white and some will seem blue-green. This type of lighting is very harsh, even garish, and it is repro-

duced on film as primarily green. Any subjects photographed under fluorescent lights without correction filters will be imbued with an unflattering green cast. Mercury vapor lights, such as street lamps, also produce a harsh illumination. Although the light appears white to our eyes, it appears blue-green on daylight film and a deep blue on tungsten-balanced film.

Electronic flash is designed to provide true white light, but even the light from strobe units can vary in color. Some units produce slightly cooler, or more bluish, light; others produce light that is warmer than midday sunlight. For the most accurate color output, purchase a strobe that is color temperature rated at 5500 K, the same color temperature rating of the midday sun.

AVAILABLE LIGHT INDOORS

The diffused light that we see indoors—inside a room, away from the windows—has a bluish tinge to it. From large cathedrals to your home, the color of the light is significantly cooler than sunlight. This isn't readily apparent until you try taking an interior photograph on daylight film without a flash or any correction filters. The resulting bluish cast will be far more pronounced than your eyes could detect. All the colors in the room will be influenced by the color of the light. People, as well as objects, will appear to be cooler on film than they do to your eye. To counterbalance the blue, use a warming filter, such as the 81A.

This beautiful patio behind the Salobreña Hotel on the Costa del Sol in Salobreña, Spain, illustrates how a subtle change in light affects color. These images were photographed at sunset, when the sun radiates low-angled, golden light. The photo on page 44 shows the typical yellow-tone lighting shortly before sunset. After I made the exposure, I changed my composition slightly and, just as I was about to shoot again, a thin cloud layer moved in front of the sun. In the photo above, only faint shadows were still visible, and the color of the light has changed markedly, taking on a slightly bluish tinge. You can see this very clearly if you look at the stones in the patio; they have changed from a yellow-gray to a blue-gray. The sky has also been affected. When the thin cloud cover blocked the sunlight, the rich blue color in the sky was diminished.

EXERCISE IN COLOR AWARENESS: You can actually see the color of light change if you take the time to notice. Try this exercise, and see what you discover. On a sunny afternoon, find a comfortable spot and a subject—a landscape, a building, a cooperative friend's face or practically anything else—that you can study for several hours. Watch how the color of your subject changes as the sun sets; document it on film with a series of shots for a permanent record. If you begin observing the light three hours before sunset in a temperate region, you can watch the light change from "white" light, gradually becoming more yellow and, finally, a reddish yellow.

Technical Data:
Both photos—Mamiya RZ 67, 50mm wide-angle lens, 1/4 second, f/22, Fujichrome Velvia, tripod.

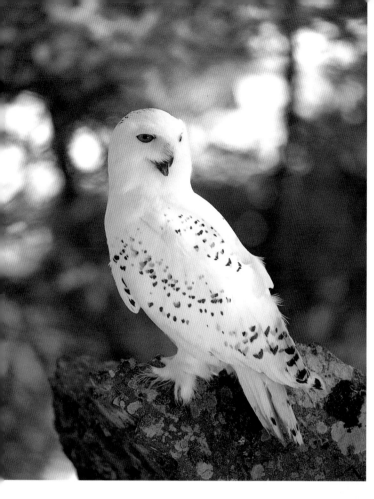

Variations in the colors of natural light are easily seen on a white subject. This snowy owl was photographed in British Columbia, Canada, from two slightly different camera angles. The photo on the left was taken when the sun was largely blocked by tree branches, putting the raptor in shade. The color of the light on its white feathers shows subtle blue tones, in spite of the fact that the ambient daylight was very close to white. Deep shade is always more blue than direct sunlight. This is clearly seen in the area of the head.

The photo below was taken a couple of minutes later when the sun moved a few degrees in the sky. The bird was receiving more direct rays (as was the background), and the white feathers now appear closer to pure white, without the bluish tinge. Both exposures are acceptable; which you prefer is a matter of personal taste.

You need to learn to appreciate and take advantage of changes in light, such as the one illustrated here that produced two different, but equally effective, shots. Train your eye by observing the difference between direct sunlight and diffused light on a day when the sky is changing frequently from clear to cloudy. When the sun is behind a cloud, the ambient light is cooler, or bluish. Direct sunlight at midday, on the other hand, is natural white light. Don't confuse the brightness of the light with its color. Direct sun is brighter than the diffused light produced by a cloud cover, but the color is also different.

Technical Data:
Both photos—Mamiya RZ 67 II, 350mm APO telephoto, Fujichrome Provia 100, tripod. Left—1/125, f/5.6. Below—1/125, f/8.

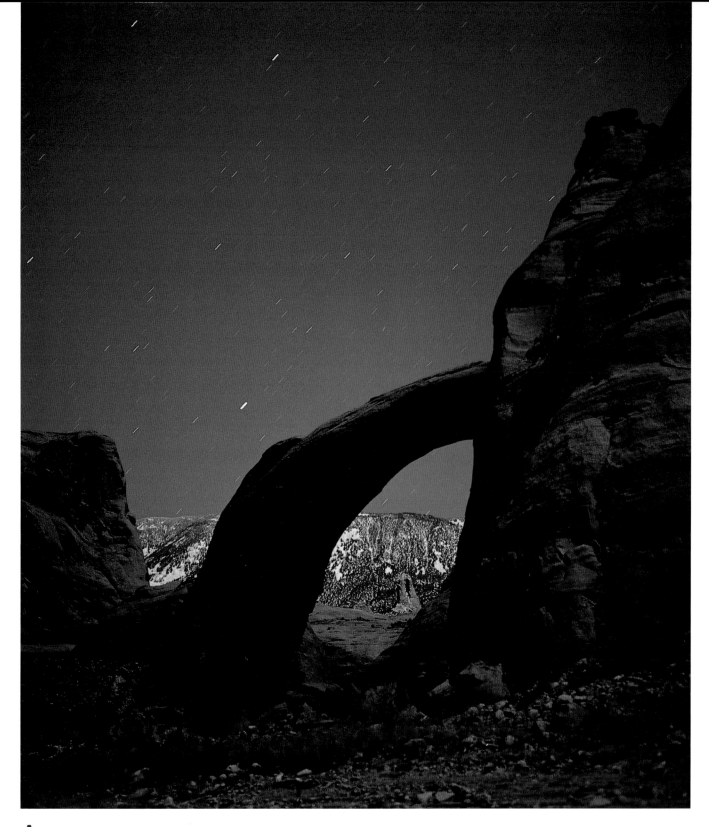

A full, or almost full, moon provides enough light to make landscape photos, providing you use a tripod for the long exposure. However, the pictures will have a bluish color cast.

I took this image of Rainbow Bridge at Lake Powell in Utah at three o'clock in the morning. The wind was very strong, and I was concerned that the severe gusts might cause unwanted camera movement, so I tried to shield the Mamiya with my body. My exposure was not based on a meter reading—it was pure guesswork. I was afraid that a meter would interpret this night scene as medium gray and overexpose the shot.

The short star trails result from the Earth's rotation. I would have preferred longer trails, but I didn't think the camera was stable in the wind. The light here, beside being bluish, is very contrasty. The moon was overhead and provided harsh light similar to that of a noon sun.

Technical Data:
Mamiya RZ 67, 50mm wide-angle lens, 3 minutes, f/4.5, Fujichrome 50D, tripod.

The shades of cool tones that exist outdoors vary according to climatic conditions. Both dense fog and shade produce cool tones, but the tonal range varies according to the weather, the condition of the sky and the ambient light. The photo on the left was taken on Hurricane Ridge in Olympic National Park, Washington, in the midst of a thick fog. The cool, bluish cast is subtle. At first glance, you would call the predominant color gray rather than blue. But after critical examination of the shot, you can more easily see the bluish tonality. Fog or haze will soften all the colors you see; you get the most delicate and subtle color effects in these conditions. At times, as you can see here, the colors are so grayed out that the effect of the shot as a whole is almost monochromatic.

This shaded waterfall in Quichee, Vermont, is more blue than the forest on Hurricane Ridge. The photo below was taken under a blue sky, but the falls were in the shade of a thicket of maple trees. Notice the absence of true white in the water and how narrow the tonal values are. Even at midday, with a clear sky, the deep shade of the forest transforms what we really know is pure white—tumbling whitewater—to blue-white.

Technical Data:
Forest—Mamiya RZ 67, 250mm telephoto, 1/30, f/8, Fujichrome Velvia, tripod. Waterfall—Mamiya RZ 67 II, 350mm APO telephoto, 1/4 second, f/22, Fujichrome Velvia, tripod. I metered both shots with Minolta's Flash Meter IV, which is also an incident meter. Incident meters read the light that falls onto a scene rather than the light reflecting from elements in a picture. As long as the light that is falling on the scene is also hitting the meter, the reading should be very accurate.

The most spectacular lighting in nature is low-angled sunlight combined with a dark gray sky. I photographed this mother giraffe and her week-old calf in the Maasai Mara Game Reserve in Kenya. The late afternoon side lighting rim-lit the animals, while a storm was moving across the grassland toward me. The darkened sky provided an ideal background to the beautifully illuminated scene. The contrasting colors—the rich, warm brown and yellow hues of the animals' hides juxtaposed against the dark, brooding clouds—turn an ordinary scene into one with high drama. The combination of a special moment in nature with stunning lighting is rare, but when it happens it is pure magic. This is one of my all-time favorite images.

Technical Data:
Mamiya RZ 67 II, 350mm APO telephoto lens, 1/125, f/5.6–f/8, Fujichrome Provia 100. The camera rested on a beanbag in the Land Rover.

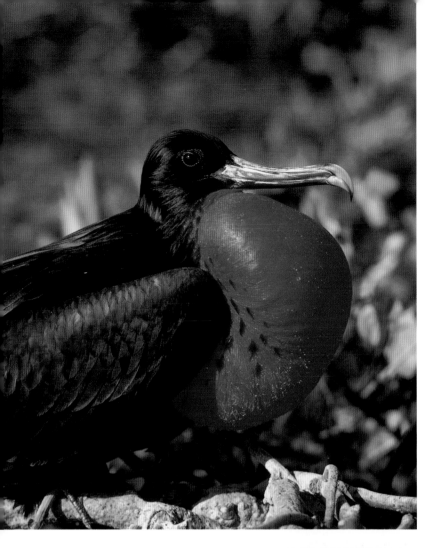

The same subject, seen from two different angles at the same time of day, will often reveal very different color schemes. Sometimes the difference is obvious; sometimes it is very subtle.

The photo at left shows a male magnificent frigate bird in the Galápagos Islands displaying his red throat pouch to attract females during the mating season. Photographed with front lighting, with the sun at my back, the pouch is a brilliant red while the iridescent green feathers reflect the early morning light. A second bird (below), just a few feet from the first, was identical in color and was photographed with the sunlight coming from behind. The backlight changed the color of the pouch, because the translucent tissue allowed the light to come through, giving it a very different quality. In addition, the iridescent feathers aren't reflecting their color back to the camera.

Notice also the quality of the black feathers. In the shot at left, they reflect the front lighting and appear to have a sheen to them. When backlit, in the photo below, they have most of their detail.

Technical Data:
Both photos—Mamiya RZ 67 II, 350mm telephoto lens, Fujichrome Provia 100, tripod. Left—1/250, f/8–f/11. Below—1/125, f/5.6.

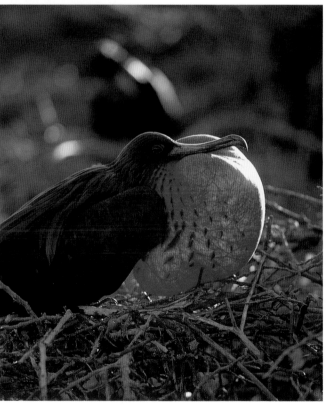

North Window and Turret Arch combine to make a well-known and classic photograph in Arches National Park, Utah. This shot was taken within five minutes of sunrise, showing the warmth of the low-angled light. Note the warm, rich, reddish-brown color of the rock formation. The shadow cast on the arch face by a large rock behind the camera position is not imbued with warmth by the yellow light, however. It appears to be almost blue. Even when the ambient light is yellowish, shadowed areas are significantly cooler in color than other parts of the image.

Twenty minutes later, I walked down to Turret Arch and shot back toward North Window. Notice how the colors have changed dramatically in the shot below. The three colors that predominate now are black, blue and white. Not only is the time of day critical to color, and hence mood, but the composition relative to the sun is very important. This is an extreme example of how changing your camera position, and therefore, the angle at which light strikes your subject, affects the color you capture on film. By shooting back toward the eastern sky, the brilliant light contrasted with the arch silhouette to produce a cool-toned, bold graphic. Notice how the light within the arch is warmer than the sky at the top of the frame. This brilliant portion of the image is right next to the sun, which is obviously more yellow than the sky above the arch.

Technical Data:
Both photos—Mamiya RZ 67, 50mm wide-angle lens, Fujichrome Velvia, tripod. Above—1/8 second, f/22. Right—1/125, f/8.

Photographs virtually devoid of color can be quite dramatic in their own right. One of my favorite outdoor conditions is a whiteout, where a snow blizzard and low clouds lower contrast and eliminate color. The shot at right of an Arctic fox was taken during such a storm. Normally, overcast conditions produce bluish tones in a scene, but the brilliant snow on the ground combined with the blowing snow in the air apparently kept the color more neutral. In addition, the cloud cover was relatively thin, permitting a very bright, diffused light on the land, which also contributed to the white color of the ambient light. In spite of the monochromatic scene, notice how the subtle variations in the colors of the fox's fur are delineated against the snow. This is a good example of the many different meanings the color white actually has.

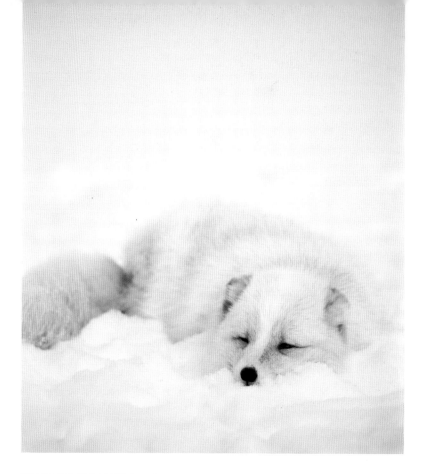

The photo below is an example of the opposite situation—black marine iguanas were photographed against black lava in the Galápagos Islands. Color has been supplanted by tonalities of black and gray, yet the image is a striking one. This image was taken under a clear sky about nine o'clock in the morning. The sun was high enough to provide good front lighting. Contrasty side lighting wouldn't have worked here because the dark shadows would probably have gone black, with no detail.

Shooting white-on-white or black-on-black with color film is similar to, but not identical to, shooting with black-and-white film. On color emulsions, there are beautiful and subtle hues that don't exist in black and white. For example, white can be tinged with yellow or blue. Similarly, black or dark gray portions of the composition can contain trace amounts of those and other hues.

EXERCISE IN COLOR AWARENESS: To increase your awareness of the subtleties of black-and-white subjects on color film, set up several shots. Once you start thinking of the possibilities, you'll find it's easy to do and will be photographically rewarding. For example, shoot a blonde girl in a white dress on a foggy day against a white sky. Or photograph a white dog on snow. With a black-on-black theme in mind, try shooting black pottery on black or dark gray slate, or perhaps a black cat against a black quilt.

Technical Data:
Arctic Fox—Mamiya RZ 67 II, 350mm APO telephoto lens, 1/250, f/5.6, Fujichrome Provia 100, tripod. Marine Iguanas—Mamiya RZ 67 II, 110mm normal lens, 1/30, f/22, Fujichrome Provia 100, tripod. The exposures of both photographs were determined the same way. I used the Minolta Flash Meter IV to read the ambient light falling on the scene. Alternatively, I could have used a TTL meter to read a gray camera bag and then manually set my camera with this reading.

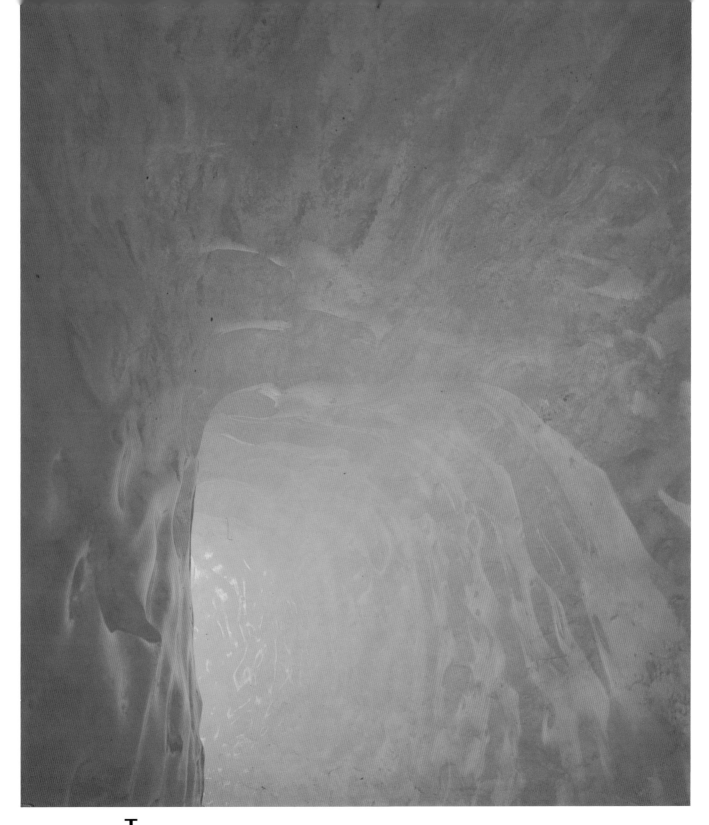

The color of light is dramatically influenced by translucent substances it passes through. Translucent objects, such as a leaf, a single feather or the petal of a flower, allow light to pass through them. As the light passes through the colored subject, it is altered in the same way a filter changes the color of light. The intense blue light seen in this photo was captured in an ice cave on a glacier in the Swiss Alps. The ice filtered out the warm end of the spectrum by absorbing the red and yellow wavelengths. The short blue wavelengths penetrated the ice. (See chapter one for more on how light produces colors.) Look for translucency in both natural and man-made objects, such as a spinnaker on a sailboat, sheer fabric, tall grasses and the wings of birds as they fly past an overhead sun.

Technical Data:
Mamiya RZ 67 II, 110mm normal lens, 1/4, f/16, Fujichrome Velvia, tripod.

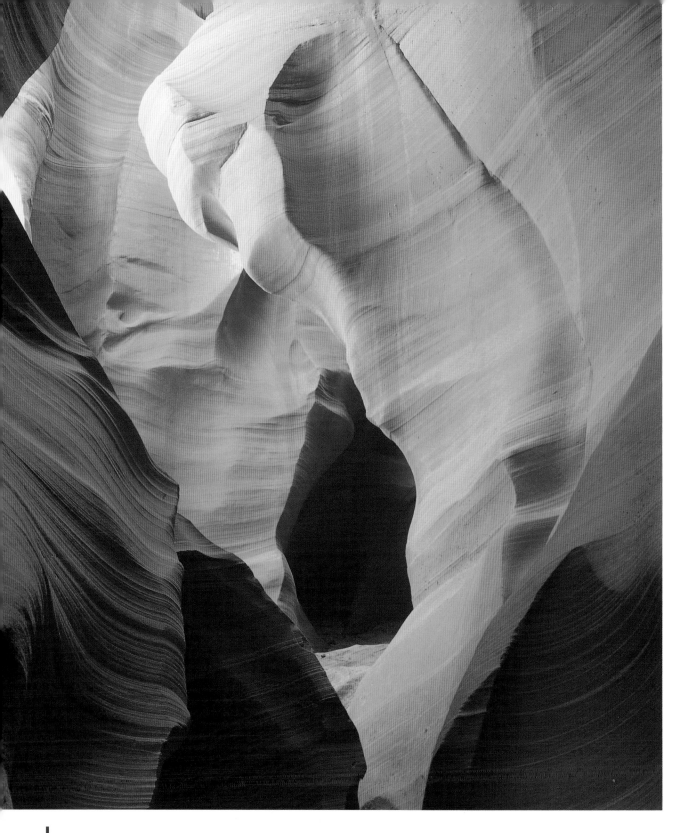

In Lower Antelope Canyon near Page, Arizona, light entering a narrow slot at the top of the rock formation reflected off the orange sandstone and virtually glowed with intensity. The contoured surface in the somber light of the deep canyon appeared dull, but with the bright ambient daylight striking it, the rich color inherent in the formation popped. By moving the camera position until I found the optimum angle, I was able to capture the most saturated part of the color created by the reflected light.

It is interesting to note that both this photograph and the one on page 53 were taken under an overcast sky. The diffused skylight was able to create ultra-intensity in color without the use of a strong, directional sun. Although bright sunlight can bring out saturated color, it isn't always necessary, as you see here.

Technical Data:
Mamiya RZ 67 II, 250mm telephoto lens, 1/2, f/22, Fujichrome Velvia, tripod.

We often think of the way water reflects light, but it also reflects color. Environmental elements, such as the sky, trees, flowers and rocks, can all inject color into the surface of a body of water. Reflections can be subtle or dramatic.

The photo at right was taken at Mammoth Terraces in Yellowstone National Park. The still pools of water are tinged with blue because they are reflecting the color in the sky. This subtle hue is an interesting contrast with the colors of the mineral formations, which are mostly yellowish. Blue and yellow are complementary colors, which means this juxtaposition is especially striking, even though both shades of color are desaturated. Had the sky been overcast, the water would have appeared very light, with little color shift at all.

The photo below presented a significantly more dramatic situation. The tree stump sticking out of a pond in northern New Hampshire is a strange counterpoint to the brilliant colors of autumn foliage reflecting in the water. I chose a long lens to eliminate everything in the composition except for the color and the stump, thus turning an ordinary reflection into an abstraction. Notice how the intensity of the color is so dominant that only the ripples (and the stump's reflection) reveal that you are actually looking at water.

Technical Data:
Mammoth Terraces—Mamiya RZ 67, 110mm normal lens, 1/4, f/22, Fujichrome Velvia, tripod. Fall Colors on Water—Mamiya RZ 67, 350mm APO telephoto lens, 1/8, f/22, Fujichrome Velvia, tripod.

The colors of twilight are especially striking because the deep, rich, cobalt blue ambient light contrasts with artificial lights. This shot of Budapest, Hungary, was taken from a distant hilltop, and the classic European architecture dramatically stands out because the buildings, which were illuminated by sodium vapor lights, are sharply defined against the blue background.

I prefer in most cases to shoot twilight and night cityscapes without correction filters. Most historical and commercial architecture is either neutral in color or very dull. Without the infusion of bright colors from sodium or mercury vapor lights, buildings in dim light would not make interesting photographs. In other words, if I corrected the color shift back to the original tone, the drama of twilight and night shooting would be compromised.

EXERCISE IN COLOR AWARENESS: In the diminished light of twilight, observe how the colors of a landscape have changed from what you see in daylight. Everything has a bluish cast, as you see in this photo. Film exaggerates this characteristic, but you can easily observe the loss of the red end of the spectrum with your eyes.

Technical Data:
Mamiya RZ 67, 350mm APO telephoto lens, 15-second exposure, f/5.6, Fujichrome Velvia, tripod.

Many photographers think strong, midday sunlight is necessary to produce rich, saturated color on film. This is not true in many situations. It's quite possible that overcast conditions can actually give you a degree of saturation that is more attractive than direct sunlight.

Study these two images. The Goldie lorikeet (on the right) was photographed in midday, direct sun, yet the intensity of the red feathers is not overwhelming at all. The bird appeared deeper in color to my eyes. On the other hand, the foxglove flowers (below) were photographed under a deep overcast during a light rain. It's obvious that the color of the flowers is very rich and saturated, and the delicate details in the leaves and petals aren't lost in the harsh shadows or highlights of direct sunlight. Providing the exposure is correct, this is a predictable result for subjects such as flowers, fall foliage and colorful wildlife. It can be more difficult to photograph these subjects in low-light conditions, especially on slow, fine-grained film, because longer shutter speeds are required, but the richness and depth of color make it worth the effort.

Technical Data:
Goldie lorikeet—Mamiya RZ 67, 250mm telephoto lens, 1/125, f/8-f/11, Fujichrome 50D, tripod. Foxglove flowers—Mamiya RZ 67, 250mm telephoto lens, no. 1 extension tube, 1/2, f/16, Fujichrome 50D, tripod.

Iridescence is not common in nature. When you can find it in a feather, the wings of a butterfly or, perhaps, in an abalone shell, the dazzling and intense colors immediately attract the eye. If you can capture iridescence on film, it makes a wonderful image.

This butterfly, photographed in tropical Mexico, belongs to the famous genus called *Morpho*. These butterflies are known for their incredible neon blue coloration. When seen from a certain angle in sunlight, the intense blue is iridescent. The first time I saw a morpho flying through the dense vegetation in the Amazon Jungle, I was absolutely spellbound.

No unusual considerations are needed to expose for this kind of situation. Your TTL meter will work well. However, I would suggest using a fine-grained film that produces saturated color. You will then capture all the detail and the rich color of the unique subject. Make sure, if possible, that the sunlight strikes your subject at the appropriate angle to catch the sheen.

Technical Data:
Mamiya RZ 67, 127mm normal lens, #1 extension tube, 1/125, Metz 45 CL flash, Fujichrome Velvia, handheld.

The color of natural light can be influenced by many factors, including dust. Sandy-colored dust particles not only cause a color shift to the warm portion of the spectrum, but the glow that results can envelop a subject dramatically.

These horses were photographed on a ranch in Oregon. It hadn't rained for months, and the ground was very dry. The animals' hooves kicked up clouds of dust as they moved; when the low sun penetrated the dust, it made the horses appear almost like phantoms. Notice how the animals are not only silhouetted, but the diffused light, seen especially in the horses farthest from the camera, reduces the contrast between them and the background.

Dust is terribly harmful to cameras. Fine particles can get into every crevice and do serious damage to electronics as well as lenses. It's always best to carry a plastic bag, like a trash bag, with your gear for protection in these situations.

Technical Data:
Mamiya RZ 67, 50mm wide-angle lens, 1/125, f/5.6, Fujichrome Velvia, tripod.

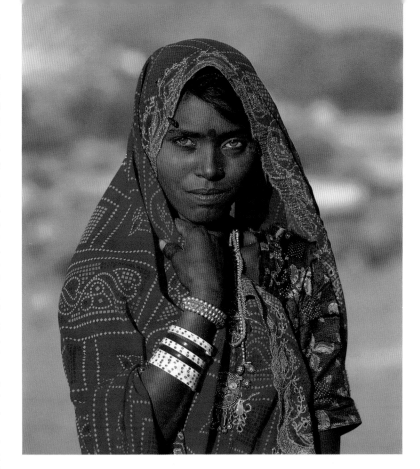

I never photograph a person in midday sunlight unless the harsh light can be diffused. (You can use a diffusion panel or move the subject into the shade.) An overhead sun creates ugly shadows under the brow, often turning eyes into black orbs, and an unwanted highlight forms on the bridge of the nose and the forehead.

The only direct light I use for portraits outdoors is a sun that is close to the horizon. In the early morning and late afternoon, the low-angled front light fills shadows and provides flattering illumination. Some photographers find the distinctive warm color that results from shooting at this time of day objectionable for skin tone. I like it, however, and frequently take pictures of people in nature's "sweetlight." Make sure the sun is low enough in the sky that its intensity is diminished. This prevents your subjects from squinting.

The photo at right was taken at the Pushkar Fair in India. It was shot about an hour before sunset, and the golden light enhanced the beautiful skin tone of the young girl. Notice that she is looking in the direction of the sun without squinting. The dust in the desert air helped diffuse the distant sunlight, and this made it easier for her to look into the western sky.

The skin tone in portraits taken in the shade, or on overcast days, has a very different color balance. Diffused natural light produces subtle tones of blue, or if there is a lot of foliage near the subject, the light can actually have a green cast. This young dancer was photographed in Myanmar. The sun was high in the sky, so I asked her to step into the shade to take advantage of the soft light. Notice the color of her skin. It has a very slight green cast from the proximity of the foliage.

Technical Data:
Girl in sun—Mamiya RZ 67, 250mm telephoto, 1/250, f/5.6, Fujichrome Provia 100, tripod. Young dancer—Mamiya RZ 67, 250mm telephoto lens, 1/125, f/4.5, Kodak Ektachrome EPN, tripod.

A shot of the interior of a commercial building or warehouse offers photographers a challenge because usually such buildings are lit with fluorescent illumination. Film interprets this artificial lighting as greenish. When daylight enters the building and mixes with the fluorescent fixtures, the results can be hard to predict and difficult to correct. In those instances where tungsten lights are also being used, it's really impossible to correctly balance all the light sources unless all the bulbs are changed to match the type of film being used.

This shot was taken in the hangar where the space shuttle was being readied for another launch. You're looking into the tail end of the shuttle. Daylight entered through one side of the building, but fluorescent fix-tures added their greenish light from the ceiling. It's interesting to note the elements in the lower part of the frame have a predominantly correct color balance, while the ceiling area definitely has a green cast.

EXERCISE IN COLOR AWARENESS: Compare various fluorescent fixtures and see the difference in their "white" light. Large ceiling areas in commercial stores are good places to observe this. Grocery stores, huge electronic outlet stores and discount warehouses are good places to observe the wide variation in the color of light actually produced by fluorescent fixtures.

Technical Data:
Mamiya RZ 67, 50mm wide-angle lens, 1-second expo-sure, f/22, Ektachrome 64, tripod.

This remarkable spiral staircase in the monastery of Melk, in Austria, was photographed with daylight-balanced film. The tungsten illumination, typical of home interiors and some commercial and public buildings, appears yellow-orange. Contrast this color with the daylight illuminating part of the staircase. It looks white, which would be expected when outdoor film is used with natural daylight. It is the juxtaposition of these two types of lighting, plus the beautiful graphic design of the architecture, that makes the shot so powerful.

I used a fish-eye lens here, but notice that there is no apparent distortion. Fisheye lenses typically curve straight lines, but when the lines in a composition are curved or circular, it appears that no distortion occurs, because to curve a circle really means no change takes place.

EXERCISE IN COLOR AWARENESS: Place a household lamp with a tungsten lightbulb next to a window. During daylight hours, compare the difference in color between the artificial light and the sunlight outdoors. You will notice that the tungsten light appears more yellow than the daylight.

Technical Data:
Mamiya RZ 67, 37mm fish-eye lens, 4-second exposure, f/4.5, Fujichrome Velvia, tripod.

The color temperature of firelight and candlelight is rated at about 2000 K. When either light is captured on daylight film, the reddish yellow color is exaggerated and intensified. This portrait of my niece Andrea Brennglass lighting Chanukah candles was taken on Fujichrome Provia 400. I used a fast film due to the diminished illumination, and I used a daylight-balanced film because I wanted to dramatize the color of the firelight.

Tungsten film, which is manufactured to produce accurate colors at 3200 K, renders images of fire with an exaggeration of the reddish yellow portion of the spectrum. This exaggeration, however, is not as extreme as with daylight film.

EXERCISE IN COLOR AWARENESS: Compare the color of firelight with that of a tungsten lightbulb. Sit in front of a fireplace and hold a mirror in front of your face. See how red-yellow the light is on your skin. Turn around and face a 100-watt or brighter lightbulb in a lamp fixture and see how much less red the light is. It is more yellow than daylight, but not as warm in color as the firelight.

Technical Data:
Mamiya RZ 67 II, 110mm normal lens, 1/30, f/5.6, Fujichrome Provia 400, tripod.

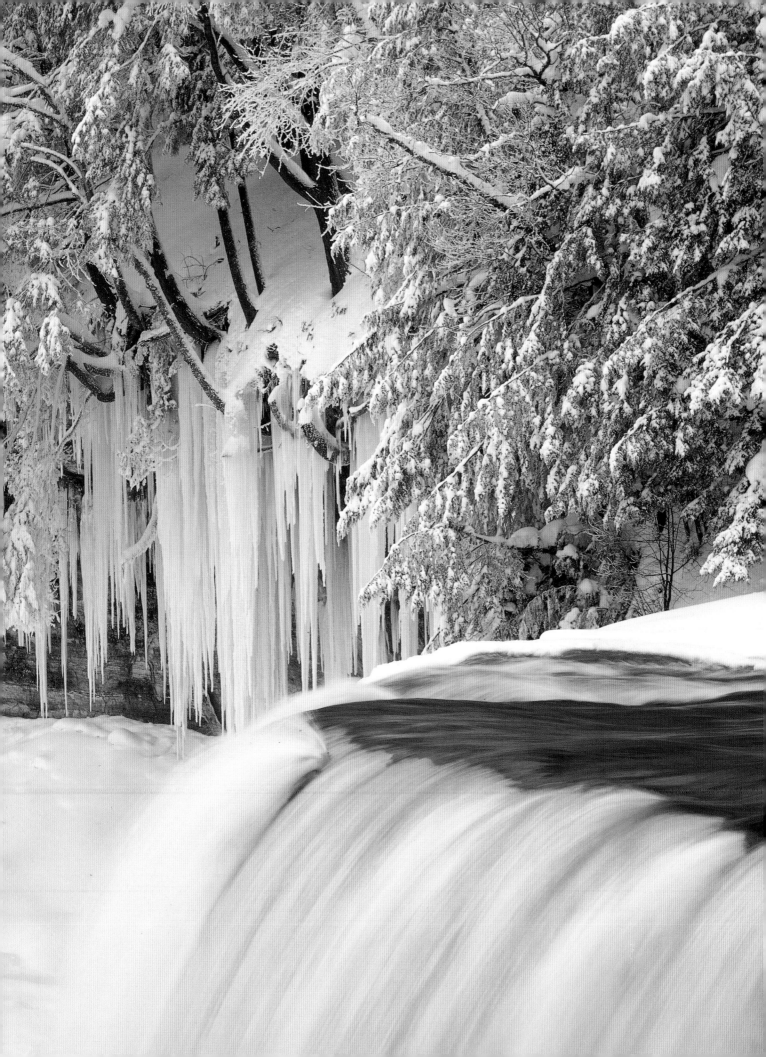

5

Making Powerful Statements With Color

Many amateur photographers wrongly assume that color photography is more difficult than black-and-white. I've heard often that photo students take courses in black-and-white photography before attempting color because they think that good color images are much more challenging to take. Actually, the opposite is true. A stunning black-and-white print results from the meticulous manipulation of tones of gray through exposure, developing and printing. On the other hand, you can create a powerful statement in a color photograph by using the colors that exist around you to communicate with the viewer.

Dramatic color images can be found or created. Sometimes I will see a striking composition in color while I'm driving my car. I will then return with my camera to capture the shot at the right time of day. On other occasions, I get an idea to shoot a particular subject in a colorful way, and then I will bring the various components together and set them up.

A Single Color

Filling the frame with a single, vibrant color, such as a macro shot of a portion of a flower or a painted wall, is an effective way to use color. But filling your frame with only one color isn't enough to create a great image. The key to making this kind of photograph work is having a strong design element within the composition. The subject must be interesting enough to warrant the effort. Harsh shadows or textural side lighting will make all the difference in dramatizing and enhancing a monochromatic composition.

Color Accents

A single, colorful element that stands alone in a scene can make a very powerful statement. Whether you are shooting landscapes, architecture, wildlife or models, a splash of color in muted surroundings transforms an ordinary image into a striking one.

You can accidentally discover such compositions. In fields of flowers, for example, a flower of one color might be surrounded by flowers of another color. In California, I found a purple lupine growing in the midst of orange poppies. My favorite find, however, was a bright yellow prairie sunflower growing in the Great Sand Dunes National Monument. The earth tones of the dunes, and the starkness and desolation of the environment, contrasted poignantly with the colorful flower.

You can accomplish the same end by preconceiving a particular shot and then bringing the elements together. A brilliantly colored insect can be placed on a flower where the colors complement each other. The photograph may be biologically incorrect (i.e., this insect may never visit this flower), but it nevertheless makes a stunning—and salable—image. If you are shooting in the controlled conditions of a studio, it is a simple matter to create a set with a colorful surprise. Simple examples include a field of black marbles with a single red marble, a portrait of a dark-skinned model wearing bright earrings or colorful eye shadow, and an arrangement of clear glass vases with one filled with a colored liquid.

Introducing a single colorful element into a black-and-white image makes that element the dominant focal point of the image. This style of photography has proven very successful in the marketplace in recent years, with subjects such as children and models. There are two ways to achieve this look: hand-coloring black-and-white prints and digital manipulation with a computer.

For Shock Value Only

Bold combinations of color can be used for visual shock value. Using neon colors or fluorescent dyes, or simply juxtaposing outrageous colors in the same shot, you can create images that literally scream with impact. The easiest way to combine colors is to go with the complements. Blue and yellow, green and magenta, and red and cyan are combinations that always look great. For colors that are jolting, try experimenting with combinations like lime green with purple, turquoise blue with chartreuse, or orange, magenta and yellow. Fabrics, paint, colored glass, Plexiglas, neon light fixtures and industrial inks are materials that you can purchase for studio setups. Garage sales and swap meets are good places to find inexpensive things to use in these kinds of pictures.

▶There are two ways to add a spot of color to black-and-white images—hand-coloring prints or digitally manipulating them with a computer. It is easier and much less expensive to hand-color prints with Marshall's Oil Colors and/or Marshall's Colored Pencils than it is to create the same effect with digital manipulation. The color is applied to a fiber-based, matte-finished black-and-white print, usually an 8×10 (20cm \times 25cm). The oil colors are applied with a cotton swab or a piece of cotton wrapped around a pointed object, like a pencil. A small amount of color is placed on an area of the print and smeared until the desired saturation level is achieved. If the color ends up in the wrong area or you wish to start over, a chemical called "Marlene" (included with Marshall's Oil kit) is used to erase all or part of the applied color. The colored pencils are used to apply pastel color to small areas on the print. (For more information on this technique, see my book *Outstanding Special Effects on a Limited Budget*.)

Computers can be used to do the same thing. (See pages 92-96 for a detailed discussion of digital manipulation.) In the program Adobe Photoshop, you can begin with a black-and-white image, select the area of the image to be altered and use the Color Balance dialog box to introduce any color desired. To increase or decrease the saturation of the new color, make the adjustment in the Hue/Saturation dialog box.

Black-and-white portraits can be dramatized by applying color to facial features. Colorful eye shadow, lip color and blush make arresting counterpoints to the tones of gray in the rest of the print. When the color of the eyes is altered or intensified, the result can be stunning. In choosing the makeup colors, either follow convention, where lips are red, blush is a deeper red and the eye shadow complements these colors, or get really creative, where anything goes.

Technical Data:
Mamiya RZ 67, 250mm telephoto lens, 1/250, f/22, Speedotron 2403 Power Pack, exposure determined with a Minolta Flash Meter IV, Tri-x, tripod. This portrait of Rondi Ballard was colored with Marshall's Oil Colors. A black-and-white 8×10 (20cm \times 25cm) print was made on Agfa Portriga paper and then the colors were applied with cotton swabs. The color that comes out of each tube is ultrasaturated, so I smeared the paint in order to decrease the saturation until I achieved the look I wanted.

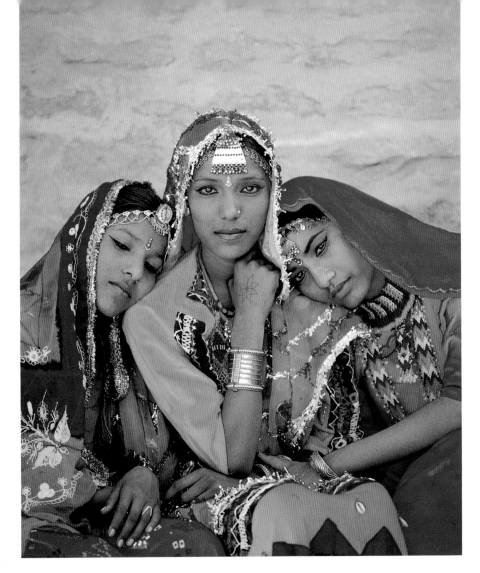

One of the shots I took of these three Indian girls is reproduced on page 38. It is one of my all-time favorite travel portraits, and I wanted to create another version that had a very different look. I made a black-and-white 8 × 10 (20cm × 25cm) print from the color transparency original on fiber-based Agfa Portriga paper. The print was pinned flat on a piece of foamcore, and then I applied Marshall's Oil Colors. I wanted a striking contrast between their faces, which I left uncolored, and their clothing. I carefully painted the saturated oil color in the appropriate areas and smeared it just enough for a uniform covering, preferring to keep the artificial color startling in its intensity.

Any color original can be hand-colored by first converting it to black-and-white. Most custom labs can do this for you, or you can do it yourself in the darkroom using black-and-white internegative material as the intermediate step between the slide and the print.

Technical Data:
Original image—Mamiya RZ 67, 250mm telephoto lens, 1/60, f/5.6, Fujichrome Provia 100, tripod.

A single splash of color in an otherwise muted or monochromatic composition usually makes a very effective photograph. To be dramatic, a color doesn't have to be intense, but it must contrast with its environment. The fact that this flower, which is yellow (and hence suggests warmth), is a dynamic contrast to the cold ice also helps make this an unusual and striking shot. Had the accent been blue or green, it would have been necessary for it to be extremely bright in order to have the right amount of impact.

I found this unusual shot while driving through Paradise Valley near Livingston, Montana, early in the morning. The water from sprinklers had frozen on the vegetation during the night. Before the sun was high enough in the sky to melt the ice, I spotted this beautiful composition. The yellow color is pastel, rather than bright, yet it is a compelling point of focus. This little spot of color becomes the center of interest because it is different from all the other colors in the shot and, isolated by that uniqueness, draws the viewer's eye.

Technical Data:
Mamiya RZ 67 II, 250mm telephoto lens, no. 1 extension tube, ½ second, f/22, Fujichrome Velvia, tripod.

Color Harmony

Colors that are adjacent to each other on the color wheel, such as yellow and green, are generally harmonious. Color harmony is another way of creating visual impact, although the impact is more subtle than that of contrasting combinations. It's useful for emphasizing the sameness of elements in a scene and creating a sense of unity. Harmonious colors can evoke feelings of peace or romance. Color combinations such as dark green and beige, navy blue and gray, and lavender and mauve are soothing to the eye. Sometimes flower arrangements, whether wildflowers in a field or cultivated flowers in a shop, blend together in a calming and satisfying way. A shot of a young blonde girl with fair skin dressed in a pastel shade of pink, with its complementary yet harmonious colors, is romantic. These types of photographs are often sold as greeting cards and calendars.

Muted Color

Some of my favorite images are those that have only muted colors. Soft lighting, desaturated color and low contrast produce exquisite shots that can be just as expressive as those with strong colors. In nature, muted color is a common occurrence. On overcast days, the low lighting reduces the saturation of the colors of vegetation, rocks, bodies of water, mountains and even wildlife. In the East and Midwest, during the winter months, the leaden gray skies mute even snow-covered trees. I took an entire series of photographs in the Upper Peninsula of Michigan at Tahquamenon Falls during one of these days. The combination of white trees and huge icicles was like shooting art in nature.

Even when the sun is shining, many nature photographers prefer to shoot with muted light. I usually carry with me a large diffusion disc (Photoflex makes several that fold into small, round zippered cov-

ers) to soften the sunlight so my subjects—usually wildflowers, leaves or insects—will appear more muted in color.

Color Key

High-key images have only pale, bright tones, and the sheer brilliance of the light itself is eye-catching. There are few shadows or even midtones. This lighting is created naturally by fog, mist, or reflective surfaces such as snow, sand and water. High-key images generally convey a sense of lightness, heat, delicacy and happiness. A low-key image has only deep, dark tones. There are many shadow areas but few highlights. The dark tones are actually a product of the light quality. Low-key images generally seem mysterious, dramatic and dark.

One way to create impact with color is to fill the frame with a single, intense color. When relying on a single color to deliver the impact, it shouldn't be a color of ordinary saturation. Instead, it should hit you in the face, so to speak. There can be other colors in the shot, too, as long as they don't dilute the power of the color that's making the shot successful. This shot was taken in the port of Motril, Spain. The side of the ship was painted a rich, bright blue, and I thought the pattern created by the ladder and its shadow made an interesting design. Notice how the black shadow not only repeats but emphasizes the graphic lines of the ladder. Without this, the color isn't enough to make the picture work. Both elements—the color and the design—are necessary for a successful image. Bold color without an artistic design doesn't have enough impact. The harsh sunlight actually aids in making this photo interesting. The intensity of the blue color and the perfectly placed shadow result from the brilliance and direction of the midday sunlight.

Technical Data:
Mamiya RZ 67, 250mm telephoto lens, 1/125, f/8, Fuji-chrome Velvia, tripod.

Doors often provide interesting graphic designs. This windmill was photographed on the Greek island of Mykonos. The whitewash of the mill and the pastel blue-gray sky provide an almost colorless environment that contrasts sharply with the bright blue door. The fact that the sky has a cold, bluish cast is a tie-in with the door and helps pull the picture together. Although the composition in this picture is graphically pleasing, the entire success of the photograph is due to the impact of the bold color of the door.

The position the door occupies in the frame is an important part of the success of the picture. Because it looms large in foreground, it leads the eye into the frame. This means, of course, that depth of field is an important consideration here. If I had hand-held the camera, the door would have been my point of focus and, even though I was using a wide-angle lens, which has enormous depth of field, the background would have been less than sharp. There wasn't enough light for me to use a lens aperture small enough to render the entire frame critically sharp at a shutter speed fast enough to hand-hold the camera. A tripod allowed me to use f/32 to ensure maximum depth of field.

Technical Data:
Mamiya RZ 67, 50mm wide-angle lens, 1/8, f/32, Fuji-chrome Velvia, tripod.

Making Powerful Statements With Color **67**

The red maple leaves you see in this shot were placed on a rock next to a small stream in southern Vermont during the peak of autumn foliage coloration. The long exposure blurred the moving water, which adds an ethereal quality to the image, but it is the brilliant red leaves that make the photo work. Since bright colors seem to jump out at you from the picture, they seem nearer to you, and much more significant than the muted tones. Note also how the leaves balance the composition with the blurred water.

Technical Data:
Mamiya RZ 67, 250mm telephoto lens, 4 seconds, f/22, Fujichrome Velvia, tripod.

When you shoot a monochromatic subject, pay attention to its graphic design, texture, lighting and dimensionality. These qualities, along with the color, will make or break the photo.

The Grand Palace in Bangkok, Thailand, is one of the most spectacular architectural wonders in the world. The complex is ablaze with color, but here I focused on a monochromatic design in gold.

Several aspects of this image make it successful. First, the range of tonalities is dramatic. From highlights to black shadows, the late afternoon sun softened by the mist of high humidity provided dimensionality that almost looks like a bas-relief. Second, the angle of the light relative to the stupa introduces a rich texture that enhances the design. Notice how the side lighting causes an attenuation of light from one side of the image to the other. And third, the gorgeous design of Thai architecture makes the monochromatic subject fascinating to study.

Technical Data:
Mamiya RZ 67, 350mm APO telephoto lens, 1/15, f/22, Fujichrome Velvia, tripod. The exposure was determined by taking an incident light reading with a Minolta Flash Meter IV. I feared that a reflective reading off the gold color would not be accurate due to the brilliant reflection of the sunlight.

In the old town of Prague, the Czech Republic, I was about to photograph this door when a small boy ran up to it, played with the knocker for a few moments and then retreated to the safety of his mother. I instantly recognized the artistry of the situation but wasn't quick enough to capture it on film. I went over to the boy's mother and, using my interpreter, asked her if she would have her son repeat his actions. He did, and this time I was ready. I set up my camera, took a light reading and prefocused on the right spot. When the little boy knocked on the door, I made several exposures.

If the child had been wearing a coat that was dull blue, I probably never would have taken this shot. The splash of color in the otherwise muted environment, plus the cute subject, makes this a successful image. Note also the contrast between the child's small stature and the size of the huge door. In addition to the color, this also helped make this shot work. Had the boy been an adult, this photograph would have been very different, and probably not as successful.

Technical Data:
Mamiya RZ 67, 250mm telephoto lens, 1/60, f/4.5, Fujichrome Provia 100, tripod.

I created this image as a conceptual shot for my stock-photo agency, Westlight. The concept is "Mexico." I chose the brightly colored subjects to maximize the impact and make the image as salable as possible. Using a number of rich, bright colors in one shot creates a lively, upbeat mood. I thought clients who use travel brochures and print ads to entice tourists to Mexico would find the shot appealing, and in fact it has sold several times.

Red is a powerful color and especially good for attracting a viewer's attention. The diagonal lines of purple, green and white juxtaposed with the red make this photograph visually arresting. I used the film Fujichrome Velvia, rated at ISO 40, because it renders color with additional intensity. Even though the saturated colors of the serape dominate the image, they also call attention to the neutrally colored sombrero simply because it stands out against the background color.

Technical Data:
Mamiya RZ 67, 110mm normal lens, 1/125, f/16, Fujichrome Velvia, Speedotron 2403 Power Pack, two flash heads, two Photoflex soft boxes, tripod. The exposure was determined with a Minolta Flash Meter IV.

I am always on the lookout for brilliant combinations of color. They can suddenly be right in front of you when you least expect it. I came upon this colorful group of what I call "interracial teddy bears" in an amusement park. There is a fine line between capturing the vitality of striking color combinations and introducing confusion with too many conflicting elements of color. These colors work together because they share tonalities (all are at the cool end of the spectrum), and this helps hold the image together.

They were in deep shadow under an overhang, which meant I needed a flash to bring out the wonderful color. I didn't want to use a tripod and make a long exposure, because I was concerned that the bluish quality of the shadows would shift the color balance. Bluish tonality can be quite effective in some circumstances, but it can also alter the colors in a way that is unflattering to the original hues. In this case, the striking dyes in the teddy bears were too beautiful to allow a shift.

I moved back and used a telephoto lens; otherwise I would be looking up at the teddy bears at a severe angle, which would distort the composition and cause depth of field problems. Using a telephoto lens from several feet away, the film plane could be more parallel to my subjects to ensure maximum depth of field.

Technical Data:
Mamiya RZ 67 II, 250mm telephoto lens, 1/125, f/11, Metz 45 CL flash, Fujichrome Velvia, handheld.

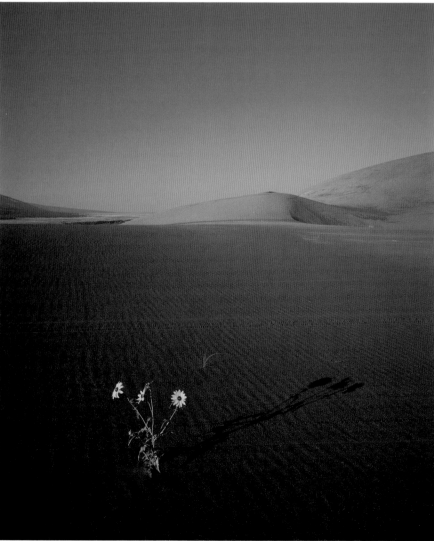

When you compare these two pictures, it becomes obvious how effective a single colorful element can be. They were taken on the Great Sand Dunes National Monument in Colorado in the early morning. The photo on the left isn't a bad shot, but it doesn't have the impact of the photo below, where the expanse of earth-toned dunes, darkened by overnight airborne moisture, contrasts sharply with the single prairie sunflower. In the first image, there are many focal points; in the second, there is only one. A single focal point in a photograph usually (but not always) makes a much more powerful statement.

Notice the placement of the flower in the composition. The intersections of the vertical and horizontal imaginary lines that crisscross the frame in thirds like a tic-tac-toe game are the prime locations in a photo where you will never go wrong in placing the subject. This doesn't mean the subject can never be placed in the middle of the frame or that subjects that are not positioned in one of the four intersections will be compositionally incorrect. But this type of artistic design is generally considered to be the strongest.

Flower photography requires infinite patience because the wind is so often a problem. Even if there is a slight breeze, delicate flowers move ever so slowly, just enough to cause a blurred image. If your goal is a critically sharp photograph, you have to watch the flowers through the viewfinder and wait until there is a break in the wind. Since flower photography usually involves slow shutter speeds and small lens apertures for maximum depth of field, windy days make it impossible to shoot. Early morning, before the sun comes up, is the best time for flower photography, because the air is often very still.

Technical Data:
Both photos—Mamiya RZ 67, 50mm wide-angle lens, 1/8, f/22, Fujichrome Velvia, tripod.

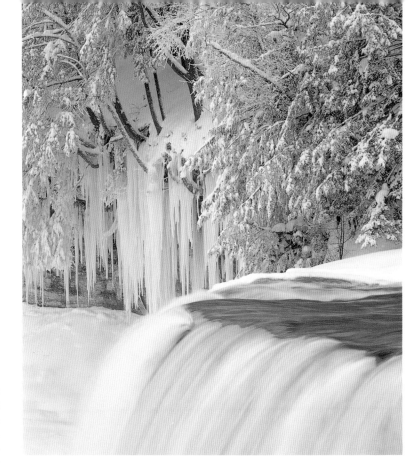

Harmonizing colors make a photograph pleasing to view. Colors that harmonize are usually from the same family: for example, blue/purple/magenta and orange/yellow/red.

In nature, it's impossible in most instances to create color harmony, because you can photograph only what already exists. Only by choosing the composition do you make a selection. In commercial, fashion or studio work it is easy to harmonize colors because you have total control over the various components being photographed.

The photo above shows a portion of Tahquamenon Falls in Michigan. The butterscotch color in the falling water is a result of tannic acid given off naturally by decaying trees upstream. Notice how the yellowish water contrasts with the bluish white trees and icicles. These two colors don't really harmonize together, although both are desaturated and therefore not as harsh together as they might be. In spite of this, I happen to like this image very much.

On the right is a shot of the Alaska Range at twilight and a silhouetted caribou. The mauves, purples and soft bluish tones harmonize perfectly together. I couldn't have made the colors in this image better if I had chosen them from a painter's palette. Even the snow-capped mountains have a purple cast.

Technical Data:
Tahquamenon Falls—Mamiya RZ 67, 350mm APO telephoto lens, 1/2 second, f/22, Fujichrome Velvia, tripod. Alaska Range—Mamiya RZ 67, 350mm APO telephoto lens, 1/125, f/5.6, Fujichrome Provia 100 pushed two stops, tripod.

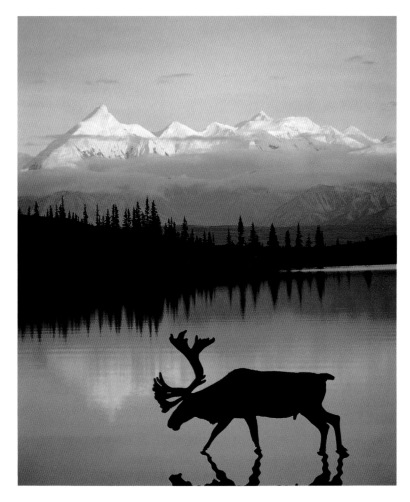

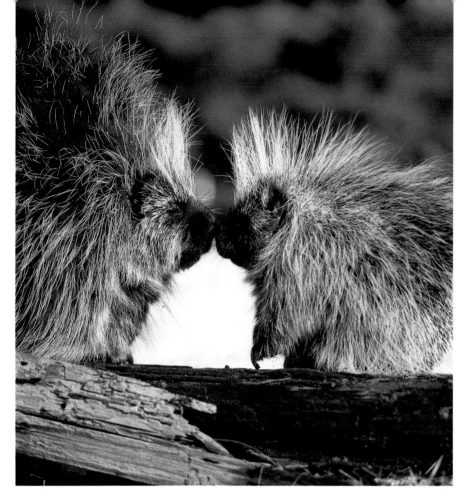

Bold color combinations such as purple and lime green or orange and blue are electrifying. But subtle combinations of color such as the two earth-tone shades seen in this mother and baby porcupine are simply elegant together. When shooting wildlife, it's obviously impossible to choose specific color combinations. You must shoot what you find and hope your composition has artistry in its graphic design as well as in the juxtaposition of colors.

This image is particularly interesting for a few reasons. The interaction between the two animals is endearing, of course, but notice the background colors. The dark green out-of-focus forest allows us to focus our attention on the porcupines, while the white snow, seen only in the center of the frame under their noses, leads our eye to the most important part of the picture—"the kiss."

When you are shooting fast, this kind of analysis is obviously impossible. However, after the fact, it is rewarding to find such a wonderful composition where all the elements perfectly fall into place.

Technical Data:
Mamiya RZ 67, 500mm APO telephoto, 1/250, f/5.6, Fujichrome Provia 100, tripod.

Some images offer maximum impact when they are subtle. Indeed, it is the subtlety itself which is so powerful. One of my favorite nature photos is this winter shot of a cliff face adjacent to Tahquamenon Falls in the Upper Peninsula of Michigan. An overcast sky provided soft illumination, devoid of harsh shadows, which created a lovely blend of muted colors. Winter is an ideal time for finding muted tones in nature. The leaden gray skies of the East and Midwest all throughout winter may be emotionally depressing, but they can provide some great photography.

Making a correct exposure reading was difficult because there was virtually no medium gray. I was shooting from across the frozen river in a forest, and the light falling on the camera position was different than that hitting the cliff face with the ice. Therefore, an incident meter couldn't be used. Instead, I used a Minolta Spot Meter F, which offers one-degree sensitivity. I placed the meter's target circle on the gray stone between the icicles and used that as the medium gray region of the frame.

Technical Data:
Mamiya RZ 67 II, 350mm APO telephoto lens, ½ second, f/22, Fujichrome Velvia, tripod.

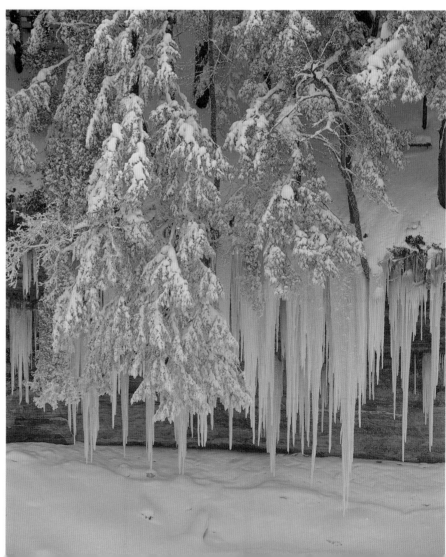

Muted colors can be caused by conditions other than an overcast sky. Deep shadows also produce soft colors, even though the sun might be shining brightly elsewhere.

This Nile crocodile was actually photographed at sunrise, when golden light flooded the landscape in Kenya. However, a large rock kept the reptile in the shade, protecting it from the yellow light and creating muted earth tones for my composition.

The problem, of course, was that the light was about two f/stops darker than the sunrise lighting. Since I was shooting the crocodile head on, I was going to have serious depth of field problems. Shooting from a Land Rover with a beanbag for support, a slow shutter speed and small aperture seemed out of the question. But I wanted the entire animal in focus, so I asked my driver to turn off the motor and remain very still. I nestled the Mamiya into the beanbag, composed the shot and then made a 1-second exposure, with a cable release, at f/32. Reptiles don't move when they are cold, so I could risk the long exposure. I took three shots, holding my breath, and all of them are tack sharp.

Technical Data:
Mamiya RZ 67, 350mm APO telephoto, 1-second exposure, f/32, Fujichrome Provia 100; a beanbag resting on the open window of the Land Rover steadied the camera.

High-key lighting gives an image a unique quality because of the eye-catching brilliance of the light. This sea lion on a beach in the Galápagos Islands was playfully inviting a close encounter, so I walked within ten feet of him and composed the shot with a wide-angle lens. The width of the lens let me include the background in the frame, plus the sun and its reflection on the ocean and the entire length of the animal's shadow. I wanted the whole shadow because its graphic contribution to the composition helps make the photo distinctive.

Notice how the sky around the sun is entirely washed out. Had I exposed for the bright sky, the sea lion would have been a black silhouette, and the delicate color in the water would have been lost to underexposure. It still might have been a good photograph, but I wanted to capture the experience of a glorious morning on a perfect, white sandy beach. A darker version of this image wouldn't have done that. Only the high-key version really communicates what I saw and felt.

Technical Data:
Mamiya RZ 67, 50mm wide-angle lens, 1/125, f/11–f16, Fujichrome Provia 100, handheld. Normally I use a tripod, if possible, but the active sea lions were constantly in motion and my tripod would have been an inhibiting factor.

A low-key image is one where the tonal values are dark and somber. It's a function of light rather than color, although darker colors are usually associated with low-key images.

This lava heron was stalking small fish in a tide pool in the Galápagos Islands. It's a very unusual low-key photograph. The sun was bright in the sky and illuminating the bird, as you can see from its shadow. However, the tonal values are quite low because the gray-black feathers of the bird and the lava rock absorb so much of the light.

The correct daylight reading with ISO 100 film in bright sun is 1/250 and f/8 plus $^2/_3$ f/stop. Had I used those settings, the bird would have been hopelessly underexposed. When shooting black subjects, I always open the lens aperture one full f/stop when my light reading was determined by an incident meter. A reflective TTL meter, on the other hand, should give you the corrected shutter speed and aperture combination.

Technical Data:
Mamiya RZ 67, 350mm APO telephoto lens, 1/125, f/8 plus $^2/_3$, Fujichrome Provia 100, tripod.

▶ The color and tone of the background play an important role in the overall impact of a photograph. Neutral-color backgrounds, like dark gray rocks and forest greenery, help emphasize a bright subject, while lighter backgrounds can do the same with a neutral-toned subject.

The photo on top was taken at the famous Khmer ruins of Angkor Wat in Cambodia. The neutral color of the twelfth-century stonework directs all your attention to the brightly attired dancers. Had these two figures been photographed in front of a wall of brilliant flowers, the background color would not only clash with the subjects, but it would also compete for your attention as you studied the image.

A similar situation can be seen in the photo on the far right of page 77, but instead of a dark gray background of rock, jungle foliage provides the muted backdrop that concentrates attention on the archery lesson in Irian Jaya, the Indonesia portion of New Guinea. Notice how you really can't focus on anything in this picture except the painted faces of the father and son.

The photo at the bottom functions similarly but the tonal relationships are reversed. The white background of snow directs your eye to the design of sand and the dried desert flower. This shot was made in the Coral Pink Sand Dunes National Monument in Utah as the snow was melting. Because the snow has very little texture or form, the composition really forces you to look only at the neutral-toned graphic form.

Technical Data:
Dancers—Mamiya RZ 67, 110mm normal lens, 1/125, f/8, 45CL Metz flash, Fujichrome Provia 100, tripod. Father and Son—Mamiya RZ 67, 250mm telephoto lens, 1/30, f/4.5, Fujichrome Velvia, tripod. Flower in Snow—Mamiya RZ 67, 110mm normal lens, #1 extension tube, 1/4, f/22, Fujichrome Velvia, tripod.

Changing Color After the Fact

Once an exposure is made and the film is developed, that color image is fixed and unchangeable. However, you can manipulate the colors of an original slide to correct, alter or improve a photograph once it has been taken. These changes are made on a duplicate of the original image. You can make subtle changes in skin tone, add warmth to a landscape and even intensify the colors in a sunset. These changes can be used to correct an unwanted color shift, such as a portrait taken in open shade that turned out too blue, or they can be a creative tool to add impact and drama to a shot. Increasing the color saturation of a flower garden, for example, will make it virtually jump off a slide screen or the printed page. Adding mauve and lavender hues to a sunset may not represent what you saw with your eyes, but it could turn an ordinary photograph into an extraordinary one.

Making Changes

There are two techniques for altering color after the fact: darkroom manipulation and digital image editing on a computer. I will discuss both of these methods in detail to give you an appreciation of the tools at your disposal. You can achieve a great deal with both techniques, but there are limitations to what can be done.

A bad picture is a bad picture. No amount of darkroom or digital work can transform a poor photograph into a striking one by altering color or contrast. Don't rely on after-the-fact modification to salvage bad images.

Lost detail cannot be replaced. When a slide is overexposed and the highlights have been washed out, detail is lost. Similarly, in an underexposed slide, shadow detail may be too dark to detect even the most subtle detail. In these cases, no amount of exposure adjustment will bring this information back.

Duplicate transparencies and computer-output transparencies are never as sharp as the originals. Even if you have the best, most expensive optics or electronics and the sharpest original photographs, and you are meticulous in your work, the second-generation images will never be as critically sharp as the originals. They will be very close, and they can be used for reproduction in books, magazines and even posters, but they won't be as good as the first-generation photos.

Although it's not a limitation on your capabilities, you should also remember that you are, in effect, changing reality by altering an image from what you actually saw. Some photographers are adamantly opposed to any manipulation of images, especially those of nature, after they are taken. Others feel that adding or subtracting color and altering contrast is acceptable, but it is unethical to create a scene that never existed. For example, they would be angered if a photographer increased the density of animals in a migration or juxtaposed a polar bear photographed on the Canadian tundra in front of icebergs photographed in Antarctica. People who love the natural world and value scientific realism in photography resist what they perceive as assaults on the integrity of the photograph.

I respect that view. But I also see photography as an artistic medium where one's personal vision of the world can be expressed, including enhancing color or making other changes to an original photo as part of the creative process. I don't want to misrepresent science or nature, but I do reserve the right to use modern tools—darkroom or digital—to create images that please my artistic sensibilities. Determine your own comfort level with manipulation after the fact and act accordingly.

Color Manipulation in the Darkroom

Changing the color balance of a slide is a one-step process. You make a high-quality duplicate of the original slide, and with the use of color filters you achieve the desired color shift.

You can create dupes from any size film. When my original image is 6×7cm, I always make a 1:1, or 6×7cm, duplicate. When I shoot 35mm, I will make either a 35mm or 6×7cm dupe. 35mm dupes are less expensive and quicker to make. Even when the original image is 35mm, however, it is often better to make a medium format duplicate than a 35mm dupe. My stock-photo agency taught me many years ago that "bigger sells better." Medium format is more desirable than 35mm, and $4'' \times 5''$ is better still. Many photo buyers believe that the larger image area of a medium format, or 4×5, transparency will reproduce better than a 35mm slide because it will require less enlargement. In addition, it is easier to view a medium format, or 4×5, image without a loupe, and the impact is more powerful than examining a 35mm slide through a $4 \times$ or $8 \times$ piece of imperfect glass or plastic.

When I make a medium format dupe from 35mm, I use the 6×7cm proportion. But I'm forced to crop some of the original on the long dimension, because a 35mm slide is actually proportional to a 6×9cm image. I don't mind this cropping because magazine covers, full-page ads, calendars and greeting cards use images in the 6×7cm proportion most of the time.

MAKING A DUPLICATE SLIDE

A duplicate slide is simply a photograph of the original one. You can make a dupe with inexpensive equipment, or you can purchase an expensive duplicator designed specifically for the purpose of producing high-quality dupes with relative ease.

An inexpensive duplicator for 35mm slides, available for under a hundred dollars, simply replaces the lens on your camera body. It's basically a tube with a slide holder on the end and a diffusing piece of plastic to evenly disperse the light source across the transparency. You point the duplicator at the light source, place corrective filters between the light and the slide and shoot. It works, but the dupes will not be considered high quality. The optically inferior built-in lens is preset at a small aperture, which makes critical focusing very difficult. Dupe slides made with this equipment can be used for slide shows and camera club competitions, but they will not be critically sharp. I no longer use an on-camera duplicator myself because of these quality problems.

I now use a Beseler Dual Mode Duplicator for making 35mm dupes. It has a built-in dichroic head that houses the three color filters (yellow, cyan and magenta) for convenient color alteration. The

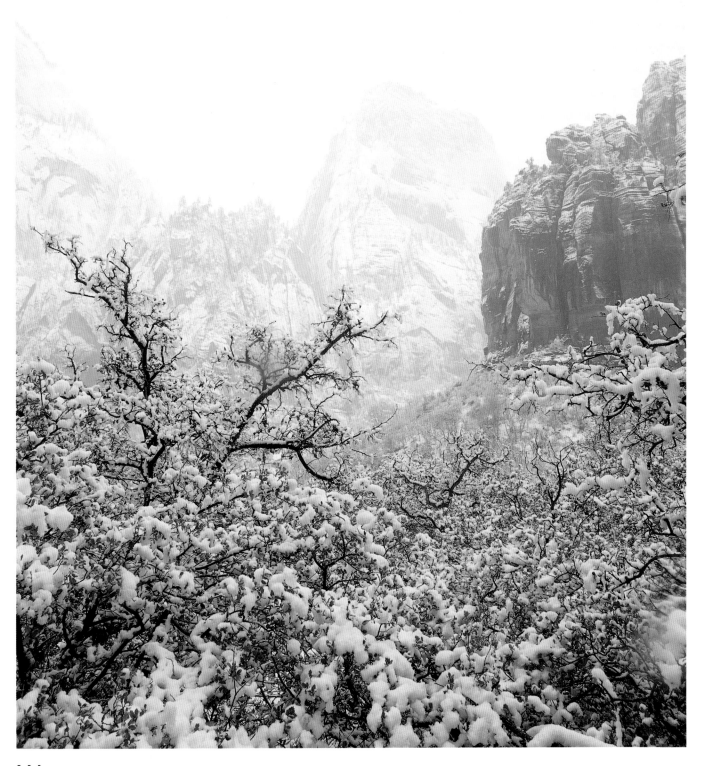

While underexposed slides can often be salvaged in the duplicating process, transparencies that are overexposed by one f/stop or more usually cannot be. This is because detail that has been lost in light portions of the frame cannot be brought back by decreasing exposure.

I took this photograph of the Great White Throne in Zion National Park during a snowstorm. The distant peaks were hardly visible through the virtual whiteout. Had I underexposed the shot, there would be very little gained with respect to increasing detail in the mountains. I would only turn the white sky and snow into gray. Underexposing the dupe in the duplicating process would produce the same result. No additional detail would be seen in the second-generation image, and the whites would become a muddy gray.

Technical Data:
Mamiya RZ 67, 250mm telephoto lens, 1/8 second, f/22, Fujichrome Velvia, tripod.

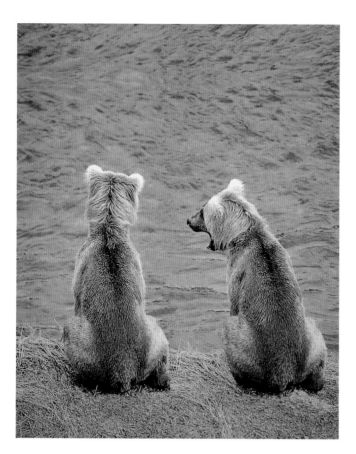

Some photographers feel that one should never photographically manipulate nature. Perhaps they feel that it is an assault on the integrity of the natural world. But photographers have, in fact, been altering the film's view of reality since the inception of photography. Even Ansel Adams manipulated contrast and tonal relationships in his black-and-white prints. Is it wrong then to use a filter that changes the color balance in a slide, such as a warming filter? What about using black-and-white or infrared films to reinterpret full-color nature? If that's all right, then why draw the line at the darkroom?

I don't draw any lines, as evidenced in this pair of pictures. My only agenda is to create a beautiful, artistic image. I will use any tool at my disposal to accomplish this. The original photograph of these bears (left) at the Brooks River in Alaska was taken under overcast conditions. The film recorded exactly what I saw—muted earth tones. I used Adobe Photoshop, a digital image editing program, to increase the saturation of color to satisfy a request by a client. I selected Hue/Saturation from the Adjust pop-up menu under the Image menu. I moved the Saturation slider bar in the dialog box to the right 15 units and got the image you see below. This alteration does not imply anything about the natural world that isn't true. It only makes the colors look like the scene was taken under a bright sun.

Technical Data:
Original image—Mamiya RZ 67, 250mm lens, 1/250, f/5.6, Fujichrome 100D, tripod. Color adjustments made in Adobe Photoshop by moving the Saturation slider bar in the Hue/Saturation dialog box 15 units to the right of center.

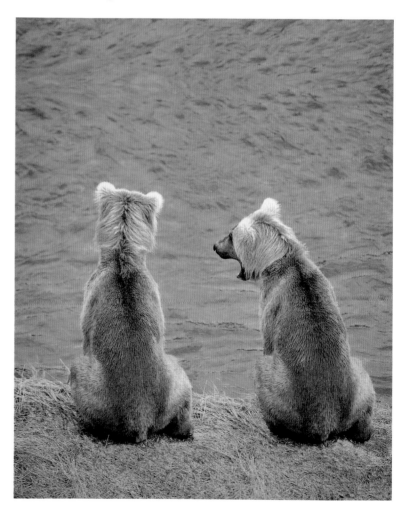

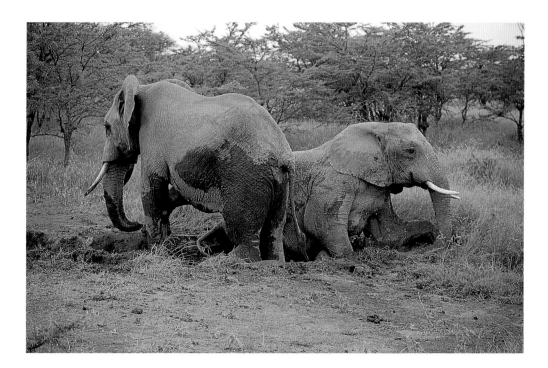

When 35mm slides are duped to 6×7cm, one or both ends must be cropped in order for the entire 6×7cm frame to be filled. Sometimes an original 35mm shot is composed so tightly that cropping would hurt the artistry of the image. In other cases, the dupes look quite good.

This shot of elephants at a mud hole in Kenya was originally shot in 35mm. Duplicating slides into medium format make them more salable, but this picture was composed with little room on either side of the animals. In the 35mm composition, it's fine. But to fit inside the 6×7cm rectangle, both sides of the picture must be cropped. The result is a borderline case where the edge of the frame comes too close to the subject to be truly artistically pleasing.

Technical Data:
Original shot—Canon EOS 1, 50-200mm f/4.5 zoom, exposure data unrecorded, Fujichrome Provia 100, camera rested on beanbag in a Land Rover.

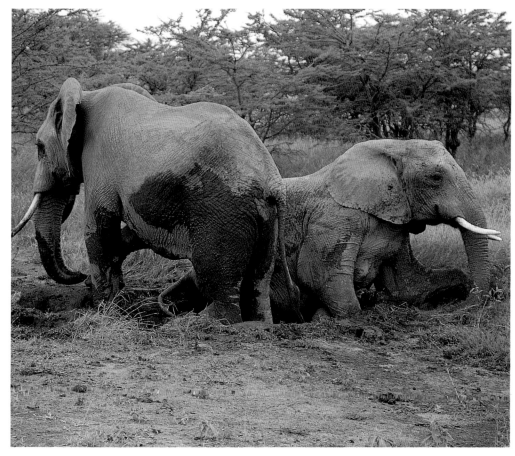

column that supports the camera is calibrated in millimeters, which lets you return the camera to a precise position to repeat a previous operation. There is a bellows that lets you crop closely on any part of the original image. The Beseler unit has two light sources—a tungsten light for focusing and composing, and a daylight-balanced flash for a brief exposure time. This unit is all you will ever need in a duplicator. It costs about $900 without an enlarging lens.

Having all these features on your duplicator makes the process much easier for you. But the single item that determines the sharpness of the dupes is the lens. So, get the best lens you can afford. I use a Rodenstock lens, the APO-Rodagon R 75mm/f4. This lens was recommended to me by my photo lab, whose primary business is making tens of thousands of duplicates for many of the major stock-photo

agencies. Another good choice is the 90mm/f4.5 Schneider APO Componon-HM. The APO-Rodagon lets me make dupes from both 35mm and 6×7cm originals, saving me the expense of buying two quality lenses.

Use compressed air to blow the dust off the original slides before you begin the duplicating process. The air cans available in camera stores work well, but they don't last long and they get annoyingly cold. In addition, there is always the danger of spraying your valuable original with propellant. I discovered that I could buy a small compressed air tank and fill it with carbon dioxide instead, using a cheap airbrush as my trigger. I have more pressure with this setup than with the small air cans, and a ten-dollar fill-up of CO_2 lasts about a year.

The actual technique for duping a 35mm slide is very simple. The original is

placed in the slide holder, while the camera is mounted with a special adapter on the calibrated column. Once you have determined the exposure and filter pack to use, you blow the dust off both sides of the film, focus and shoot as many frames as desired.

The procedure for making medium format dupes differs somewhat from that for making 35mm duplicates from 35mm originals. The film transport device, instead of a 35mm camera, is a 6×7 Beattie film back. This piece of equipment was originally designed to be used with the Mamiya RB and RZ cameras. It holds one hundred feet of 70mm dupe film (or any other kind of 70mm film), which translates into approximately 450 pictures. Beattie Systems, Inc. [(800) 251-6333] will make a frame into which the film back sits, and they will also provide an electronic trigger which advances the film one frame

The Beseler Dual Mode Duplicator has a dichroic color head with three filters (yellow, cyan and magenta) that enables you to dial in any type of color correction. A tungsten lamp lets you focus and compose, while a built-in strobe gives you the option of a brief exposure time and daylight-balanced film.

The Beattie film back, which holds 100 feet of 70mm duplicating film, is placed beneath the enlarging lens when you make medium format dupes. A button switch on a cord plugged into the film back advances the film one frame. This photo shows the dark slide covering the film, and the grain focuser I use for critical focusing. The Beattie back takes the place of a 35mm camera in the process of making 6×7cm duplicates.

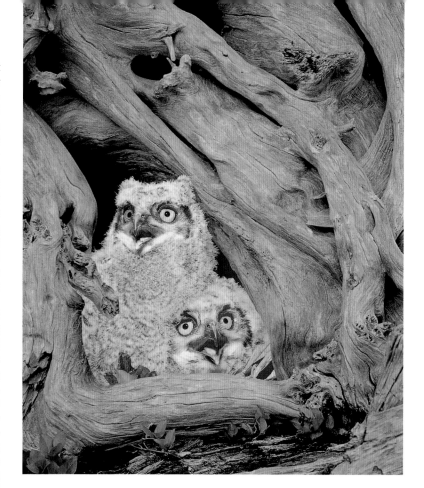

Weather conditions dramatically affect the color of outdoor photographs. Under overcast skies or in the deep shade of forests, blue tones predominate. These cool hues are subtle to our eyes, but color film exaggerates the blueness to such a degree that the original colors are often overshadowed. Sometimes this effect can be quite beautiful, turning an ordinary scene into one with unexpected drama. But other times it is artistically more pleasing to interpret the composition with warm colors. A warming filter on the lens can be used to eliminate the unwanted blue tones, but if you don't have one with you, or you choose not to use it because of the light loss, the correction can still be made in the darkroom.

I took the top photo of young great horned owls in a Washington forest just before it started to rain. It was obvious that a blue cast would dominate the colors in the image. I considered using a warming filter, but the light loss would be $^2/_3$ f/stop. This would have meant that my shutter speed would have been decreased from 1/125 to 1/60 (I couldn't open the lens aperture more because I was already shooting wide open). At that slow shutter speed, there was a possibility that the birds would be slightly blurred. So I took the shot without the filter. When I duplicated the original transparency, I added an additional 8 units of yellow (8Y) and 5 units of magenta (5M) to my color-corrected filter pack. As you see in the shot below, the blue tone is gone, due to the warmer color balance. Even with experience, it is difficult to predict precisely how much an image will be affected by a change in the filter pack. If you are not confident about how much filtration to add or subtract, try two or three different packs when duping the original and study the results. This will develop your ability to approximate the degree of change, but your final judgment will be made when the film comes back from the photo lab.

Technical Data:
Original shot—Mamiya RZ 67, 250mm telephoto lens, Fujichrome Provia, 1/125, f/4.5, tripod. Correction made in the darkroom by increasing yellow and magenta in the color-corrected filter pack (corrected to match the original).

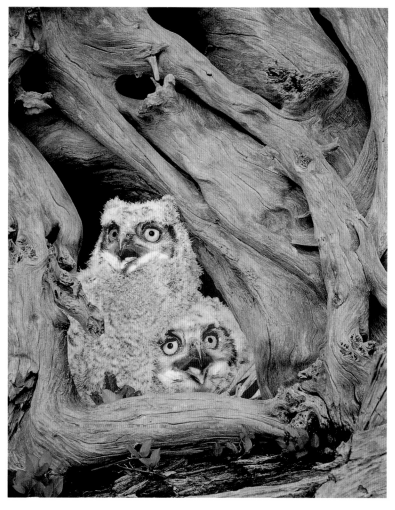

at a time. There are other methods of exposing medium format dupe film, but the Beattie back lets you easily make large quantities of high-quality dupes.

You will need a digital timer, because each exposure has to be exactly one second. An analog timer is not precise enough for the job. You must also have a grain focuser, because it allows you to focus accurately on the grain of the original piece of film. I couldn't find a grain focuser that would fit within the 6×7 cm opening on the Beattie film back, so I took mine to a local machine shop and they trimmed the base of the focuser to fit.

DETERMINING EXPOSURE AND FILTER PACK

You can't use just any film for duplicating. Use only duplicating film that is specially manufactured to minimize the unwanted gain in contrast typical of the duplicating process. If you use a conventional film such as Kodak's E-100 or Fujichrome Provia for the dupe stock, the dupes will be too contrasty. Shadows will go black with no detail, and highlights will be washed out. I do all my duping on Kodak Ektachrome Slide Duplicating Film 5071, which is perforated along both sides. It comes in rolls of 36 exposure for 35mm, and it is available in 70mm by 100 feet for medium format.

Contrast is always gained in duplicating. Even though the Kodak Ektachrome Duplicating Film is designed to minimize contrast gain, a certain amount is unavoidable. Some duplicator units have a prefogging device that puts a subtle flash of light onto the dupe film before or after the main exposure is made. The theory is that this small amount of white light will fill in the dark shadows and lower the contrast. I don't think this works very well, and I never use it.

In order to get the correct exposure and filter pack for the dupes, you will have to sacrifice at least one roll, and probably two or three, to the testing procedure. First I

determine the exposure. I select a correctly exposed slide, place it in the slide holder and turn on the built-in tungsten light source. Since duplicating film is tungsten balanced, I don't use the flash capability of the Beseler unit.

I set the APO-Rodagon lens at f/8, one stop down from wide open, for maximum sharpness (this works for all lenses), and then I make exposures from 1/125 down to ½ second. I usually find that 1/15 or 1/30 is correct on my system. Use a cable release and the mirror lockup feature on the 35mm camera to eliminate vibration.

Testing for color balance is more challenging than determining exposure. Dupe film, unlike normal daylight or tungsten film, requires a filter pack. This is a combination of magenta, cyan and yellow filters that, in conjunction with your light source, produces color in the dupe that accurately matches the color of the original slide. If you are using an inexpensive duplicator and don't have a built-in dichroic color head, CC (color-compensating) filters are available as inexpensive gels that can be placed in the light path to affect color balance.

Each roll of duplicating film comes with a Kodak-recommended filter pack printed on the box, 05C + 15Y (five units of cyan plus fifteen units of yellow), for example. You always have to modify the pack to make a perfect match between the original and the dupe. When the roll of film is developed, compare the dupes you made using the recommended filter pack with the original slide. Try to estimate how much correction—the addition or subtraction of units from the filter pack—is needed to have the dupes accurately match the colors of the originals.

If you have a duplicator or enlarger with a built-in dichroic color head, you can add and subtract units of color by simply turning the cyan, magenta or yellow dial, or any combination of these colors.

With the less expensive duplicators or

black-and-white enlargers, you must place gelatin filters in the light path to affect the color. Gelatin filters come in designated units of color saturation: e.g., 2.5 units, 5, 10, 20 and 40.

You can purchase a Color Printing Viewers Filter Kit that uses graduated filters to help you decide in which direction you need to adjust the filter pack. You view the dupe through the kit's filters, going back and forth between the two or three gradations that seem to be the most likely correction. If the dupe appears closest to the original when you are looking through the "10 green filter," then you will have to add 10 units of cyan and 10 units of yellow, which equals 10 units of green. Develop the film and check the results. This may be the match, or perhaps you still need to add 6 units of cyan and reduce the yellow by 2 units. Whatever you determine, make a second test, and a third if necessary, until the dupe matches as closely as possible. If color correction is a skill you just can't master (most photographers—even pros—can't do it), custom labs employ skilled technicians who can help you in this daunting task. It's a free service if you regularly use the lab to process film. They will study your dupe and the original on a color-corrected light table and suggest how much filtration to add or subtract.

Once the correct filtration is determined by testing, it can be used for the entire roll of dupe film, plus any other rolls of dupe film that bear the identical emulsion number. I purchase several rolls at the same time to make sure the emulsion number is identical on all rolls. If you change the bulb in the duplicator, however, you will have to retest to establish a new filter pack.

The same testing procedure is necessary for the 70mm dupe film used to create medium format dupes. Once the original is placed in the enlarger, project it down onto the Beattie film back, size it correctly and then focus. You will have to sacrifice

Any of your color slides can easily be converted to the classic sepia-toned look usually applied to black-and-white prints. The photograph of the frigate birds above was taken in the Galápagos Islands off the coast of Ecuador. The birds were following the boat, so they were easy to shoot as they glided on the wind.

Sepia is a cocoa brown color which, according to the photographic color wheel, is actually a dark orange. You make orange by combining the yellow and magenta filters built into duplicating units and enlargers. In equal amounts, yellow and magenta make red. To move the color closer to orange, you have to add additional yellow. Using my medium format duplicating setup, I made a 6×7cm duplicate and added 12 units of magenta (12M) plus 18 units of yellow (18Y) to the color-corrected filter pack. I underexposed ½ f/stop of light to darken the orange to the brownish sepia.

Technical Data:
Original image—Mamiya RZ 67, 350mm APO telephoto lens, 1/250, f/5.6, Fujichrome Provia, handheld. Color change made in the darkroom by increasing yellow and magenta in the color-corrected filter pack.

one frame of film for each new picture you duplicate because the dark slide protecting the film from light must be pulled open to allow accurate focusing by the grain focuser. Then turn off the lights (no safelight is permitted) and make your test exposures. Use precisely a one-second exposure but vary the f/stop in ½ stop increments. My current setting is f/8, but yours may be different.

You test the filter pack the same way you would test it for 35mm dupes. When you've completed your test shots, open the Beattie film back (in total darkness) and snip the 70mm film to separate the exposed portion. Place the strip with the exposed frames in the light-tight can that held the 100 feet of dupe film, use black electrical tape to seal it closed, and take it to a local lab (or process it in E-6 yourself). Ask a lab technician to suggest a corrected filter pack if you're having trouble determining this yourself. If you switch from making medium format dupes of a 6 × 7cm original to using a 35mm original, the filter pack will be unaffected but the exposure will change. You'll have to make another test.

MAKING SUBTLE CHANGES IN COLOR

The filter pack for making identical transparencies that you've taken so much trouble to determine is only the starting point. Now you can change the colors into the ones you desire. For example, if a landscape was photographed under a deep overcast sky and the colors are too cool—or bluish—you can introduce a warmer color balance to the shot. Conversely, if you were shooting a model at sunset and the low-angle light on her skin and clothing gave them a yellowish cast, you could add cooler tones to the image to neutralize the effect of the light.

You can combine the three built-in filters—yellow (Y), cyan (C) and magenta (M)—in your enlarger or slide duplicator to produce virtually any color in the spectrum. Once you determine what color should be introduced, you can dial in the appropriate filters. For example, to eliminate the bluish cast in a landscape photo, you must add yellow, because it's the complement of blue. The amount of yellow you add depends on your personal taste. Some photographers prefer a warmer bias to pictures; others like the cold, austere feeling of bluishness. Or you may want to introduce a color (for example, red) to add punch to red elements in the composition. If the filter pack you're using is, say, 11 cyan and 14 yellow (11C + 14Y), you might want to add 7 units of yellow (7Y). This would make the new pack 11 cyan and 21 yellow (11C + 21Y). You could also make two dupes, one with an addition of 7Y and the other with an addition of only 3Y (producing 11C + 17Y). This would give you two choices.

Let's take another example, one in which you want to enhance existing colors rather than correct them. You have an image of a beautiful sunset, but you would like to increase the saturation of the colors to make the shot more striking. The colors of sunset can range from mauve to orange to brilliant yellow or even red. What filter combination do you use? That depends on the effect you want to create: There are many possibilities. If you want to inject mauve, you must add some combination of magenta and cyan. To add orange, red and yellow must be increased. If you want to add red-orange, you would add more red than yellow in the new filter pack.

Here's how the numbers would look, again using 11C + 14Y for our starting point. For a subtle change toward mauve, you could add 7 cyan (7C) and 9 magenta (9M) to the original filter pack, making it 18C + 14Y + 9M. You could add a dramatic infusion of mauve with 20 cyan (20C) plus 25 magenta (25M). After the correction for a dramatic mauve increase, the new filter pack is 31C + 14Y + 25M.

With large amounts of filtration such as this, the exposure times must be adjusted accordingly. For example, tests with my enlarger show that 90 units of any single color, or of the total of any combination of colors, reduces the light by one f/stop. That means a longer exposure than the manufacturer's recommended time of one second. This could cause an unwanted color shift in the dupe. How do we reduce the exposure time and still get the effect we want? When equal strengths of all three filters are combined, you get white light. Therefore, if we subtract the same amount from each color to reduce the amount of filtration required, the final transparency will be unaffected with respect to color balance. In our example, if you subtract 14 units of color from each filter in our pack of 31C + 14Y + 25M, the final filter pack is 17C + 11M (+ 0Y). Subtracting 14 units of color from each filter reduces the amount of filtration that stands between the light source and the original transparency.

There is a catch to this color correction, however: *When making duplicate transparencies, color correction is applied to the whole image.* A shift in color affects all of the elements in the shot. The addition of 10 units of magenta to a sunset, for example, will cause a shift in all the clouds and sky toward the magenta-purple part of the spectrum. (If you want to change the color balance in only one part of the image—for example, the subject, without affecting the background—this can be done well only with a digital image editing program on a computer, as described on pages 92-96.)

CHANGES IN DENSITY

The duplication process can also be used to rescue underexposed or slightly overexposed slides. You can't bring back detail that isn't in the original piece of film, but by altering the exposure by one-half or one full f/stop, significant improvements can be made in poorly exposed originals.

Underexposures can usually be duplicated with the additional exposure and

Photographing the sensual dancers during Carnival in Rio de Janeiro, Brazil, was one of the most challenging shoots I've ever done. It is held at night, and the main parade route is illuminated with mercury vapor lights. To our eyes, mercury vapor lighting appears white, but to color film it is seen as blue-green.

I wanted to capture the action of the participants by implying motion. At night, this can be done with a flash-blur, which is a long exposure during which the camera's flash is triggered. The short duration of the strobe freezes the action, while the long exposure, 1/2 second in this case, allows the movement of the subjects to blur over their frozen image. The original image (right) turned out very successful, but the 1/2 second exposure picked up the blue-green illumination from mercury vapor.

Using my medium format duplication technique, I added 10 units of magenta (10M) and 4 units of yellow (4Y) to the color-corrected filter pack. Magenta and green are complements, so the former neutralizes the unwanted green color. I added the yellow filtration to counteract the blue portion of the undesirable cast. It takes some experience to know how much filtration of what color to add to achieve the desired effect. Through trial and error and detailed note taking, you can learn how the dupe film responds to changes in your filter pack.

Technical Data:
Original image—Mamiya RZ 67, 110mm normal lens, Metz 60 CT-2 flash, 1/2 second, f/5.6, Fujichrome 100D, handheld. Color correction was done during duplication in the darkroom by adding magenta and yellow to the color-corrected filter pack.

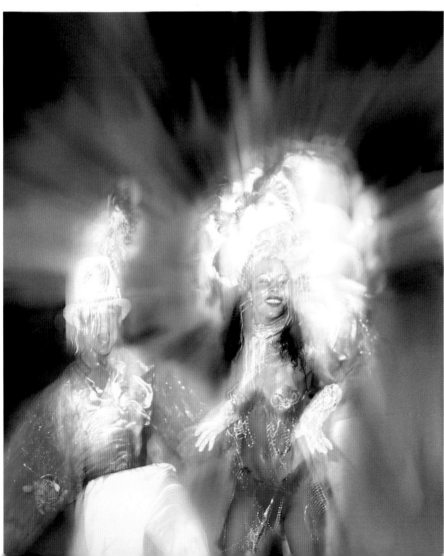

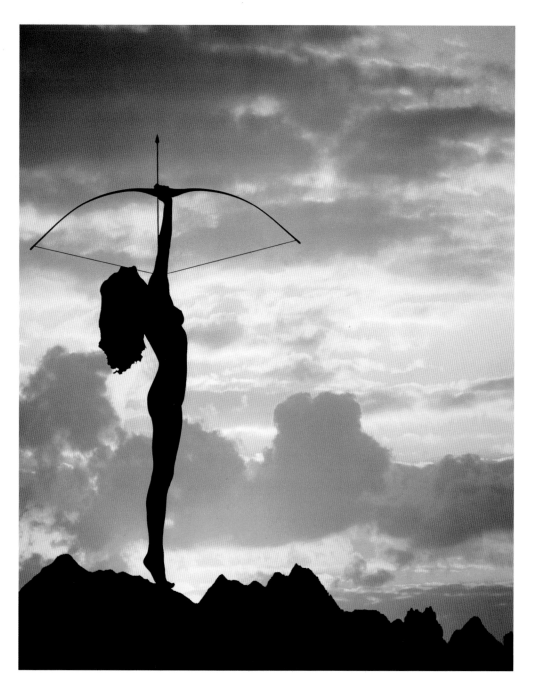

With the addition (or subtraction) from the corrected filter pack, any shift in color is possible. The original sunset silhouette, on the left, really doesn't need any additional color to be dramatic. But many times advertisers want extra punch in the colors reproduced in print ads, so it's important to know what you can accomplish and how to do it.

Sunsets are usually enhanced toward the orange or magenta part of the spectrum. To add orange to the background (top right), I added 14 units of yellow and 7 units of magenta to the corrected filter pack. Orange is a combination of yellow and red, but red filters are not used in darkroom work. Red is magenta plus yellow, so a ratio of 2:1, yellow to magenta, will equal orange.

To shift the background toward magenta-purple (bottom right), I started with the corrected filter pack and added 12 magenta and 4 cyan. Magenta and cyan make blue. Blue and magenta make purple. Hence, I added mostly magenta with a small amount of cyan. I knew this would give me magenta with a slight amount of purple.

I experimented with the filtration until I liked the result. From experience I had a general idea what to add, but the precise shade of color can't be predicted. I judged the film when it was developed. I tweaked the color by repeating the duping process after adjusting the filter pack.

Technical Data:
Original image—Mamiya RZ 67, 110mm normal lens, 1/125, f/4, Fujichrome Velvia, tripod. Color enhancement was done during duplication in the darkroom by adding magenta and yellow to the color-corrected filter pack for the top right image and by adding magenta and cyan for the bottom right image.

turn out quite well. I usually increase the exposure one-half or one full f/stop to lighten the dupe. This can be done by opening the lens aperture or by increasing the exposure time. Since the dupe-film exposure recommendation by Kodak is one second, I always make any adjustments in exposure using the aperture on the enlarging lens. When you do this, the colors in the original that looked dull due to the underexposure will surprise you in the dupe. They will probably be as bright as you originally saw them.

Overexposed slides, on the other hand, are harder to fix, because the detail in highlights is usually lost—when you darken a white portion of the picture, you haven't gained anything. Any slide that is one f/stop or more overexposed can't be satisfactorily corrected.

Digital Color Manipulation

Many photographers are excited about the ability to alter photographic images with computers. There seems to be no limit to what can be done. One of the primary advantages of a computer is that you can see how the original photograph is being affected without waiting to develop the duplicate film. On the computer monitor in front of you, any alteration in color, contrast, texture or any other effect can be immediately assessed, using a carefully calibrated monitor that displays color accurately. In addition, you have so much more control in the digital world than you do with conventional photographic techniques.

The disadvantage, of course, is the cost. In the last few years the prices of computer systems have dropped, and continue to do so, but a computer still represents a significant investment. But once you sit in front of a computer and see for yourself

what can be done to one of your images, I believe you'll be hooked. I was—and am.

Here, I'll give you an overview of the equipment you should have and the programs you'll need to learn. I include a look at some of their capabilities and how to work with a service bureau for scanning and output services.

THE HARDWARE AND SOFTWARE

The computer platform I have chosen to use is Macintosh (Mac). Macs are more expensive than computers running on Microsoft Windows, but Macs are more user-friendly (despite improvements in the Windows system). Also, Macs were designed from the outset with graphics applications in mind, while Windows-based computers and their DOS-based ancestors evolved to meet word processing and number-crunching needs.

I currently have a Power PC 9500, which opens a 40 megabyte file in about 10 seconds on my computer. The amount of Random Access Memory (RAM) you have is a significant factor in the speed at which you can work. You should have a minimum of 36 megabytes (MB, or "megs") of RAM to work with high-resolution images, but 64MB is much better. I have 150MB of RAM, so I can work on large computer files without running out of memory.

The storage capacity of your hard drive determines how many programs and scanned photographs you can keep on your computer. For photo manipulation, you should have at least a 1 gigabyte (1 GB, or "gig") hard drive. I have 8 gigs of storage capacity, divided among four hard drives—a 1GB and a 4GB internal, and a 2GB and a 1GB external—so I can store many scanned photos for quick and easy access.

Another important aspect of a digital setup is an archival storage system. Once you start scanning and saving images, you will run out of room on your hard drive

quickly. Instead of discarding this information, you'll want to store it for future use. Some of the hardware available for this purpose are Digital Audio Tape (DAT) drives, ZIP drives, CD-ROM drives and JAZ drives. The DAT system offers the least expensive method of archiving information. At this time, you can store 4 gigs on a single cassette tape costing less than ten dollars. The disadvantage is that retrieval of information from the tapes is slower than other media (although quite acceptable). And once in a while a tape crashes: This means the information can no longer be retrieved. I lost two tapes out of about thirty over a period of four years. The solution is to make an additional copy of each tape.

CD-ROM drives allow you to "burn" CD-ROMs—imprinting the digital data of each photo on the disc for storage. At this writing, CD-ROMs hold 650MB per disc, but this will soon be increased. This method is more expensive than DAT tapes but more stable; i.e., the CD-ROM discs are less likely to crash. I now use this system.

JAZ and ZIP drives are good for transporting pictures back and forth to a service bureau, but the cartridges are too expensive to be considered an archival storage medium. I have a JAZ drive and like it very much.

I use a twenty-inch monitor, although a seventeen-inch is sufficient and costs quite a bit less. The larger the monitor you use, the easier it is to examine the entire picture area of each image you work on. The resolution of the screen is 72 pixels per inch, which is actually less than a high-resolution scan of one of your slides. You need a 24-bit video card, which displays 16.8 million colors on your monitor. A 16-bit card, although less expensive, only shows about 65,000 different colors. This isn't adequate to show you all the subtle color hues in a photograph.

I use several programs, but the backbone of my work is done with Adobe

Lightning usually is rendered in tones of magenta on daylight film when photographed at night. During the storm, our eyes never see this color, so many people find it objectionable because it seems so unnatural. During the duplication process, it can be eliminated if you know which color to add or subtract from the filter pack.

There are two ways to neutralize the magenta. You can subtract magenta from the filter pack or you can add magenta's complement, green. If your color-corrected filter pack is 4 magenta (4M) and 15 yellow (15Y), there isn't enough magenta to subtract to significantly affect the result. Therefore, you must add a combination of cyan and yellow, which equals green, to the filter pack. This is what I did here. I added 20 cyan (20C) and 20 yellow (20Y), or 20 units of green, to the pack in the duplication process and got the result you see below. I also had to add ½ f/stop of light to compensate for the increased density of the filters.

Technical Data:
Original image—Mamiya RZ 67 II, 250mm telephoto lens, f/4.5, Fujichrome Velvia. The exposure was approximately ten minutes on a tripod. The magenta in the original shot was neutralized in the darkroom by the addition of green (cyan plus yellow) to the color-corrected filter pack.

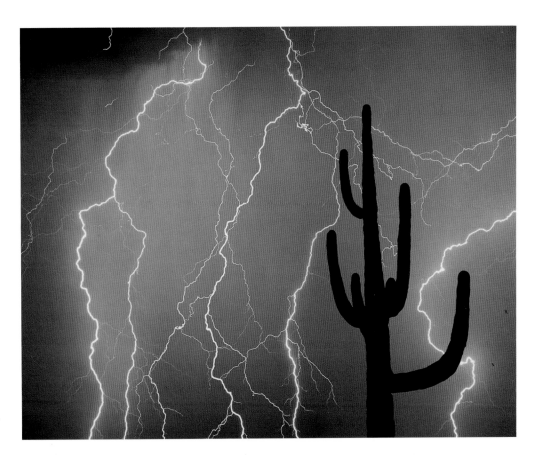

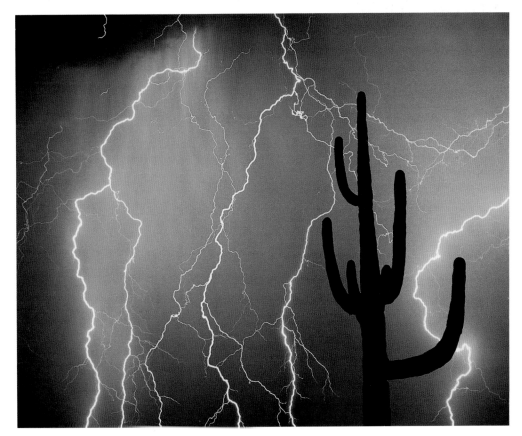

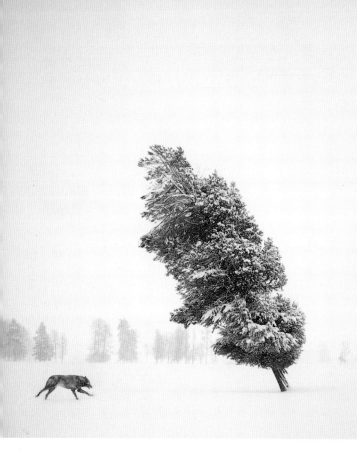

A change in color can dramatically alter a viewer's emotional response to a picture, and hence its salability. A winter blizzard in the Cascade Mountains was a virtual whiteout, with few details visible. The original photo of the tree leaning away from the wind and the wolf running into the frame is stark and dramatic (left), but I thought I would try a creative modification.

Using the medium format duplication technique, I added 20 cyan (20C) and 22 magenta (22M) to the color-corrected filter pack, and decreased the exposure by 1/2 f/stop in addition to the extra filtration. The midnight blue color that resulted implies the photo was taken at night (an impossibility, unless the film used was extremely fast and hence very grainy). I used more magenta filtration than cyan because the blue color I wanted was closer to purple than cyan.

Technical Data:
Original image—Mamiya RZ 67, 350mm APO telephoto lens, 1/250, f/8, Fujichrome Provia, tripod. The midnight blue color was produced in the darkroom by adding cyan and magenta to the color-corrected filter pack.

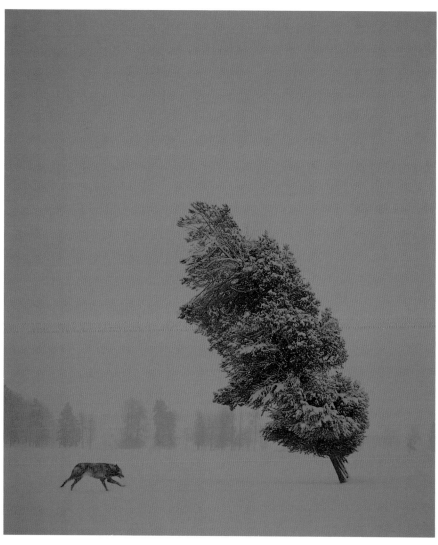

Photoshop, a digital image editing program. I am continually in awe of its capabilities to manipulate photographs. I also use Fractal Design Painter. This is primarily a program for illustrators, but it does have many applications for photographers as well, such as applying unique textures or after-the-fact lighting. I use the program Retrospect to back up images onto DAT tapes, and Toast to burn my photos onto CD-ROMs.

FROM FILM TO DIGITAL IMAGING

Whether your originals are 35mm, medium format or 4×5 inch transparencies, they must be scanned to digitize the information on the film. Service bureaus provide the link between film and your computer, turning transparencies into digital files and then back into transparencies again. Each slide is scanned with a high-resolution scanner, and then the information is transferred to a transportable medium you provide to the service bureau. These are cartridges, discs or tapes that can easily be transported between your home or office and the service bureau. The digital file is copied onto the medium at the bureau and then you copy that information onto the hard drive in your computer. This could be a Syquest, a JAZ cartridge, a DAT tape, a Joule drive, a CD-ROM disc or some other portable system. Make sure that whichever system you use, your service bureau has the same one. I bring JAZ cartridges to Imagitech, a West Hills, California, service bureau I use for scanning and output. You can save money if your archival system, such as DAT tapes, is also used as the means by which you and your service bureau exchange information.

Once you bring the scanned files home, you copy the digitized photographs onto the hard drive in your computer. Then, using Adobe Photoshop, you can alter the image as you wish. Once you are satisfied with your work, the final version you save is copied back onto the portable medium

and returned to the service bureau, where they transfer the digital information to a roll of film using a device called a film recorder. Once the film is developed, you will have either a 35mm, a medium format or a large format transparency.

The height and width dimensions of a picture file must conform to the pixel count the film recorder requires for each line it images. Your service bureau will define for you the actual pixel dimensions they require for their 35mm, 6×7cm or 4×5 inch (10cm \times 13cm) outputs. If they're using a Solitaire film recorder, here are the dimensions you will be working with:

35mm: $2732 \times 4096 = 32$ megabytes

6×7cm: $3277 \times 4096 = 38.4$ megabytes

4×5 in.: $3186 \times 4096 = 37.3$ megabytes

These pixel dimensions describe the area of each photo that you will manipulate in the computer. They correspond to a 4K, or 4000 line per inch, scan and output. For 35mm and 6×7cm, this is approximately the maximum resolution that the film can resolve. A higher resolution scan would be pointless, because the grain structure in the film can't reveal any more detail than it is already doing at a 4K scan. A 4×5 inch (10cm \times 13cm) scan and output may be made at 8K, or 8000 lines per inch. The pixel dimensions for an 8K output in a 4×5 inch (10cm \times 13cm) photo is 6372×8192 pixels per inch (which equals 149.3 megabytes).

Drum scanners offer the highest resolution and best-quality scan, but the Leaf 45 scanner used by many service bureaus is also excellent. The Leaf is much less expensive to buy; hence, the scans done on this machine cost you less. All my scans for the past six years have been done with the Leaf 45.

INSIDE ADOBE PHOTOSHOP

Altering or enhancing the color of the original image is easy. I most often use one of three dialog boxes, which are found on the *Adjust* pop-up menu under the *Image*

menu: *Color Balance*, *Hue/Saturation* and *Brightness/Contrast*. Color Balance lets you apply any color cast to a picture's highlights, midtones or shadows. Hue/Saturation lets you alter the saturation or lightness of a color. Brightness/Contrast lets you make the image lighter or darker, or increase or decrease the contrast. As you work in each of these dialog boxes, you see the results of your changes right before your eyes. Unlike the duplication process in the darkroom, where film must be developed before you can assess the results, color changes on the computer happen in real time.

In the Color Balance dialog box, you can move any or all of three slider bars, each pairing complementary colors, to infuse any color you want in any amount you choose. For example, you can shift the colors in a portrait toward the warm end of the spectrum to alter skin tone, or select the eyes and increase the amount of blue in the irises. I usually begin with the midtone setting, and then decide if I want to alter the color in the shadows or highlights.

With the Hue/Saturation dialog box, you can increase the saturation of color without introducing a new color balance. This is perfect for enriching a sunset or making the colors of a butterfly or a tropical bird stronger and purer. You can turn a full-color slide into a monochromatic image in any color you want. If you decrease the saturation of a full-color image by moving the slider bar almost all the way to the left, the photograph will resemble a sepia-toned print, or a print toned in any color on the spectrum. You can also colorize a gray-scale picture by first checking the Colorize box and using the Hue slider to select a tint. You then adjust the Saturation and Lightness sliders to get the effect you want.

The Brightness slider bar in the Brightness/Contrast dialog box lets you make the image lighter or darker. If the original shot is imbued with rich colors but was

underexposed, you can bring it back to life by lightening the entire image, or by selecting and then altering any part of it. If you want to turn a shot into a dreamy, ethereal picture where the colors are pastel, move this slider to the right to lighten it.

The Contrast slider bar is also very useful in altering the colors in a shot. Increased contrast makes them jump right out of the monitor. By lowering contrast, colors deaden and appear muted and understated. Another important use for the Con-

trast slider bar is offsetting the contrast gained in duplicating. In the digital imaging process, as in slide duplicating, contrast is always gained, but with this slider you can lower the contrast of the image to offset the gain.

Color sells. Brilliant color sells even better. Glance at any magazine stand, and you'll see how virtually every publication uses color to grab your attention. Neon colors. Colors that clash. Bizarre color combinations. Even metallic colors are used. This holds true for nature magazines as well as issues devoted to fashion, architecture, motorcycles, gardening, psychology, spiritualism and every other subject.

These rainbow lorikeets were already saturated in color (left). For additional impact, with the hope of a cover in mind, I decided to try increasing the saturation even more. I opened the Hue/Saturation dialog box in Adobe Photoshop and moved the Saturation slider bar twenty units to the right. I instantly saw the bright colors of the birds' feathers assume a deeper, richer saturation on my computer monitor, as you see in the photo on the right. This technique is impossible to achieve in the darkroom, but is very easy to accomplish in seconds with digital imaging.

Technical Data:
Original image—Mamiya RZ 67 II, 350mm APO telephoto lens, no. 1 extension tube, 1/125, f/5.6-8, Metz 45 flash, Fujichrome Velvia. Color adjustment done in Adobe Photoshop by opening the Hue/Saturation dialog box (selected from the Adjust pop-up menu under the Image menu) and moving the Saturation slider bar 20 units to the right.

Changing the color of an original image after the fact doesn't have to be limited to correcting a mistake or tweaking the mood. You can introduce radical changes quickly and easily with digital technology. Techniques that took many hours in the darkroom can now be done in seconds with a computer.

One such technique is posterization. The original photograph is transformed from a continuous-tone image into one with sharply defined areas of tonality. In a black-and-white posterization, these tonal areas are seen as shades of gray. In this example, the tonal areas are defined in color. In Adobe Photoshop, you select the number of shades, or areas of color tonality, and within a second or two the computer makes the transformation.

Using the Map pop-up menu under the Image menu, I selected posterization and then, for this example, I typed in the number 7 to define how many areas of color the portrait would be divided into.

Technical Data:
Original image—Mamiya RZ 67 II, 250mm telephoto lens, 1/250, f/16, Fujichrome Velvia, Speedotron 2403 Power Pack, one strobe head softened with a white umbrella. In Adobe Photoshop, the color image was posterized using the Map menu under the Image menu and designating seven levels of tonality.

Color correction after the fact can sometimes save an image when a technical flaw occurs. This image of Rondi Ballard and a 1936 Buick was exposed to a red light during processing. The lab technician was listening to his portable CD player while he was developing film, and the LED light on the small unit emitted enough light to fog the film. As a result, the contrast was lowered and the color balance shifted to red. The shot was taken at sunset in Malibu, California, and the golden tones of a low-angled sun I expected were eclipsed by the error.

I had the original transparency scanned by a Leaf 45 scanner at my service bureau, Imagitech [(818) 999-4319], in West Hills, California. Once I had the digital information transferred to my computer, I selected Rondi's dress to separate it from the background. In Adobe Photoshop, I used the Saturation slider in the Hue/Saturation dialog box to reduce everything in the image except the dress to black and white. I then altered the original colors of the dress with the Hue slider.

Technical Data:
Original image—Mamiya 7, 150mm telephoto lens, 1/125, f/5.6, Fujichrome Provia, handheld. The computer work was done with a Macintosh 9500. The scanner was a Leaf 45, and the 6 × 7cm output to film was done with a Solitaire.

This portrait was made on Agfachrome 1000 that was several years old. Even though the film had been refrigerated, it underwent a gross shift toward magenta during processing. Both the lab manager and I were surprised by what happened, and neither of us could explain it. Before the digital revolution, I would have thrown the film away.

Instead, I thought I could save the slides by using one of the tools in Adobe Photoshop: the Color/Balance dialog box. In this menu, there are three slider bars, each with complementary colors on either end: the cyan/red bar, the magenta/green bar and the yellow/blue slider bar. By moving the slider back and forth along the bar the color balance of the entire photograph changes. To eliminate the predominant magenta cast and replace it with normal colors, I adjusted the three slider bars until I liked the result at 52 units of green, 86 units of yellow and 25 units of red. Note how much green and yellow had to be added to counteract the magenta and blue. The photograph is muted because Agfachrome 1000 is low in contrast and very grainy.

Technical Data:
Original image—Mamiya RZ II, 250mm telephoto, 1/250, f/8, Agfachrome 1000, tripod. The color correction was made using the Color/Balance dialog box (selected from the Adjust popup menu under the Image menu). 52 units of green, 86 units of yellow and 25 units of red were added.

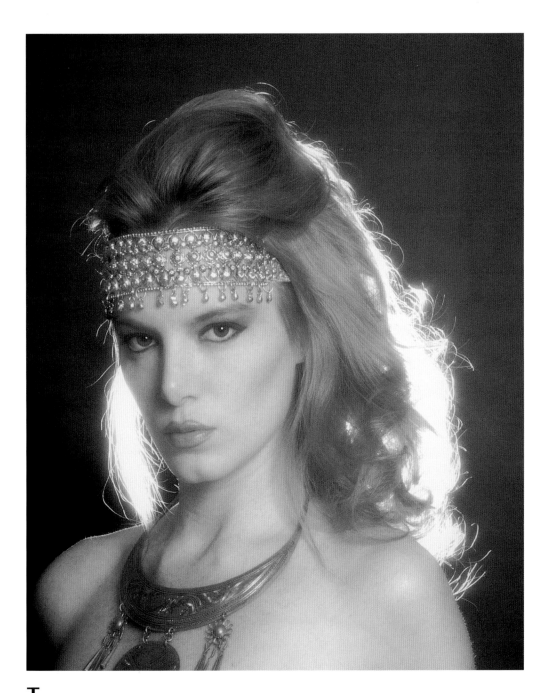

The original portrait of model Rondi Ballard (top left) was underexposed by about one f/stop. Notice that all the detail is there. Even in the underexposed shadows, you can still see the texture of skin. I had the transparency digitally scanned by my service bureau, Imagitech, brought the digital data home on my portable JAZ drive, and then copied it onto one of my Macintosh 9500's internal hard drives so I could work on it with Adobe Photoshop. Using the Brightness/Contrast dialog box, I lightened the image by 15 units (opposite) and increased the contrast by 8 units.

Then, using the slider bars in the Hue/Saturation dialog box, I turned the portrait into a monochrome. I lowered the saturation until it resembled a black-and-white-toned print and then moved the Hue slider bar to the right until I liked the shade of mint green. The image above then simulated a conventionally toned photo (except there aren't any mint green toners available).

Technical Data:
Original image—Mamiya RZ 67 II, 250mm telephoto lens, 1/125, f/8, Speedotron 2403, a single Photoflex softbox as the main light and a bare-bulb Speedotron flash head behind the model for a hair light that was set for two f/stops brighter than main light, Fujichrome Velvia, tripod. The photo was underexposed because I triggered the strobe before it had fully recycled. Corrections were applied in Adobe Photoshop using the Brightness/Contrast and Hue/Saturation dialog boxes (both dialog boxes selected from the Adjust pop-up menu under the Image menu).

You have total control over both color and contrast in the digital imaging process. I overexposed the original portrait of Rondi Ballard in an attempt to produce white skin with very little detail. The eye and lip makeup was applied very dark to withstand the overexposure on the film. However, I didn't get the effect I wanted and had to resort to the computer and Adobe Photoshop.

In the Brightness/Contrast dialog box, I adjusted the contrast until most of the skin was white. I also used the Dodge/Burn tool to dodge (lighten) wrinkles and other details in the skin that I wanted eliminated. Then, opening the Hue/Saturation dialog box, I used the Saturation slider bar to increase the saturation of Rondi's red hair color (above).

I then completely altered the color balance in the photo by moving the Hue slider bar toward the blue-purple section on the left until I liked the color (page 105). When that was completed, I selected each lens on the sunglasses and filled it with a gradient color that matched the hair. These steps were accomplished by (1) using the magic wand tool to select

the glasses, (2) choosing the colors to be inserted within the glasses with the eyedropper tool and (3) filling each glass lens with the chosen colors using the gradient tool.

Technical Data:
Original image—Mamiya RZ 67 II, 250mm telephoto lens, 1/250, f/11, two Speedotron flash heads in Photoflex softboxes, Fujichrome Provia. Changes made in Adobe Photoshop by opening first the Brightness/Contrast dialog box to adjust the contrast by 30 units and then switching to the Hue/Saturation dialog box and moving the Saturation slider bar 20 units to the right (both dialog boxes selected from the Adjust pop-up menu under the Image menu). The Dodge/Burn tool was also used to lighten and eliminate unwanted details. The Magic Wand and Gradient tools were used to select and then fill the glasses with the desired colors.

The Colors of Night

If you were to make a long exposure of a landscape at night, far away from city lights, the colors in the scene would shift toward the blue end of the spectrum, and the contrast would be very low. The natural colors of night are not very dramatic, except for the aurora borealis and distant nebulae visible through powerful telescopes.

Artificial light, on the other hand, offers myriad possibilities for drama and creativity. When various light sources are used in a single image, the combinations of colors they produce can be truly stunning. There are many different types of lights, and the way color film reacts to them provides us with a unique way to visually represent night.

Seeing the Colors of Night

Night photography is most dramatic when various kinds of lighting are combined. This is exemplified when shooting a city skyline. Neon lights mix with the light from fluorescent fixtures in the windows of buildings, while mercury vapor street lights and miscellaneous tungsten bulbs add additional colors to the scene. Long exposures at night mean that anything that is illuminated and is in motion, such as traffic, airplanes, rotating signs, fireworks and amusement park rides, will leave trails of colored light in the frame. Shooting at night is an opportunity to create wonderful images ablaze with color.

Below is a list of artificial light sources and an explanation of how color film responds to them.

Fluorescent Tubes. There are many different types of fluorescent fixtures from various manufacturers with a range of light colors—cool white, soft white and so on. Virtually all fluorescent tubes, however, are seen by color film as greenish. Corrective gels and filters can be used to neutralize the green cast by placing them over the light tubes or in front of the camera lens.

Mercury Vapor. Lightbulbs that are filled with mercury vapor gas appear to the eye as a very "cold" white light and are photographed as bluish green. The most common use of mercury vapor illumination is street lamps. A magenta filter, the complement of green, neutralizes the color of the light, but it will change the color of the whole scene.

Sodium Vapor. Some cities have installed sodium vapor street lamps in place of the mercury vapor ones to minimize the glare from the lights. Sodium lights appear an intense yellow and are reproduced on film as saturated yellow or sometimes as a rich red-yellow.

Neon Fixtures. Neon lights come in many different kinds of colors, and they typically photograph similarly to how our eyes perceive them. Care must be taken not to overexpose neon, or the saturated colors will be lost.

Tungsten Lightbulbs. Tungsten bulbs photograph with a yellow-orange cast on daylight film. The illumination provided by tungsten bulbs appears "warm," or yellowish, to the eye, but daylight film exaggerates this color. Tungsten-balanced film corrects the yellowish cast and brings the color balance back to what our eyes perceive as accurate.

Electronic Flash. Electronic flash is rated at 5500 K, which means that it appears as white light when photographed with daylight film. If you flash a subject in front of other types of illumination at night, your subject will be reproduced with correct coloration while the background lighting will exhibit the shift described above.

Making Correct Exposures

It is practically impossible to use a light meter at night to determine exposure. Light meters analyze the highlight and shadows in a composition and compute the best f/stop and shutter speed combination for a proper exposure. At night, however, the brilliant highlights produced by light fixtures and the black night sky are so extreme that a meter cannot be programmed for a good exposure. If an average reading is made between the lights and the sky, the sky will be too light—it will look gray—and the lights will be overexposed. Night lights that are overexposed look washed out. If you take a spot reading on a bright light, it will appear midtoned, which means it will look too dark.

My correct exposures at night have been determined by analyzing tests made in many different nighttime locations. For most situations, 10 seconds at f/5.6 works for Fujichrome Velvia (ISO 40), and an exposure of 10 seconds at f/8 is appropriate for ISO 100 films such as Fujichrome Provia 100 and Ektachrome E-100S. Films rated at ISO 200 would require one additional f/stop less, or 10 seconds at f/11, and for ISO 400 the exposure should be 10 seconds at f/16. Night skylines, amusement parks, fireworks and neon signs should all be properly exposed when you use these guidelines. If the lights are unusually bright, or if you are very close to the light sources, you may have to adjust the exposure, closing the lens down one or two f/stops.

There is tremendous latitude in exposure when shooting at night, and you can be one full f/stop over- or underexposed and still be pleased with the image. This leaves a great deal of room for error. Once you expose one or two rolls of night exposures, you will get a feel for which camera settings you prefer. Take notes when you shoot so you can repeat good exposures on future shoots. In the beginning, you may want to bracket your shots one full f/stop on either side of my recommended guidelines. For example, when bracketing Fujichrome Velvia while shooting at night you take three shots—one for 10 seconds at f/4, one for 10 seconds at f/5.6 and one for 10 seconds at f/8.

Creative Techniques

Blurring and combining the myriad colors at night can produce some exciting abstracts. Shooting a brightly lit city scene out of focus, for example, produces soft spheres of color. If you double-expose the out-of-focus frame with a sharp rendition of the same scene, a mass of exciting color

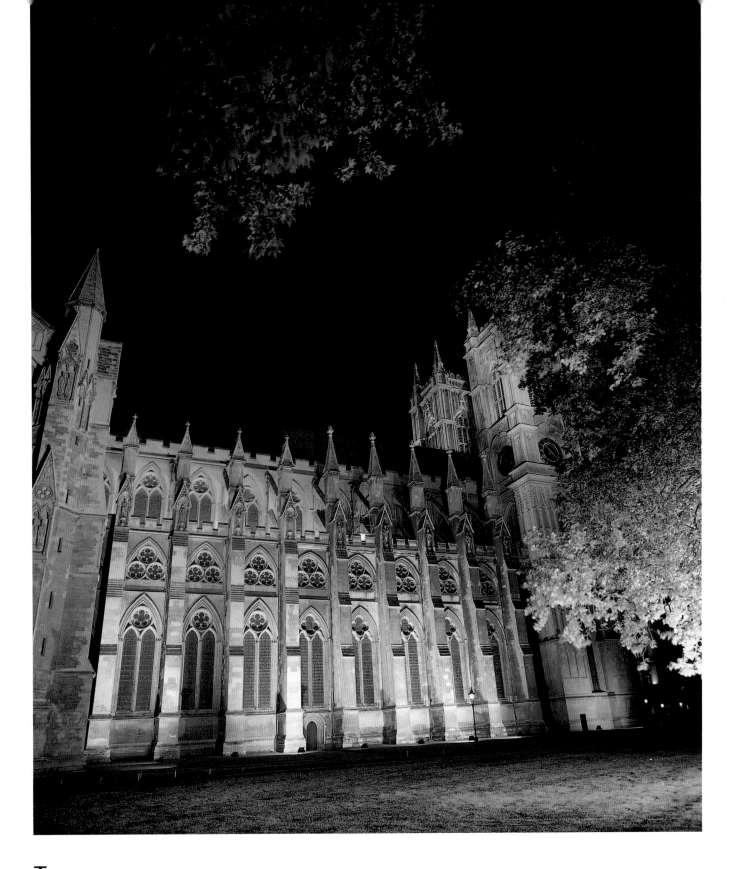

The side of Westminster Abbey in London is illuminated at night with a variety of lights. To the eye, the combined color of all the lights appears white and the cathedral's stonework looks gray. Color film, however, tells a very different story. The different kinds of fluorescent tubes plus mercury vapor lighting reveal a remarkable variation in hues cast onto the building and the trees.

Architecture can appear unphotogenic at night, but when you understand how colorful structures can be when photographed on color film, you will be inspired to experiment. Sometimes an ancient building is more beautiful at night than in daylight. When smog or haze prevent you from capturing a monument effectively during the day, nighttime illumination may be the answer.

Technical Data:
Mamiya RZ 67, 50mm wide-angle lens, 10 seconds, f/5.6, Fujichrome Velvia, tripod.

Just before dark, there is a ten- to fifteen-minute window of opportunity to capture the cobalt blue color of twilight sky. When the city lights appear bright enough against the sky, and the color in the sky has deepened to a rich, dark blue, the contrast of artificial and natural light is quite beautiful. Many of my favorite "night" shots have actually been taken at twilight.

The Atomium, a famous structure in Brussels, Belgium, is illuminated by sodium vapor lights. The yellow glow from the high-intensity lamps reflects off the aluminum and makes it appear to be some alien spacecraft. The contrast of colors between the twilight sky and the sodium lights makes the shot.

Technical Data:
Mamiya RZ 67 II, 110mm lens, 10 seconds, f/5.6, Fujichrome Velvia, tripod.

results. I recommend underexposing each exposure by one f/stop.

Using long exposures for moving objects at night is a familiar technique. Instead of using a tripod for moving traffic, try hand-holding the camera and moving it back and forth and up and down over a ten second period. The results are always a surprise, and the abstracts you create will each be unique. If you include street lamps in the frame, they will appear as dashed lines because their light is actually intermittent, not constant. The lamps flash on and off sixty times per second—too fast for our eyes to see—but the light trails on the film as you move the camera past the lamps, make this cycle obvious.

Try using a zoom lens and changing focal lengths during the exposure, with the camera on or off a tripod. It doesn't matter whether you zoom in or out. If you zoom the lens with the camera on a tripod, the resulting streaks of light will be straight. If the camera is handheld, the streaks will be jagged. Make sure most of the frame is filled with lights.

The fluorescent light fixtures in office buildings mean that photographs of city skylines usually have a greenish cast. I wanted to eliminate the green in this shot of the Hong Kong skyline, so I used an FLD filter over the lens. This piece of glass is magenta to the eye and is designed to neutralize fluorescent illumination. I accomplished this, but in addition the filter also affected the sky, the mountains and the water in the harbor. Introducing color at night through the use of filters expands your ability to interpret a cityscape.

When calculating exposure, don't forget to take into account the loss of light. Most color filters decrease exposure from one to two f/stops. The TTL meter in your camera will automatically compensate, but if you are using a manual camera without a built-in meter, consult the instructions that came with the filter. Or use a handheld reflective meter, like the Minolta Spot Meter F, and take a reading on a neutral background with and without the filter. The difference between the two readings is the compensation factor. However, this calculation should be done under normal daylight conditions, not at night.

Technical Data:
Mamiya RZ 67, 250mm telephoto lens, 10 seconds, f/4.5, Fujichrome Velvia, FLD filter, tripod.

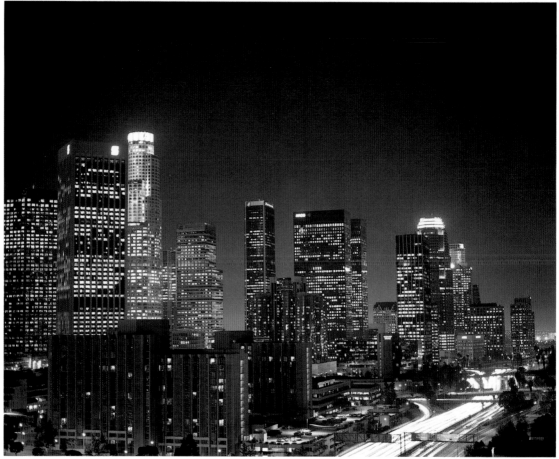

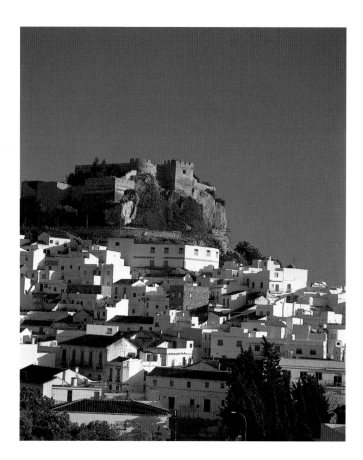

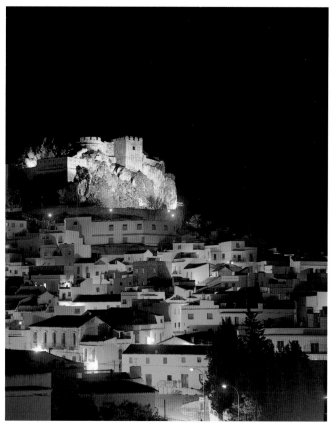

Salobreña is a beautiful town on the Costa del Sol in southern Spain. It is built on a hill adjacent to the Mediterranean, and the sunset lighting that illuminates the whitewashed homes and the medieval Moorish fortress creates a classically beautiful shot, as you see in the photo above left.

On some evenings, tungsten lights highlight the impressive walls of the fortress and dramatically contrast the blue-green mercury vapor illumination on the structures below, as the shot above illustrates. To the eye, both types of lighting appear white, but color film clearly differentiates between the two types.

In calculating the exposure for the night shot, I added one f/stop to my standard exposure because most of the image was reflected light—that is, light reflecting from the homes and fortress—as opposed to a composition that included primarily bright street lamps and neon signs. Also, my camera position was approximately a half mile from the town, and I noticed a decrease in light intensity due to the distance.

Technical Data:
Daylight shot—Mamiya RZ 67, 350mm APO telephoto lens, 1/125, f/5.6, Fujichrome 50D, tripod. Night shot—Mamiya RZ 67, 350mm APO telephoto lens, 20 seconds, f/5.6, Fujichrome 50D, tripod.

◄These two images of the Los Angeles skyline show the differences in twilight and night photography. The photo on top was taken while the ambient daylight still overpowered the greenish fluorescent illumination coming from the buildings. The photo at the bottom was made after dark, and the colors created by fluorescent and mercury vapor illumination dominate the picture. Even the hazy sky is influenced by the greenish color characteristic of these types of artificial light.

I used quite different exposure times for each shot. The twilight photo required less exposure, only 2 seconds, and the trails of traffic lights are shorter. The longer exposure time for the night image, 20 seconds, caught more movement by the cars on the freeway, hence the headlights are brighter and the streaks of light are longer.

Technical Data:
Both photos—Mamiya RZ 67, 110mm normal lens, Fujichrome Velvia, tripod. Twilight shot—2 seconds, f/5.6. Night shot—20 seconds, f/5.6.

This is a double exposure of Nathan Avenue on the Kowloon side of Hong Kong. I first composed a mass of neon signs and photographed them significantly out of focus. Then I exposed the street scene on the same frame of film, but this time I focused correctly. Each shot was underexposed by one f/stop from my normal night-exposure formula.

When experimenting with special effects, it is necessary to take many shots to ensure you'll get a successful one. There are many factors involved that can thwart your efforts. For example, several times when I was shooting this street scene, a double decker bus stopped in traffic right in front of the camera during a long exposure. Sometimes the traffic would stop, and I filled my frame with clearly defined taxi cabs instead of streaks of light. Other times, curious people walked up to my camera, stood in front of it during an exposure, and asked me questions. In each instance, the shot was ruined. Out of twenty attempts, I got only three good double exposures.

Technical Data:
Both frames of the double exposure—Mamiya RZ 67, 110mm normal lens, 10 seconds, f/11, Fujichrome Velvia, tripod. I closed down the lens from my typical exposure guidelines because the lights were so bright.

A classic way to create color abstracts at night is changing the focal length on a zoom lens during the exposure. You can move from wide angle to telephoto or vice versa. The result will be the same. In this shot of neon lights in Las Vegas, I used a tripod so the streaks of light would be straight. (A handheld camera will produce jagged streaks of light.) I moved the lens from the telephoto to the wide-angle position over a period of four seconds. My usual ten-second exposure at night was shortened to four seconds because I was very close to the neon sign and the light was quite bright.

Technical Data:
Mamiya RZ 67 II, 100-200mm zoom lens, f/8, 4-second exposure, Fujichrome 50D, tripod.

Color That Sells

Color sells. It always has, and it probably always will. Publishing companies, advertising agencies, trade show concessionaires and fund-raisers all know that they must grab your attention in order to persuade you to buy a product or service. And they know that the competition for your attention is fierce.

What does all this mean to photographers? When you take shots you want to sell, it's important to consider how your clients use color as part of the message to their audiences. Bright, bold colors are used on magazine covers and in advertising, so choose or plan shots that will work for those markets. Animals that are brilliantly colored are more likely to sell for ads and covers than those that are earth toned or very dark. Photographs of brilliantly colored costumes during a festival will grab a photo buyer's attention—and the public's—before a neutral-toned image of the same event.

There are many situations, of course, where you don't have any choices about the colors you'll get. Photographing a snarling grizzly or a wolf in a snowstorm, for example, gives you no options at all—you'll get browns or grays and whites. That doesn't mean the shot won't sell. In these cases, the muted earth tones of the natural world are not the compelling force behind the sales potential of the shot: It is the impact of the subject itself.

Most mammalian predators have very muted coloration, but other characteristics, such as their behavior and body language, draw attention to the photograph. When clients want to express a particular concept that is associated with an animal, such as fear, aggression, ferocity or speed, the role of color is subordinated to body language and facial expression. In this close-up of a snarling grizzly bear, for example, the color is irrelevant to its sales potential, while the facial expression is everything. The viewer's visceral response guarantees attention will be paid to the message accompanying the photo. If this picture were used on the cover of a magazine or book, the dramatic image would inspire many people to pick up the publication and look at it more closely.

I took this shot in Alaska near the Brooks River in Katmai when a young bear false-charged me just outside my cabin. Bears do this to intimidate—and believe me, it works! I practically had a heart attack at first. But the open door to the cabin was just a few feet away, and the bear was about thirty feet distant, so I was relatively safe. I had seen him approaching, so I was already composing the shot when he made the aggressive move.

Technical Data:
Mamiya RZ 67 II, 500mm telephoto lens, 1/250, f/5.6, Fujichrome Provia 100, tripod.

Orange, yellow and red always attract the eye. The term "hot" is often associated with this end of the spectrum, and this is nowhere more evident than in a photograph of a blazing fire. Even though the subject in this image is the firefighter, it is the color of the flames that gives this shot drama. Anyone thumbing through a magazine who sees this picture will certainly look at it. And that's the whole point. The image virtually jumps off the page.

Technical Data:
Mamiya RZ 67 II, 250mm telephoto lens, exposure unrecorded, Fujichrome Provia 100, handheld.

What the Different Markets Want

Different markets have different needs with respect to color. A large magazine stand, for example, has hundreds of titles. How does one issue stand out? How does it vie for your attention and then entice you to pick it up for a closer look? There are only two ways: The photograph or illustration on the cover must have a compelling subject, and/or it must have eye-catching colors. The same is true for advertisements on billboards, in trade magazines and on the sides of municipal buses. So the advertising market typically looks for bold, bright color that says, instantly, "Notice this product!"

By contrast, editorial layouts for articles in magazines or for books rely on content more than color. Although attention-getting color is important, photos that support text must relate to the content of the story. Often the lead photo is colorful or dramatic in some other way, while the others may offer a range of hues and values from compelling to subdued.

Greeting cards, calendars, posters or art prints don't necessarily rely on brilliant colors to sell. Subtle colors and muted tones may be very successful in this marketplace. Bright colors can be hard to live with in a living room or bedroom, while the softer colors are soothing. Muted colors in greeting cards are used for certain types of themes, such as sympathy, love and friendship.

Stock agencies sell photographs to hundreds of different kinds of markets, so they need all types of color images, from bold and dramatic to subtle. It depends on the subject and how a potential client might use an image. For example, a romantic couple photographed on the beach might be dressed in muted colors for the greeting card market, or they could be photo-graphed in black and white and hand-colored for a poster. Similarly, a stock agency would sell a bald eagle—which is black and white—for a patriotic theme symbolizing the United States, or they could sell a picture of a scarlet macaw to be inserted into a new computer monitor to imply how brilliant the colors are in this product.

Selling Your Work With Color

There's nothing wrong with photographing a subject or scene simply because you like it. If you want to earn a living from your photography, however, you must also shoot to sell. That means looking carefully around you and thinking about not only how to compose the shot, but also about what markets it might work for. When I travel, or when I am spending time in a local shopping mall, I constantly look for subjects to photograph both for personal pleasure and with an eye to future sales.

I put together compositions where I have total control of the color combinations. I photograph exotic birds in captivity, or dress a model in a stunning orange outfit and pose her against a turquoise blue 1932 Ford hot rod. The chance of making a sale multiplies by a factor of ten when bright colors become an important aspect of a picture. Sometimes I will buy a colorful object without a concept in mind, because I know that it may be part of a composition at some point in the future. I bought a brightly colored umbrella in Venice, Italy, and an Indian blanket in Taos, New Mexico, because of the primary colors in the designs of both items. Primary colors are often used in ads and on magazine covers because they are visually arresting, so I thought I might be able to use these props in a future composition.

Bringing in the Brights. A single splash of color in an environment of dark or muted tones can be very striking and therefore salable as an advertisement or cover. When bright colors have a particular connotation, they can have special appeal also. For example, warm images (sunsets, firelight, etc.) are frequently used not only to attract attention, but also to create a positive feeling. The cover of my last book, *Techniques of Natural Light Photography*, features an African silhouette against a brilliant orange sunset. The marketing department at Writer's Digest Books chose this image because the contrast between the warm colors of the sky and the flat black of the silhouettes is so eye-catching.

Using the Primary Colors. Combinations of the primary colors—red, blue and yellow—really turn heads. The cover of another of my books, *Outstanding Special Effects on a Limited Budget*, uses a shot of a model with blue skin, her hair covered with a red piece of fabric, wearing yellow-rimmed glasses. When you see this cover on a shelf among other books, it is the first one you notice. I originally planned to sell the shot to *Petersen's Photographic Magazine*, which ran it on the cover in January, 1989. As soon as the editor saw it, he liked it. The color combination sold the image.

Shooting for Shock Value. As dramatic as the primary colors are, other groupings of color can be even more arresting. The complementary color combinations of red/cyan, blue/yellow and green/magenta are always eye-catching. Usually, you don't just happen upon a subject with a combination of two complementary colors: You must choose and arrange elements with these colors into an interesting photograph.

For visual shock value, you can also put together combinations of color—such as orange and red, lime green and turquoise, and purple and yellow—that don't harmonize well and are almost disturbing. Remember, the objective in advertising is to grab your attention in a couple of seconds before you look away. Images that can do that may not be ones that you would

Color requirements in the editorial market can vary considerably, depending on the placement of the photograph. For example, the photo at right was taken in the deep shade of the foliage on a crocodile farm in Jayapura, Indonesia. The muted blue tones create a largely monochromatic image that is a dramatic first page for an article, but it probably wouldn't sell as a cover if the magazine had to compete on the newsstand. The photo of a Huli tribesman from the state of Irian Jaya in Indonesia (below) would more likely make the cover, because the arresting image is so colorful.

However, magazines that don't compete on the newsstand, such as *National Geographic*, are not constrained by the same market forces as other periodicals. They have more artistic freedom to choose their covers. If the photo editor likes a more muted or subtle photograph for its artistry, he or she may choose to use it over the image that is more visually arresting.

Technical Data:

Crocodile Farm—Mamiya RZ 67 II, 250mm telephoto lens, 1 second exposure, f/22, Fujichrome Provia 100, camera rested on a high concrete wall. Huli Tribesman—Mamiya RZ 67 II, 250mm telephoto lens, 1/60, f/5.6, Metz 45 CL flash, Fujichrome Velvia, tripod.

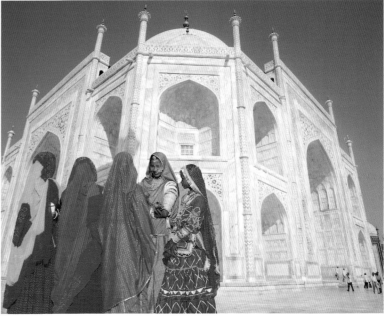

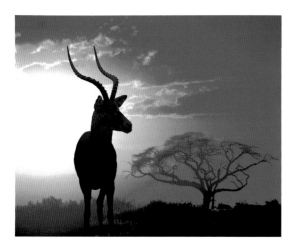

A stock-photo agency markets its images to thousands of clients with a wide range of photographic needs. No matter which category of picture is under consideration—wildlife and nature, people, travel locations, high-tech, medical, aviation—all concerned parties know that color plays a crucial role in determining which images sell. Sometimes muted color is exactly what the client wants, perhaps for the background of an advertisement, the cover of a classical music CD or a sensitive greeting card. At other times, bold color is required to grab attention or make a statement. A stock-agency photo editor knows that certain subjects call for different kinds of color and looks for a variety of color in a submission.

The images reproduced here could be a typical submission to a stock agency either from a photographer trying to become accepted into the company or from one who is already part of it. (In fact, my stock agency in Los Angeles, Westlight, has these particular images in their files right now.) The photo editor is trained to look for things like negative space for advertising copy, images that can be used for certain types of concepts and images with salable colors.

When determining which slides to submit, think about what each picture is trying to say. A tropical scene in Tahiti or Hawaii, a field of Texas bluebonnets or California poppies, poisonous frogs and foreign festivals should have saturated colors. Other subjects, such as a winter snowstorm, twilight on the Oregon coast, a macro shot of a flower after a rainstorm or a white-tailed deer peering at the camera through a forest, can all have muted colors.

This beautiful field of European poppies and other wildflowers was photographed in central Spain in April. The primary colors—red, yellow and blue—are often used in the print media as an attention-getting technique, but red is probably the most dramatic color. A profusion of red in nature is a valuable find.

This type of image, a frame-filling shot ablaze with color, can be used for packaging, calendars, fine art and editorial layouts. But this shot probably wouldn't sell for use in an ad, because there is really no place to put ad copy. The flowers dominate every square inch of the composition; copy in any color would be made virtually invisible by the overwhelming impact of the red and yellow flowers. The shot could be used for an ad if the design of the advertisement included a border around the picture with the copy placed well outside the image area, if a box for the text was placed over part of the field of flowers or if a section of the flowers was screened back (reproduced at only a percentage of the contrast and midtone values of the original). The advertiser's message could then be stripped into this area of the layout.

Technical Data:
Mamiya RZ 67, 50mm wide-angle lens, 1/30, f/16, Fujichrome Velvia, tripod.

Not all contrasting colors are garish or loud. Some juxtapositions of color are cool or elegant, yet they offer as strong a contrast as brilliant sunsets or outlandish clothes on a fashion model.

I took this photograph of the Grand Tetons early one January morning, when it was twenty degrees below zero. The air was crisp and clean, and the color of the sky against the white snow was exquisite. The only significant colors in this picture are blue and white, yet they offer an effective contrast that is refined, artistic and elegant. It is true that the majesty of the mountains contributes to this perception, but in different seasons and at different times of day the Tetons can appear to possess other qualities, such as ruggedness, strength and timelessness. I would reserve the word "elegant" for this particular color scheme and weather condition.

Technical Data:
Mamiya RZ 67, 250mm telephoto lens, 1/125, f/8, Fujichrome Velvia, tripod.

Not all color images used successfully in advertising must be visually shocking. Depending on the market, the colors in the photograph can be subtle. CDs of classical music, for example, often have pastel colors and diffused images on the covers. The background of an ad for wedding rings might also use soft pictures with low-contrast colors.

I photographed this violin for my stock agency. They needed pictures of musical instruments, and I thought this approach would be distinctive. I bought a used violin in a pawn shop and painted it white. I then placed it on black Plexiglas and photographed it with the flowers carefully arranged over it. I shot many variations on this theme, using techniques such as diffusion and color filtration and introducing other types of flowers, such as rose petals. My goal was to use the subtlety of color to evoke a quiet, contemplative mood that I hoped would appeal to advertisers. Ad agencies might consider this type of image for promoting anything from facial tissue to perfume. It's also quite possible that a creative art director might conceive of an advertising campaign for a product that has no apparent connection (at least to me) to this image, but he or she thinks it's the perfect visual message.

Technical Data:
Mamiya RZ 67, 110mm normal lens, 1/250, f/22, Fujichrome Velvia, 2403 Speedotron Power Pack, a single flash head softened by a Photoflex soft box, exposure determined by a Minolta Flash Meter IV, tripod.

Sometimes photographs can be made salable in a different market when the colors are altered. Even nature photos, which many people feel should be sacrosanct, can be made more attractive to photo buyers with manipulation. Often, advertising clients are less concerned with what is biologically correct than with what draws attention to a product or service. If unnatural color does the job, then that's what they want.

This elephant charged my vehicle in Amboseli National Park in Kenya. My driver had gotten too close to his harem, and the huge pachyderm was determined to trample us if he could outrun the Land Rover. I can still hear his loud trumpeting! I took two shots as both of us were on the move, and only one was sharp.

I had the image digitally scanned and, in Adobe Photoshop, enhanced and altered the color using the Hue/Saturation and Color/Balance dialog boxes. My choice of color was based on nothing except personal preference, but the photograph now has a strong punch to it.

Technical Data:
Mamiya RZ 67, 110mm normal lens, 1/125, f/4, Fujichrome Provia 100, handheld in moving Land Rover.

Some colors are associated with concepts that are familiar to all of us. For example, red is "hot," "passion" and sometimes "anger." Green is often interpreted as "peaceful," pink is seen as "feminine" and blue is called "cold."

This extreme close-up of snowflakes was originally photographed against black. I liked the stark contrast between the flakes and the dark background. When I submitted the image to my stock agency, Westlight, they requested that I replace the black with blue. According to the photo editors, the feeling of coldness would make the shot more salable. I accomplished this through the use of a computer (see pages 92-96 for more information on this technique), and as a result it has sold several times.

Technical Data:
Mamiya RZ 67, 110mm normal lens, two no. 1 extension tubes plus two no. 2 extension tubes, 1/400, f/32, Metz 60 CT-2 flash, Fujichrome Velvia, tripod. During a snowfall in Yellowstone National Park, I caught dozens of snowflakes on a piece of cold glass. The flakes were examined through an 8× loupe to find three that were intact after their collision with the glass and that were perfectly formed. With a fine camel hair brush, I segregated my three choices, placed the flash below the glass off to one side and used the Polaroid back to the Mamiya to determine the exposure. The film plane was parallel to the sheet of glass to maintain maximum depth of field.

The digital alteration of color was done in the program Adobe Photoshop. I selected the black background using the magic wand tool and then filled the selection with blue. I used a Macintosh 9500 computer, the scan of the original image was done with a Leaf 45 scanner, and the output 6×7cm transparency was made with a Solitaire Film Recorder.

A dramatic clash of color in the natural world is illustrated by this shot of a Parson's chameleon against a background of bougainvillea flowers. This image screams for attention. You couldn't miss it on a magazine rack or in a print ad. In addition to the juxtaposition of cyan and magenta, colors that don't harmonize well, the chameleon is such a bizarre creature that it arouses our interest at first glance.

Notice the space at the top of the frame for ad copy. When you are thinking of marketing your work, leave room in your composition for an advertiser's message. This may be a magazine's logo (which advertises the publication) or a slogan for an advertised product. The copy might be placed along one side of the image, at the top or at the bottom. Had I composed this image tighter so the frame was filled with the reptile's head, it would have been significantly less valuable.

Technical Data:
Mamiya RZ 67, 250mm telephoto, 1/125, f/8, Fujichrome Velvia, tripod.

choose to live with as framed prints in your living room.

Creating Elegant Contrast. Some publications don't shock viewers with color—they use elegant combinations of tones that contrast with one another instead. A shot of a beautiful woman in a white dress standing on a white balcony that overlooks the blue sea is an example. The juxtaposition of white against blue offers a dramatic contrast, even though the colors are soft and subtle. The contrast, rather than the colors, attracts the eye.

A classic example from nature is the dramatic contrast between a dark, threatening sky and sunset lighting on a landscape. The warm, golden hues of the sunlight against the gray-black approaching storm is the most beautiful natural light we have, and it is always eye-catching. The exquisite light of nature is elegant and touches us on a very deep level.

Selling Subtle Colors. Pastels and other subtle hues can be salable for the right markets. These soft colors are relaxing and blend easily with many interiors. The color harmony created by the limited palette or narrow range of values also has a soothing quality. Most of the nature photographs I've sold as fine art have been images composed of subtle colors. I recently sold twenty large prints for the oncology ward of a hospital, and all of them had muted and soft colors. Even the autumn foliage shots they selected were chosen using this criteria.

When I make an editorial submission, I always include a few shots with bright color for possible cover use, but most of the other images are a mix of bright, neutral and muted tones. Photo editors appreciate a choice in designing a layout and, even if they like to use saturated colors, they will often include images that are more neutral interspersed among the others so the reader isn't visually overloaded.

Making Associations With Color. People associate certain colors with specific concepts. Photo buyers are people, and they may more readily purchase an image when they are emotionally influenced by your choice of color—and know the public will be, too.

What are these influential colors? Blue is perceived to indicate cold. A bluish snow scene, for example, appears more frigid than one where white is the dominant color. Even a portrait done in deep blue feels very cold and emotionally distant.

Green is a color of peacefulness and harmony. Thick green foliage or a hillside of green conifers is used to communicate these feelings. There are many shades of green, however. It is the light, yellow-greens of spring that are the most salable. If a particular photograph you have taken in the past shows a stand of dark green trees, you can alter the color after the fact using the techniques described on pages 80-96.

Orange, yellow and especially red are associated with passion, heat and excitement. The more saturated the hue, the more strongly the message is communicated to the public. It's no coincidence that law enforcement officers monitor the speed of red sports cars more closely than cars painted darker colors!

White is usually associated with purity, cleanliness and even spirituality, while pink is the color of femininity. Deep purple is used sometimes to convey the concepts of royalty, richness and flamboyance. Black can be both elegance and evil.

Photographic Reproduction in Print

When you sell your work for publication, it is often disappointing to see how photographs are reproduced in print. When you compare the original transparency to the image on paper, the subtle detail in the highlights and shadows and the rich tonalities of the colors are sometimes lost. Or the contrast of the original hasn't been retained, and the reproduction seems flat and lifeless. Some colors in the original shot may look very different when you see them in a printed piece because they are so difficult to match accurately in the printing process.

There are many factors that influence the printing process. These include the quality of paper, the number of times the paper goes through the printing press, the sophistication of the press and the skill of the operator. Because printing is very expensive, the designers who plan print jobs must often make trade-offs in quality to stay within their budgets. Unfortunately, the optimal reproduction of photographs in print is very expensive, so designers may choose to accept some loss of reproduction quality to achieve other objectives. For example, a designer may use a lower quality, less expensive paper so the printed piece can be a larger size that will have more impact but still cost the same as a smaller piece on more expensive paper.

The aspect of printing that has the most effect on the reproduction of photographs is how the pages are actually printed. Color printing uses four inks, called process colors. These ink colors are cyan, magenta, yellow and black (referred to as CMYK). These inks are combined in different proportions to create thousands of colors.

In order to reproduce the colors of your shot in print, the original film is scanned by a high-resolution transparency scanner, and all the colors in the image are translated into percentages of the four process colors. The result of this process is a color separation, which is composed of four pieces of film—one for each of the process colors—composed of tiny dots that, when reassembled, equal the size of the final printed image. The color separation (sometimes referred to simply as a "sep") is then used to make four plates that are placed on the printing press to lay the ink colors on the paper for the images and the type. A photograph of an intense orange, yellow and rose sunset sky, for example,

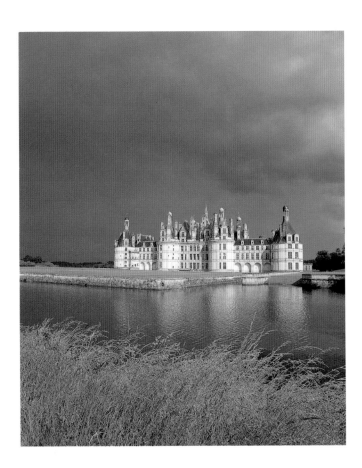

Travel brochures, guidebooks, postcards and posters generally include shots of famous places under the predictable blue sky. The pictures are usually taken at midday when the sunlight is harsh and unattractive. The reason is obvious. People don't want to travel to a place that looks like bad weather is a significant possibility.

Shots taken under sunrise or sunset lighting can be as appealing as those taken under midday sunlight—and they have the advantage of standing out from the competition because they are different. The yellow-orange tones of low-angled light are enticing, in addition to implying good weather.

These two shots of the Chambord Chateau in France illustrate the need to be objective about the shots you take when evaluating their marketability. Both are beautiful, but only one is salable to the travel market. The photo on the left shows a brooding, stormy sky with dark, moody colors. I actually love the contrast between the angry, gray sky and the rich green grass in the foreground, but I know that this picture would never sell in a travel brochure. It would discourage most tourists from even planning a visit.

The photo below was taken about an hour later when the sky had partially cleared. Although only a little blue can be seen above the chateau, the sky is much more friendly and the late afternoon sunlight bathed the architecture in tones of golden yellow. It is this image that would sell.

Technical Data:
Both photos—Mamiya RZ 67 II, 50mm wide-angle lens, Fujichrome Velvia, tripod. Stormy sky—¼ second, f/16. Sunset sky—⅛ second, f/22.

is reproduced by the magenta and yellow plates depositing significant amounts of those two ink colors on the paper, plus small amounts of black and cyan from the other plates.

Highly saturated colors, the red in a rose for example, will usually not match the original depth of color in the transparency. Color printing relies on a delicate balance of ink colors across the page. Adding extra ink to match one color will affect everything else on the page. If the printer increases the amount of magenta to try and match the richness of the red in the rose in the original photograph, everything else will take on a magenta cast or become a muddy color. This color problem can be solved by adding another plate that will only overprint the areas that need the extra saturation. This fifth plate, however, adds substantially to the cost and will be used only when the color reproduction of a particular image is critical to the success of the printed piece as a whole.

Some colors, such as peach, chartreuse, gold and neon blue, are very challenging to reproduce accurately using only the four process colors. Some shades, such as lime green, can't be accurately reproduced at all. In these cases, the designer or print production supervisor will simply try to come as close as possible to the desired effect.

Extra ink colors can be used to solve the problem of colors that can't be reproduced well, or at all, by four-color printing. Match colors are specially blended inks created to exactly reproduce hundreds of different colors, including lime green, peach and neon blue. In a match color system, each shade is assigned an identification number, and a printer can consult a chart that indicates the precise combination of inks that produce that particular hue. This system is similar to the way stores that sell house painting supplies use those little numbered color swatches to mix exactly the paint color you want. Some match systems even offer metallic inks that capture the true colors of gold, silver and copper. One of the best-known systems of match colors is the Pantone Matching System; designers often refer to the colors from this system simply as PMS colors.

Each special color requires its own plate, sometimes instead of, but generally in addition to, the four plates for the process colors. Eight, or even more, plates may be needed to reproduce a host of unusual colors. This significantly increases the cost of printing, so it is seldom used for editorial work, even in upscale publications, or for the advertisements you see in them. Extra plates are used in high-budget printed pieces, such as brochures targeted to an upscale market, and on work printed for the fine art market, where the quality of color reproduction is critical to the success of the whole piece.

OTHER USES OF COLOR IN DESIGN

Art directors and graphic designers frequently choose match colors for type or border designs on brochures, posters, greeting cards, magazine covers, book jackets and calendar layouts. The work you sell may be reproduced in conjunction with one or more match colors chosen for the finished printed piece. These color design elements can affect how your photo appears on the page. The blue of the ocean by a tropical beach may appear even more blue if a blue match color is used for the type on the page or a border around it.

If you elect at some point to invest in your own poster or calendar, you will have to make the decision as to the color or colors of the copy and other design elements that will show your work to its best advantage. You will then have to weigh the pros and cons, just like a publisher, of spending the extra money to print a fifth, sixth or even a seventh color to accent your work. Sometimes simplicity is best. It is certainly less expensive, which means that you can charge less for the poster or calendar in order to appeal to a broad market. In other cases, you may want to go all out and present your work to a more upscale, but limited, market. An elaborate design may be just what is needed to increase the perceived value for the potential buyer.

The ceremonial attire worn by the inhabitants of different countries and cultures around the world offers wonderful opportunities to capture brilliant color. I photographed this young girl in a Maasai village in Kenya in the shade of a hut that blocked the harsh African sun from my subject. A gold reflector was used to bounce warm light back into her face.

Without the colorful necklaces and headpiece, this shot could be used in a travel article, but the higher paying advertising market would look for a more colorful photo. I arranged through an interpreter to photograph several Maasai in their beautiful beadwork. By spending the extra time (and money) to make these arrangements, I made the images significantly more valuable. The series of pictures I took can now be used for travel brochures, magazine and book covers, airline posters and other high paying markets.

Technical Data:
Mamiya RZ 67 II, 250mm telephoto lens, 1/125, f/5.6, Fujichrome Provia 100, Photoflex gold reflector, tripod.

Photographs that document famous locations will often sell for textbooks, encyclopedias, CD-ROMs and travel brochures. But the better paying markets—advertisements, travel posters, magazine and brochure covers, annual reports and trade show displays—are reserved for only the best and most dramatic images. Color plays a pivotal role in decisions about what makes the "best" image for any given use. The art directors who procure photography for their high-paying clients can afford to be highly selective. By incorporating a sophisticated use of color in your photography, you can compete with other professionals for the stock sales and assignments that pay big dollars.

This ancient column that once supported the main temple of the Toltec culture in medieval Mexico is virtually colorless. The neutral gray stone offers hardly any significant contrast against the blue sky seen so often in this desert region. The colorful rainbow arch transforms an ordinary image into an extraordinary one. The contrast between the monument and the background sky adds drama as well as color to the shot. The rainbow with its promise of a bright tomorrow creates a poignant counterpoint to a monument created by a people who no longer exist.

Technical Data:
Mamiya RZ,67, 127mm normal lens, 1/30, f/16, Ektachrome 64, tripod.